Noriyuki Haraguchi

Noriyuki Haraguchi

CATALOGUE RAISONNÉ 1963–2001

Helmut Friedel

Hatje Cantz

Contents | Inhalt

Helmut Friedel

7 Elements of Perception
The Work of Noriyuki Haraguchi: 1963–2001

17 Elemente der Wahrnehmung
Noriyuki Haraguchi: Arbeiten 1963–2001

Noriyuki Haraguchi

27 Circulations: The Permanent Process

31 Zirkulationen – Der permanente Prozess

35 CATALOGUE | KATALOG

203 Exhibition Biography | Ausstellungsbiographie

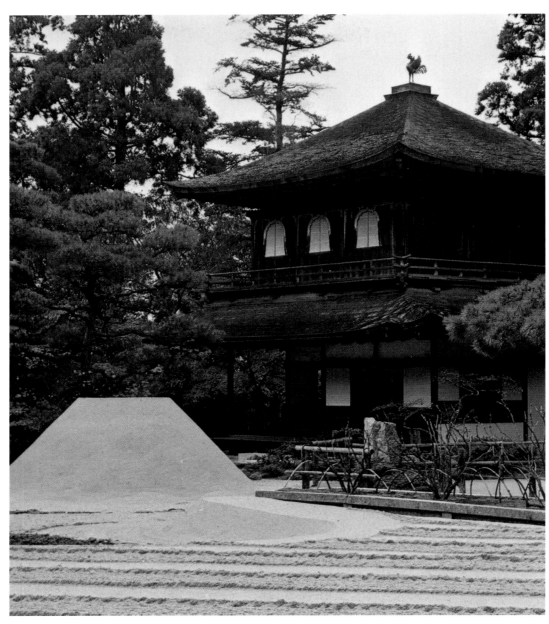

1 Ginkaku-ji, Kogetsudai, Kyoto

In the garden of Ginkaku-ji, the silver temple built by the Shogun Ashikaga Yoshimasa (1436–90) just outside Kyoto (Fig. 1), there is a sculpture made from pale silver sand. It is shaped liked a cone without a tip – an allusion to Mount Fujiyama – and is a little over one and a half metres in height. The cone, a strictly stereometric figure made from loose sand, has been in existence since around 1615; this has entailed its being regularly re-made according to ancient instructions. The sculpture is part of a Zen ritual, and its form is determined by a concept which was once devised by a great master and which has been kept 'alive' ever since. In accordance with a similar tradition the stone garden at Ryoan-ji, another Zen temple in Kyoto, has also been preserved over the centuries. In the *hojo*, the quarters of the highest ranking monk in the monastery, there is a *karesansui*, a dry landscape garden with a famous formation of rocks laid out by Hosokawa Katsumoto in 1681 (Fig. 2). Standing on mossy 'islands' the rocks bring to mind thoughts of mountainous cliffs with a 'sea' of pebbles washing around them. This area is regularly raked, following a plan that stipulates precisely where the ripples should be. Here, too, a form of art is being practised that requires the active presence of at least one individual who has a part to play but only as prescribed in a given plan, which is carried out with meticulous rigour.

These two examples of ancient Japanese art, to which many more could readily be added, show very clearly that in Japan the approach to art is unlike the European approach, that there is a very different notion of artistic 'work'. In the Japanese view the work is not first and foremost a pictorial concept executed in a certain material and thereby immortalised; and it is this Western notion of the concretion of an idea in a durable material, progressing from the artist's *disegno* to the finished work, that has nurtured the European concept of a memorial, of the permanence of a work of art. According to Japanese custom, even temple buildings, like the Temple-Shrine of Ise (Fig. 6), are regularly re-built by each new generation – with the old temple subsequently being taken down within one year – demonstrating a very different concept of both permanence and originality. Scarcely any importance is attributed to weathering or the patina of age, which in Western thinking express history and the passage of time, and determine historical value. Instead, in Japan, the work itself remains young and in fact only exists as long it is remembered by certain people, that is to say, as long as the tradition is upheld.

In 1977, at *documenta 6* in Kassel, Noriyuki Haraguchi caused a major stir with his work *Matter and Mind* (Fig. 3, CAT. No. 66), which was shown with the title *Busshitsu (Matter)/Relationship*. One part of the work consisted of a reflective black surface which virtually covered the entire floor area of the exhibition space, the other part consisted of steel plates propped up against the wall. At first sight the reflective black floor had echoes of the magnificent lacquer work found not only on domestic items but which has also often been used in Japanese architecture. In another Zen temple in Kyoto, in Rokuon-ji, there is a golden pavilion, which has given the temple its more familiar name, Kinkaku-ji (Golden Temple; Fig. 7). The pavilion was made in 1408 in memory of the Shogun Ashikaga Yoshimitsu (1358–1408). The wooden walls are completely faced in gold, inside and out, and the floor is covered with gleaming, black, highly reflective lacquer. The reflective floor is in harmony with the dark surface of the lake in which the pavilion is standing. Here, as in the case of Haraguchi's black rectangle, the surrounding architecture sinks into the imaginary realms that form in the reflections. But, despite this effect, Haraguchi's installation is far removed from a traditional example of lacquer work.

Haraguchi's work consists of a simple, black steel frame which serves as a shallow container for used oil. The thick, viscous, jet-black waste material spreads out smoothly; surface tension holds it steady and rigid like a frozen fluid. Puzzled by the industrial odour and scarcely able to suppress their inquisitive urge to test the surface, time after time visitors mar the perfection of the floor. But, in contrast to the examples in the Zen gardens of Kyoto, this surface reforms entirely of its own accord. In many respects this work is the diametric opposite of artistic positions in Europe and America, most memorably represented by Wolfgang Laib with his *Milchstein*, the first of which he made in 1975. This was exhibited in Kunstraum München in 1978. A wider public later saw it at *documenta 7* and at the Venice Biennale in 1982 (see Fig. 8 for a later variant on this theme). Laib's work is governed by similar principles to those described above, and which are typically found in Zen traditions – where the material properties of a work mean that it requires permanent care and reconstitution. Laib's interest in the philosophies of the Far East is unmistakable. But while Laib is dealing with foodstuffs – milk, rice, and pollen – Haraguchi seeks out the darker side of materials like oil, steel, and polyurethane. The solemnity of *Matter and Mind* derives from the noble, mute depth of a black that the Western eye associates not least with the sight of the highly polished surface of a concert grand.

But Haraguchi's 'solemn' floor piece has to be seen in relation to a second work in raw steel. *Matter (documenta 6)* (CAT. No. 67) consists of two long, narrow strips of steel folded lengthways to form a right angle, one 20 x 20 (the two sides of the right angle) x 300 cm in length, the other 20 x 20 x 400 cm. These are attached horizontally and vertically to the wall. With these 'axes', the artist demonstrates the basic conditions of spatiality, as they matter to him, and also as they apply both to objective spatial situations and to an individual's subjective perception. Haraguchi said as much in a short statement reprinted in the catalogue for *documenta 6*: "We recognise the conditions in our surroundings – the situation, you might say – by relating them to universal concepts, be these the cosmos, nature, the laws of physics, or simply the space in which we find ourselves. . . . An exhibition space creates a particular

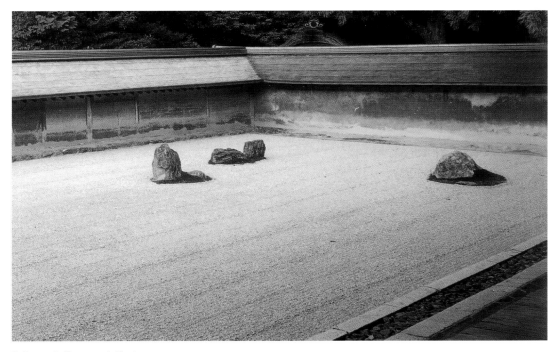

2 Ryoan-ji, Karesansui, Kyoto

kind of self-contained, closed-off situation which can be understood conceptually. Since the point is to express the totality of all our perceptions in this situation, I convey my concepts in an extremely simplified form. In my work I want to present all the elements involved in the process of perception, including myself, in a fixed, balanced relationship. My aim is to objectify horizontality, verticality, materiality, reflections, fluids, containers, physical phenomena of all kinds including myself (body, feelings and thoughts)" (volume 1, page 186).

Haraguchi again objectified space in *Event of the Transfer of Steel* (Fig. 4, CAT. No. 63), which he performed in 1975 and 1976 in the Nirenoko Gallery and in the Maki Gallery in Tokyo, moving twenty-seven steel plates (each 180 x 22.5 cm) around in the space, thereby 'occupying' the floor and the walls in a variety of configurations. There is a certain affinity between this Action and a similar work by the sculptor Franz Erhard Walther who also participated in *documenta* 6 in Kassel at the same time as Haraguchi, and who revealingly called his work with elemental materials *Aufbau als Werkform* (Construction as Form; Fig. 9). Neither in this piece nor in the work by Laib is there any question of a direct influence on Haraguchi, yet it is clear that the latter was formulating his work in the same 'language' that other artists in Europe and America were using at the time.

Haraguchi's persistent interest in planes and surfaces is seen to particular effect in *Untitled (Yokosuka)* of 1973 (CAT. No. 53), where a gleaming black rectangular plane (4 x 8 metres) was created by pouring oil into a depression in the concrete floor of a former dockland warehouse. This powerful, large-scale undertaking had been preceded in 1970 by a small floor piece measuring less than one square metre. All it consisted of was a section of the floor being marked out by a wax outline, which then gave form to a puddle of water. The water-repellent property of this material also meant that the surface of the water could be marginally higher than the wax rim without overflowing. Thus the minimally, yet recognisably, higher film of water seemed to create a glassy plane – a reminder that glass itself is simply a solidified liquid. Even earlier in 1968, when he painted an area of concrete with solid white paint in

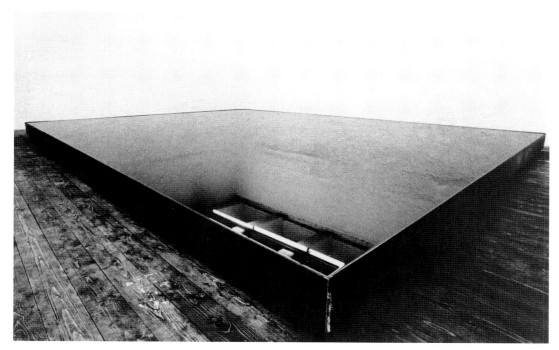

3 Noriyuki Haraguchi, *Matter and Mind* (CAT. No. 66), *documenta* 6, Kassel, 1977

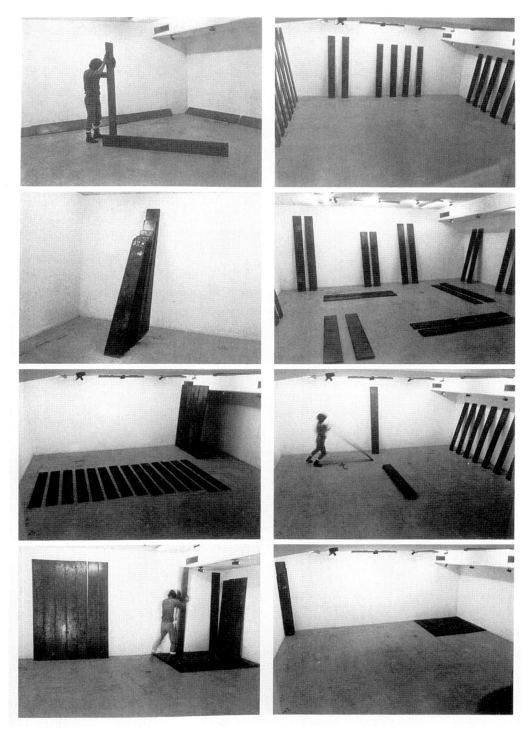

4 Noriyuki Haraguchi, *Event of the Transfer of Steel* (CAT. No. 63), Nirenoko Gallery, Tokyo, 1975

a piece for the Hibiya Gallery in Tokyo (CAT. No. 9), Haraguchi had already demonstrated his intense interest in ways of defining planes, surfaces, and space.

That same year he also made a work entitled *Positioning of Matter (or Materiality)* (CAT. No. 56), in which he explored different 'materials' as a means of defining a surface area. Of particular note, in light of our observations so far, is a plexiglas cylinder standing on a steel plate. It is filled with water, thus becoming a solid body, heavy yet transparent and deceptively light. The water is level with the top of the cylinder, forming a column of water standing upright on the steel and corresponding to a roll of sheet lead that is lying at the edge of the steel plate. The two elements point in different directions: vertical as opposed to horizontal. Haraguchi himself commented on this work in a conversation with Akira Ikeda: "It was not a matter of expressing the artist's intention or bringing out the inner creativity of the material, it was simply about 'setting' the work in the context. The work was not an attempt to reveal the artist's innermost thoughts, it was about the particular situation of certain objects and the way they were configured."

In almost complete contrast to his work on elemental definitions of surface areas, Haraguchi also turned his attention to everyday things (see for instance *Tsumu 147*, 1966; CAT. No. 8). Even in the earliest years of his career between 1963 and 1965, he was already making works with models of ships 'sailing' under a transparent plexiglas hood on the uppermost plane of a white lacquered block (CAT. Nos. 1–7). His models of ships very clearly have connections to his own biography.

Haraguchi grew up in post-war Japan in Yokosuka, which was by then already a major strategic base for the American Navy. The port of Yokosuka itself had an illustrious history: it had been instrumental in the opening up of the country after the Edo period, and during the subsequent Meiji period it had become an important naval base in times of war. Haraguchi's family had in a sense been caught up in the history of the port. Then, with the outbreak of the Cold War Japan increased its military activities on the islands in its northern territories and Haraguchi's father found work on Hokkaido as a radar technician, with the result that the young Haraguchi spent his childhood in an extreme landscape on the furthermost point of a headland. To this day he recalls the fascinating natural phenomena he witnessed there: "In the small island-empire of Japan, where I was born and raised, the four seasons of spring, summer, autumn, and winter are especially beautiful. The vegetation is unique and the climate is characteristic. Even frost damage and typhoons cannot get the better of Japan's blessings. The different seasons are full of variety and constant change" (see the essay by the artist in this volume). As a teenager Haraguchi returned to Yokosuka and was impressed by the docks and the naval base. He started drawing intensively, showing the Japanese landscape increasingly being encroached upon by industry as the country entered into a phase of flourishing economic growth. At this stage he was still using a traditional form, namely landscape drawing, to depict the blatant alterations and destructive interventions he saw in his surroundings. Then, barely eighteen years old, he started to express these observations in what were his first independent artistic works: *Ships* (CAT. Nos. 1–5) and *Submarines* (CAT. Nos. 6–7). These have little to do with the simple models of fighting vessels of the kind that many young people build; instead – by being set on a white block and encapsulated in a transparent hood – they express a particular response to a moment in the country's culture and civilisation which requires more than mere illustration. The colourless, rectangular covering encloses the operational territory for these miniatures of threatening yet fascinating ships and submarines, some of which are partially destroyed. In these works Haraguchi is in fact already addressing fundamental questions (which he later clarified in his oil reflections) as to how space may be construed and differentiated; for he was not simply constructing display

cases to house finished models, instead the bases of the vessels are sliced off so that they seem to be sailing on abstract white.

In 1968 and 1969 Haraguchi showed a number of works and short series in various exhibitions in Tokyo, which all go by the name of *Air Pipe* (CAT. Nos. 13–23). These are sculptures in the shape of technical fittings, more precisely ventilation and air-conditioning systems with slit-shaped openings and which only seem like works of art by the way they are placed or by the unusual way they have been trimmed. In a way these works already seem like 'copies' of ready-mades (see CAT. No. 18). At the same time some of the objects almost seem like easel paintings, in the sense that the artist presents them much like tableaux on a wall (see CAT. Nos. 19–21). But, by the very way that they are set against this flat wall, they can also be seen as reliefs.

From here Haraguchi progressed directly to his extreme sculpture *A-4E Skyhawk* of 1969 (CAT. No. 24), which makes an immediate impact for its size alone. This wooden 'reconstruction' of an aircraft tail unit confronts the viewer with the stunningly immediate presence of airborne weaponry, above all when it is shown in the confined conditions of a gallery space. On the other hand, its scrappy construction and obviously not-smooth landing on the floor of the gallery make an ironic comment on power and military might. The cheap wood and its evident fragility confirm this impression. According to ancient mythology, the artist, personified in the figure of Hephaistos (Vulcan), fashioned the finest of weapons for Ares (Mars), the god of war. But then Hephaistos' wife Aphrodite (Venus) betrayed him with Ares – and now it seems that in this work the artist has taken his revenge. An ineffectual piece of military equipment, doomed to failure, lies on the ground, 'only' of any use as a sculpture.

While Panamarenko's flying objects cast the artist as inventor, reviving the utopian dream of flying (see Fig. 5), and Pino Pascali exhibited a real rocket in 1965 with his *Colomba della pace* (Fig. 10), Haraguchi's copying and reconstruction of existing forms adds yet another dimension to the above. In it we see very clearly his understanding of the model-like quality of his own work: art creates conceptual yet tangible models of reality. Of course these are deficient compared to the original, hence their status as 'just' images, but as physical objects in their own right they are themselves securely anchored in reality and therefore more than mere images. Unlike the inventor Panamarenko who, faced with inevitable failure, seeks a way out in art, and unlike Pascali who takes a threatening ready-made and presents it as art, Haraguchi's section of an aircraft is an image which may take the form of a tail unit but which – quite apart from its fragmentary nature – by virtue of the material used can only ever be seen as the *imago* of a fighter plane. The non-pictorial illustrative character of the Zen garden at Ryoan-ji described above also seems to have left its mark in this area of Haraguchi's work.

Right from the outset, therefore, Haraguchi's work has operated on very different formal levels: distinctly temporary surface demarcations, bodies (materials) 'set' and reflected in defined surroundings (outdoors and inside), and sculptures which not only depict reality but which also imitate it in another material.

Over the years Haraguchi has 'set' expanses by using gleaming oil in very different situations. And it is clear that the placing of each of these addresses a different question for the artist. For example, when he places *Matter (Kiba) No. 7* of 1978 (CAT. No. 72) right by an area of water, a canal, then the ensuing image has particularly clear echoes of the situation of the Golden Pavilion in Kyoto with its black lacquer floor above a dark lake. In complete contrast to this, the horizontal plane of gleaming oil in *The Matter of Black 1. 2. 3.* of 1981 (CAT. No. 83) is answered by two pitch black, almost square 'reliefs' on the wall.

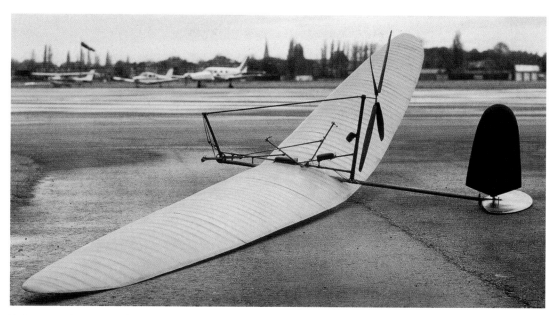

5 Panamarenko, *U-Kontrol III*, 1972

The way that Haraguchi handles forms and materials derives from an ethos that contrasts markedly with Western attitudes. The material he uses to make the black reflective surfaces is arbitrary and interchangeable. Unlike Wolfgang Laib's *Milchstein*, made from ever-lasting marble, in Haraguchi's work it is only the idea, the thought behind it, that endures. But in the sense that the work of art can be reconstructed whenever one wants, it is also indestructible. All that is required is the determination and the decision to see the work again. But, in contrast to Conceptual Art as practised by Lawrence Weiner for one, where it is not deemed necessary for a work of art to be realised by the artist or by anyone else for that matter, Haraguchi's work demands to be realised. His work only comes back to life when it is made or 'set' in a certain place; it is not enough for it to exist on a purely conceptual level.

When Haraguchi places black, green, and sometimes even aluminium plates vertically, the resulting works more or less defy categorisation using the customary nomenclature. Since almost all of these wall pieces – which first appeared in 1978 – are coated in polyurethane (CAT. No. 73 and onwards) and are a good ten centimetres and more in thickness, they are clearly bodies, reliefs against the wall. But since the front surface is generally smooth, and the works are almost entirely non-haptic, they seem more like easel paintings. Moreover, by the way they are presented – now standing on the floor, now squeezed into a corner, now hung like a painting – they put the viewer into a somewhat ambiguous position. In the case of *Untitled* of 1981 (CAT. No. 84), the piece is as much as 181 x 161 cm by 26.5 cm in depth, and *Untitled* (CAT. No. 85) is no longer against the wall but stands in the space exactly like a 'sculpture'. A pictorial element that defines a wall has become an object with the same capacity to divide space as any wall. In *Taura No. 6* (CAT. No. 156) of 1984 the artists demonstrates ways of freely 'setting' shapes in space: black cubes stand out against the white walls around them and articulate the space. They share the same reality as the viewer and lay claim to the same status as him or her. The ensuing tension expresses what Haraguchi refers to in the statement cited earlier in this text: namely his aim to 'objectify' all manner of physical phenomena including himself. In the large-scale pictures of 1985–86 entitled *Construction* (CAT. Nos. 162–164), the artist applies his knowledge of spatial issues to a plane, but creates a work of such dimensions that it of necessity engages with the architecture of the exhibition room.

Besides these planar 'wall-bodies', in the 1980s Haraguchi also made pieces that demarcate three-dimensional physical forms. Amongst these is the sculpture *Untitled* of 1982 (CAT. No. 140), made from layered steel plates. Twenty-five layers of steel are used to make a cut-off pyramid 73 cm in height and with sides of 280 cm in length. The slight narrowing of the shape towards the top gives the form a more plastic appearance. The relatively thin layers of steel together make up an immensely solid piece, which seems to articulate the dead weight of the material. The piece itself is very different to solid sculptures by other artists, by Richard Serra for instance, for in Haraguchi's case one can easily picture it as a stack of numerous surfaces, with each of these being the topmost surface for a moment. Thus the processual quality of the work, its construction over a period of time, becomes an important criterion of the work; at the same time one can equally well imagine the work being dismantled, taken apart piece by piece. A similar effect is also created in *100, Revised* of 1985–86 (CAT. No. 160) which consists of a pyramid of wooden beams and angled sheet copper.

In 1988, in an exhibition in the Akira Ikeda Gallery in Tokyo, Haraguchi showed four large sculptures in steel, aluminium, and glass: at the same time as being distinctly structural pieces they also achieve much of their effect by the quality of their surfaces and even by the way these surfaces gleam. In *Kiku II* (CAT. No. 201) flat perforated metal encloses but does not entirely hide the structure. Meanwhile one side of *Sakura I* (CAT. No. 200) reveals the construction of the piece while the other is the 'viewing side' which, consisting of reflective surfaces, largely hides the mechanical, tectonic structure and instead reflects the surroundings, thereby incorporating them into the work. *Kashinoki IV* (CAT. No. 203) unites structure and surface as one spatial entity. The same contrast is seen in a more condensed form in the reliefs which seem to progress naturally from these large, complex sculptures: bent sheet metal is used to create constructed surfaces (for the earliest examples, made in 1988, see CAT. Nos. 204–205). These are often complemented by optical structures which, as indentations or stamps in the metal, are clearly the result of some mechanical intervention. In addition to this, these surfaces also owe much to their colouration.

In the early 1990s, Haraguchi made a number of works that take the circle as their basic form. Cylinders, tubes, and even a round pool of oil (CAT. No. 219) now make an appearance. Most notable amongst these is probably a 125 cm high aluminium cylinder made in 1990 (CAT. No. 222). The shimmering, glistening sheet aluminium reflects its surroundings like a dull mirror, albeit altering and distorting them because of the curve of the surface. If one looks inside the piece, one can see the internal metal supports. For all the illusionistic properties of the reflections in Haraguchi's output, his works are never without an element of rationalism, in that their structure is always perfectly apparent to the viewer. The polar opposite of this piece is *Untitled, FBS* (CAT. No. 224). This consists of a thick rubber mat rolled up to form a cylinder with a diameter of 280 cm. Despite the fact that the cylinder itself is hollow, the huge weight of the material still creates an impression of immense heaviness. No highlights on the surface lighten its bulk, its melancholy ballast. By contrast, the most light-hearted circle is a ring of coloured steel plates measuring 26 metres in circumference (CAT. No. 226). Like a round-dance of twirling figures the never-ending circle of movement radiates a levity all of its own.

Haraguchi also uses the circle – the most unified and self-contained of all forms – to describe a place or to demarcate a space, focusing on the difference between inside and outside. This is seen most vividly in his installation with a 260 cm high steel cylinder (2.5 metres in diameter) floating just above the ground (CAT. No. 233). In this piece there is a clearly defined exterior that correlates to an interior, which cannot be viewed but which is nevertheless recognisable and imaginable: the concretely graspable as opposed to the invisibly imaginable.

In 1992 Noriyuki Haraguchi's wife, Ikuko Sakata, died. The artist made no work that year. It was not until the following year that he showed work again, in the New York branch of the Akira Ikeda Gallery. The work in question was a series of uniform, lightly curved metal sheets on aluminium frames, all of which were painted black (CAT. Nos. 238–250), and looked like shields, curving into the space from the wall. This succession of silent, black signs – one after the another like rests in a piece of music – together created the effect of a solemn requiem.

Besides a number of very similar works which followed this piece, the basic notion of an upright rectangle is seen again in a very different realisation in a work with steel plates, which seems to have echoes of Haraguchi's Action of 1975–76. At that time he made a number of different spatial demarcations; in 1996 in *14 Boards* (CAT. No. 276) he laid out a distinct, unique arrangement. Equally succinct is the work *L*, made in the same year (CAT. No. 277), consisting of a five and a half metre long angle, which seems to cut through the wall: a later stage, as it were, of one of his *documenta* pieces. And all the time, Haraguchi returns again and again to his work with gleaming black oil. He changes the position from the centre to the edge of the room, the form mutates from rectangle to circle to square, combinations with wall pictures or partition-like steel plates are explored – but in all of these the notion of space as such determines the form the work takes, as was already the case in his first installation in the mid-1970s. It is as if a play were being performed numerous times, with different results each time because of the different conditions in the venue, the place, and the time. As though following a ritual in a Zen garden Haraguchi performs acts of devotional repetition, always seeking to produce something new in the process. His work seems to progress in cycles, as we see when he returns after over thirty years to the early aircraft piece from the 1960s and revives it in an altered state (CAT. No. 287) – a black fragment, an importunately present shadow.

(Translated from the German by Fiona Elliot)

Elemente der Wahrnehmung
Noriyuki Haraguchi: Arbeiten 1963–2001

Helmut Friedel

Im Garten des Silbertempels, des vom Shogun Ashikaga Yoshimasa (1436–1490) erbauten Ginkaku-ji (Abb. 1), der sich am Rande von Kyoto erhebt, steht eine Skulptur aus silberhellem Sand. Sie besitzt die Form eines Kegelstumpfes, womit sie an den Fujiyama erinnern soll, und ist etwas mehr als eineinhalb Meter hoch. Seit etwa 1615 wird diese streng stereometrische Figur aus leichtem, ungebundenem Sand erhalten; das bedeutet, sie wird regelmäßig nach einem altem Plan wieder geformt. Die Skulptur ist Teil eines Zen-Rituals und folgt in ihrer Form einem Konzept, das einst von einem großen Meister entworfen worden ist und seither „am Leben" gehalten wird. Aufgrund einer verwandten Tradition wird auch der Steingarten des Ryoan-ji, ebenfalls in Kyoto gelegen, über die Jahrhunderte hinweg erhalten. Dieser Zen-Tempel besitzt im Hojo, das ist der Bereich des Klostervorstehers, einen Karesansui (Abb. 2), einen trockenen Landschaftsgarten mit einer berühmten Anordnung von Steinbrocken. Hosokawa Katsu-moto hat sie 1681 geschaffen. Auf bemoosten „Inseln" erheben sich die Steine als Abbilder von Fels-bergen und werden von einem „Meer" aus Flusskieseln umgeben. Diese Fläche wird regelmäßig einem Plan folgend, der bestimmte Rillen vorschreibt, gerecht. Auch hier wird eine Form von Kunst praktiziert, die die aktive Präsenz eines handelnden Menschen erfordert, der sich aber einem vorgegebenen Plan unterordnet und ihn in aller Strenge ausführt.

Mit diesen beiden Beispielen alter japanischer Kunst, denen man ohne weiteres eine Fülle anderer hinzufügen könnte, wird deutlich, dass es in Japan einen vom europäischen Verständnis verschiedenen Ansatz von Kunst, einen sehr unterschiedlichen Werkbegriff gibt. Das Werk ist demnach nicht in erster Linie die in einem bestimmten Material ausgeführte und darin zur Verewigung gelangte Bildidee. Aus dieser abendländischen Vorstellung von der Konkretion einer Idee in einem dauerhaften Material, vom Disegno des Künstlers zum ausgeführten Werk, nährt sich der europäische Denkmalsgedanke, die Vorstellung von der Beständigkeit des Kunstwerkes. Japans Weg, demzufolge auch Tempelanlagen und Schreine, etwa die von Ise (Abb. 6), in regelmäßigem Turnus von jeder Generation neu aufgebaut werden – im Anschluss erfolgt dann innerhalb eines Jahres der Abbruch der bisherigen Bauten –, zeugt von einem anderen Verständnis von Dauer wie von Originalität. Die Spuren des Alters, die für uns Zeit und Geschichte auszudrücken vermögen und den Erinnerungswert eines Dinges ausmachen, spielen dabei kaum eine Rolle. Das Werk bleibt vielmehr jung und auch nur existent, solange die Erinnerung der Menschen daran besteht, das bedeutet, solange die Tradition gepflegt wird.

Noriyuki Haraguchi erregte 1977 auf der *documenta 6* in Kassel Aufsehen mit seiner Arbeit *Matter and Mind* (Abb. 3, KAT. Nr. 66), die dort unter dem Titel *Busshitsu (Matter)/Relationship* gezeigt wurde. Der eine Teil dieses Beitrags bestand aus einer spiegelnden schwarzen Fläche, die nahezu den gesamten Ausstellungsraum füllte, der andere aus Stahlplatten, die an der Wand lehnten. Auf den ersten Blick erinnerte die Bodenspiegelung an die großartigen Lackarbeiten, die in der japanischen Kunst nicht allein bei Gebrauchsgegenständen in Erscheinung treten, sondern auch in der Architektur häufig Anwendung gefunden haben. In einem weiteren Zen-Tempel Kyotos, dem Rokuon-ji, steht ein goldener Pavillon, durch den der Tempel besser bekannt geworden ist unter dem Namen Kinkaku-ji (Goldtempel; Abb. 7). Der Pavillon ist 1408 zur Erinnerung an den Shogun Ashikaga Yoshimitsu (1358–1408) errichtet worden. Seine in Holz gebauten Wände sind innen wie außen vollständig vergoldet, während der Fußboden mit schwarzem, hochglänzendem und damit spiegelndem Lack überzogen ist. Die Spiegelfläche korrespon-

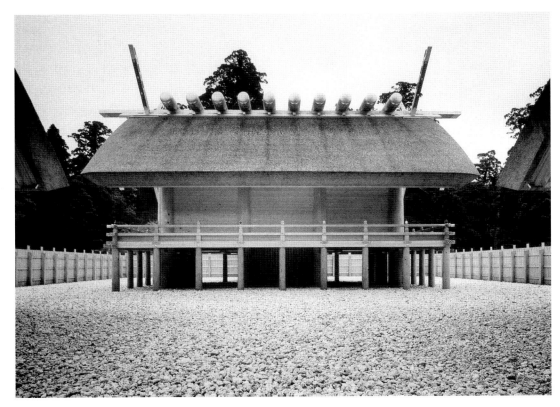

6 Shoden, Naigu, Ise Jingu

diert mit der dunklen Oberfläche des Teiches, in dem der Pavillon insgesamt steht. In diesem Boden wie in Haraguchis schwarzem Rechteck taucht die umgebende Architektur in einen Raum des Imaginären, der durch die Spiegelung entsteht. Aber Haraguchis Arbeit ist trotz der beschriebenen Wirkung weit entfernt von einer traditionellen Lackarbeit.

Haraguchis Werk besteht aus einem einfachen, schwarzen Stahlrahmen, der als flaches Behältnis zur Aufnahme von Altöl dient. Das dichte, dickflüssige und tiefschwarze Abfallprodukt dehnt sich zu einer glatten Oberfläche, die durch ihre Spannung unbeweglich und starr wie die einer gefrorenen Flüssigkeit erscheint. Irritiert durch den Geruch des Industriematerials und durch das kaum zu hemmende, neugierige Bedürfnis des Betrachters, die Oberfläche zu überprüfen, kommt es immer wieder zu Verletzungen des perfekten Zustandes. Aber im Unterschied zu den oben genannten Beispielen aus den Zen-Gärten von Kyoto, schließt sich die Oberfläche hier wieder von selbst. In vielfacher Hinsicht stellt diese Arbeit einen Gegenpol zu künstlerischen Positionen in Europa und Amerika dar, wie sie am eindringlichsten wohl Wolfgang Laib mit seinem *Milchstein* vertritt, den der Künstler 1975 erstmals gemacht und 1978 im Kunstraum München ausgestellt hat (vgl. Abb. 8). Durch Präsentation auf der *documenta 7* und auf der *Biennale di Venezia* im Jahre 1982 wurde das Werk einem breiteren Publikum bekannt. Für die Arbeit von Laib gelten ähnliche Prinzipien – permanente Pflege und Wiederherstellung des Werkes, die aufgrund seiner materialen Kondition notwendig werden –, wie sie oben als charakteristisch für die Zen-Kultur beschrieben wurden. Laibs Orientierung an fernöstlichem Denken ist dabei unverkennbar. Während er aber die Lebens-Mittel Milch, Reis und Pollen abhandelt, sucht Haraguchi nach den Nachtseiten von Materialien wie Öl, Stahl und Polyurethan. Die solemne Feierlichkeit seiner Arbeit *Matter and Mind* rührt von der edlen, toten Tiefe eines Schwarz her, wie es in

7 Kinkaku-ji, Kyoto

unserem Kulturbereich nicht zuletzt mit dem Anblick der gelackten Oberfläche von Konzertflügeln ver-
bunden ist.

Haraguchi setzt jedoch diese „feierliche" Bodenarbeit in Relation zu einem zweiten Werk aus rohem
Stahl. *Matter (documenta 6)* (KAT. Nr. 67) besteht aus Winkeleisen von zwanzig mal zwanzig Zenti-
metern Schenkellänge und einer Ausdehnung von drei beziehungsweise vier Metern Länge, die hori-
zontal und vertikal an den Wänden befestigt sind. Mit diesen „Koordinatenlinien" zeigt der Künstler
Grundbedingungen von Räumlichkeit auf, wie sie für ihn sowohl in Hinblick auf objektive Raum-
verhältnisse wie auch deren subjektive Empfindung von wesentlicher Bedeutung sind. Haraguchi hat es
in einem kurzen Statement für den Katalog der *documenta 6* folgendermaßen formuliert: „Wir erken-
nen die Bedingungen unserer Umgebung – also eine Situation – indem wir sie auf universelle Begriffe
zurückführen, sei dies nun der Kosmos, die Natur, eine physikalische Gesetzlichkeit oder einfach der
Raum, in dem wir uns befinden… Ein Ausstellungsraum erschafft eine gewisse abgeschlossene,
begrenzte Situation, die begrifflich erfaßt werden kann. Da es darauf ankommt, die Totalität aller Wahr-
nehmungen in dieser Situation auszudrücken, veranschauliche ich meine Konzepte in einer extrem ver-
einfachten Form. In meiner Arbeit will ich alle Elemente der Wahrnehmung, mich selbst eingeschlossen,
in einer feststehenden, ausgewogenen Beziehung darstellen. Ich möchte Horizontalität, Vertikalität,
Stofflichkeit, Spiegelung, Flüssigkeit, Behälter, alle physischen Erscheinungen samt mir selbst (Körper,
Empfindungen, Gedanken) objektivieren" (Band 1, Seite 186).

Solch eine Objektivierung des Raumes verfolgte Haraguchi auch, als er bei dem *Event of the Transfer
of Steel* (Abb. 4, KAT. Nr. 63), das er in den Jahren 1975 und 1976 in der Nirenoko Gallery sowie in
der Maki Gallery in Tokyo aufführte, siebenundzwanzig Stahlplatten von je 180 Zentimetern Länge

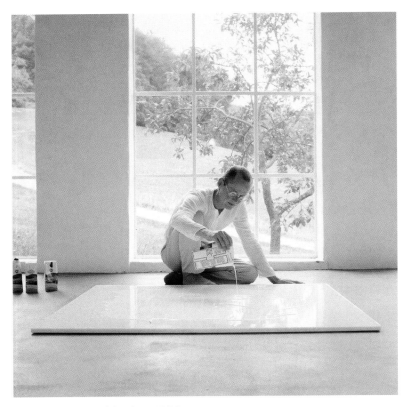

8 Wolfgang Laib, *Milchstein*, 1987/89

und 22,5 Zentimetern Breite im Raum bewegte und dabei verschiedene „Besetzungen" von Boden und Wänden vornahm. In dieser Aktion sind Bezüge zu ähnlichen Ansätzen von Franz Erhard Walther zu erkennen, der gleichzeitig mit dem Japaner 1977 in Kassel seine Vorstellung von Skulptur demonstrieren konnte und seinen Umgang mit elementaren Materialien *Aufbau als Werkform* nannte (Abb. 9). Es kann hier, wie in Bezug auf das angesprochene Werk von Laib, keinesfalls um die Frage nach einer gegenseitigen Beeinflussung gehen, doch wird deutlich, dass Haraguchi zu diesem Zeitpunkt offensichtlich mit einer Arbeit aufgetreten ist, die in derselben „Sprache" formuliert war, wie sie auch andere Künstler in Europa und Amerika verwendeten.

Dass es ihm dabei immer wieder auch um Fläche und Oberfläche gegangen ist, zeigt etwa *Untitled (Yokosuka)* von 1973 (KAT. Nr. 53), wo er eine spiegelnde Fläche als glänzendes schwarzes Rechteck (4 x 8 Meter) realisiert hat, indem er eine Vertiefung in den Betonfundamenten eines ehemaligen Hafengebäudes mit Öl auffüllte. Diesem vehementen, großen Einsatz seiner Mittel ging eine kleine, weniger als einen Quadratmeter messende Bodenarbeit von 1970 (KAT. Nr. 31) voran, die einfach darin bestand, dass der Künstler eine bestimmte Fläche des Bodens mit einem Wachsrand einfaßte und dadurch einer Wasserlache Form verlieh. Die wasserabstoßende Eigenschaft des Wachses ließ außerdem zu, daß der Flüssigkeitspegel dessen Niveau leicht überwölbte, ohne über diesen Rand zu treten. So entstand in dem dünnen, aber doch deutlich erhabenen Wasserfilm eine glasähnliche Fläche – und es wird einem zugleich bewusst, dass auch Glas eine erstarrte Flüssigkeit ist. Mit einer dicht in Weiß gestrichenen Acrylfarbfläche auf Beton hatte Haraguchi aber bereits 1968 in einer Arbeit für die Hibiya Gallery in Tokyo (KAT. Nr. 9) sein starkes Interesse an der Definition von Fläche, Oberfläche und Raum gezeigt.

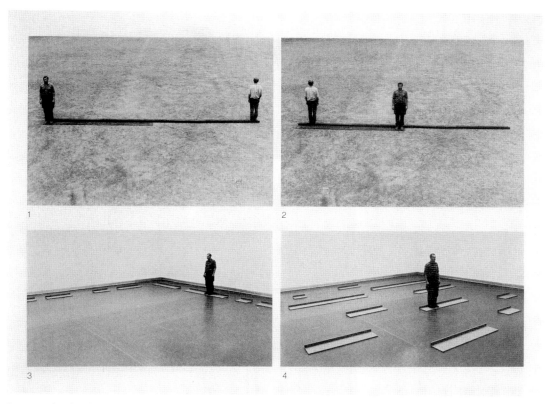

9 Franz Erhard Walther, aus *Aufbau als Werkform*, oben: *Strecke und halbe Strecke*, 1977, unten: *Schreitbahnen*, 1975

Im selben Jahr entsteht eine Arbeit mit dem Titel *Positioning of Matter (or Materiality)* (KAT. Nr. 56), in der Haraguchi Oberflächendefinitionen in unterschiedlichen „Stoffen" erprobt. Auffallend im Zusammenhang unserer bisherigen Betrachtungen ist dabei besonders ein Plexiglaszylinder, der auf einer Stahlplatte steht. Er ist mit Wasser gefüllt und damit ein massiver Körper, schwer und dennoch durchsichtig und scheinbar leicht. Den oberen Abschluss des Zylinders bildet eine Wasserfläche. Die Wassersäule steht auf dem Eisen korrespondierend zu einer Rolle aus Bleiblech, die an der Kante der Stahlplatte liegt. Die zwei Elemente zeigen unterschiedliche Richtungen an: das Vertikale neben dem Horizontalen. Haraguchi hat sich zu dieser Arbeit folgendermaßen geäußert: „In diesem Fall wiederum ging es nicht darum, die Intention des Künstlers oder eine innere Kreativität des Materials zum Ausdruck zu bringen, sondern einfach um eine ‚Setzung'. Diese Arbeit sollte nicht das Innere des Künstlers aufdecken, sondern Aufschluss über die besondere Situation bestimmter Objekte und ihre Aufstellung geben" (aus einem Gespräch des Künstlers mit Akira Ikeda).

Quasi in Umkehrung zu diesen Definitionen von Oberfläche mit elementaren Mitteln steht Haraguchis Beschäftigung mit Dingen des Alltags, die gleichzeitig stattfand (siehe etwa *Tsumu 147*, 1966; KAT. Nr. 8). Bereits zu Beginn seines Schaffens zwischen 1963 und 1965 entstanden jene Arbeiten, in denen Haraguchi Schiffsmodelle zeigt, die auf der Oberseite eines weiß lackierten Quaders „schwimmen" und mit einer transparenten Plexiglashaube überbaut sind (KAT. Nr. 1–7). In den Schiffsmodellen kommen deutlich biographische Bezüge zum Tragen.

Haraguchi wuchs im Nachkriegsjapan in der Küstenstadt Yokosuka auf. Yokosuka war damals bereits ein Hauptstützpunkt der American Navy, die den bedeutenden japanischen Hafen übernommen hatte, von dem aus einst die Öffnung Japans nach der Edo-Periode ihren Gang genommen hatte und der

in der folgenden Meiji-Zeit zu einem wichtigen Kriegshafen geworden war. Haraguchis Familie wurde gleichsam in die Geschichte des Hafens einbezogen, bis mit Beginn des Kalten Krieges Japan seine militärischen Aktivitäten auf den nördlichen Inseln verstärkte und so der Vater des Künstlers auf Hokkaido Arbeit als Radartechniker fand. Dort verbrachte Haraguchi seine Kindheit in einer extremen Landschaft an der Spitze einer Landzunge. Er spricht gern von den faszinierenden Naturgeschehnissen, die er in dieser Gegend erleben durfte: „In dem kleinen Inselreich Japan, in dem ich geboren und aufgewachsen bin, entfalten sich die vier Jahreszeiten Frühling, Sommer, Herbst und Winter besonders schön. Das Land besitzt eine ganz eigene Vegetation und ein spezifisches Klima. Selbst Frostschäden und Taifune kommen gegen seine Segnungen nicht an. Der Wechsel der Jahreszeiten hat viele unterschiedliche Gesichter und vollzieht sich in stetigem Wandel" (aus dem Essay des Künstlers im vorliegenden Band). Als Teenager kehrt Haraguchi nach Yokosuka zurück und ist beeindruckt von den Schiffswerften und dem Kriegshafen. Er beginnt mit intensivem Zeichnen, bei dem er sich mit Landschaftsszenerien befasst, in die die Industrieanlagen des wirtschaftlich aufblühenden Japans eindringen. Er suchte damals noch in einer traditionellen Form, der Landschaftszeichnung, die offensichtlichen Veränderungen und zerstörerischen Eingriffe zu erfassen. Erster künstlerisch selbstständiger Ausdruck dieser Beobachtungen werden die *Ship* (KAT. Nr. 1–5) oder *Submarine* (KAT. Nr. 6–7) betitelten Arbeiten des kaum Achtzehnjährigen. Sie sind eben nicht einfache Modelle von Kriegsgerät, wie sie viele Jugendliche basteln, sondern durch ihre Verbindung mit dem weißen Kasten und erweitert durch die transparenten Hauben drückt sich in ihnen das Empfinden über eine kulturell-zivilisatorische Situation aus, die nicht allein abbildlich darzustellen ist. Der rechteckige, farbleere Kasten ist der Aktionsraum für diese Verkleinerungen von bedrohlichen, aber faszinierenden Schiffen und U-Booten, die teilweise zerstört gezeigt werden. Zudem rührt Haraguchi hier bereits an grundsätzliche Fragen zur Raumauffassung und Raumdifferenzierung, wie sie etwa in seinen späteren Ölspiegelungen noch deutlicher zum Tragen kommen, denn er baut keine Vitrine, in der er ein ganzes Modell schlicht unterbringen würde, sondern bei ihm sind die Rümpfe angeschnitten, sodass seine Boote gleichsam im weißen, „abstrakten" Raum schwimmen.

In den Jahren 1968 und 1969 zeigt Haraguchi auf verschiedenen Ausstellungen in Tokyo eine Reihe von Arbeiten und kleineren Serien, die allesamt die Bezeichnung *Air Pipe* im Titel führen (KAT. Nr. 13–23). Dabei handelt es sich um Skulpturen, die Formen von technischen Anlagen, genauer von Lüftungs- oder Klimaanlagen mit ihren schlitzförmigen Auslässen, aufgreifen und nur wegen ihrer Plazierung oder aufgrund ihres eigentümlichen Beschnitts als Kunstwerke in Erscheinung treten. In gewisser Hinsicht scheint es sich bei diesen Arbeiten um nachgebaute Ready-mades zu handeln (siehe etwa KAT. Nr. 18). Einige der Objekte wirken allerdings wie Tafelbilder, indem ihnen der Künstler die gewöhnliche Form von Tableaus verleiht, sodass sie wie Gemälde vor der Wand stehen (siehe etwa KAT. Nr. 19–21). Da ihr Bildcharakter auf solch einer Profilierung gegenüber der Wand beruht, können sie zugleich auch als Reliefs aufgefasst werden.

Aus dieser Beschäftigung heraus gelangt Haraguchi unmittelbar zu der extremen Skulptur *A-4E Skyhawk* von 1969 (KAT. Nr. 24), die allein schon aufgrund ihrer Größe wirkt. Dieser „Nachbau" eines Flugzeugleitwerkes aus Holz stellt eine extrem direkte Präsenz militärischen Fluggeräts dar, vor allem wenn das Gebilde in der räumlichen Enge eines Galerieraumes gezeigt wird. Andererseits machen das Stückwerkhafte sowie die unverkennbar unsanfte Landung auf dem Galerieboden diese Arbeit zu einem ironischen Bild von Macht und Stärke. Das billige Holz und seine Fragilität unterstreichen diese Eigenschaft. Der Künstler, den nach antiker Mythologie Hephaistos (Vulkan) personifiziert, der von seiner Frau

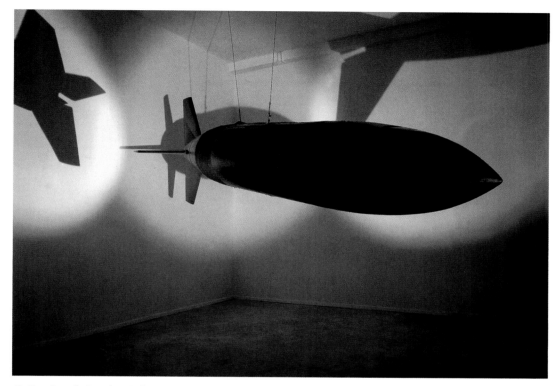

10 Pino Pascali, *Grande missile «Colomba della pace»*, 1965

Aphrodite (Venus) mit Ares (Mars) betrogen wird, der Künstler also, der die herrlichsten Waffen für den Kriegsgott schmiedet und dann dennoch von ihm betrogen wird, scheint sich in dieser Arbeit gerächt zu haben. Ein unbrauchbares, zum Scheitern verurteiltes Kriegsgerät bleibt auf der Erde zurück und taugt „nur" als Skulptur.

Stellt Panamarenko in seinen Flugobjekten den Künstler als Erfinder dar, der den utopischen Traum vom Fliegen noch einmal aufleben lässt (siehe etwa Abb. 5), und hatte Pino Pascali 1965 eine wirkliche Rakete als *Colomba della pace* (Abb. 10) ausgestellt, so bringt Haraguchi das Nachbauen, das Wiederherstellen einer Form als sein besonderes Anliegen ins Spiel. Darin drückt sich auch seine Vorstellung vom Modellhaften in seinem Werk sehr deutlich aus: Kunst stellt gedankliche und sinnlich erfahrbare Modelle der Realität her; deren Verwirklichungsgrad ist gegenüber ihrem Gegenstand zwar defizitär, daher ihr Status als „nur" Bilder, doch sind sie als physisch existente Werke durchaus selbst in der Realität verankert und daher auch keine bloßen Bilder. Im Unterschied zu dem Erfinder Panamarenko, der offensichtlich zum Scheitern verurteilt ist und sich über den Ausweg der Kunst rettet, aber auch anders als Pascali, der das Ready-made als bedrohliches Objekt zum Kunstwerk erhebt, schafft Haraguchi mit seinem Flugzeug ein Bild, das zwar die Gestalt eines Leitwerkes annimmt, aber, abgesehen von seiner Fragmenthaftigkeit, allein schon aufgrund seines Materials nur als Imago eines Kampfjets angesehen werden kann. Der nichtbildlich abbildende Charakter des oben beschriebenen Zen-Gartens von Ryoan-ji scheint auch in diesem Typus von Arbeiten nachzuwirken.

So kennzeichnen das Werk Haraguchis von Anfang an diese sich formal sehr unterschiedlich ausprägenden Ebenen: Definitionen von Oberflächen mit ausgesprochen temporärer Erscheinung, Setzungen von Körpern (Material) in definierten Umgebungen (Außen- und Innenraum) und Skulpturen, die Realität nicht nur abbilden, sondern in einem anderen Material imitieren.

Die Setzung von Flächen durch Ölspiegel erneuert Haraguchi in sehr unterschiedlichen Situationen. Dabei wird deutlich, dass die jeweilige Platzierung für den Künstler einer veränderten Fragestellung gleichkommt. Wenn er zum Beispiel mit *Matter (Kiba) No. 7* von 1978 (KAT. Nr. 72) an die Kante einer Wasserfläche, eines Kanals, rückt, so erinnert das Bild, das er schafft, besonders stark an die oben beschriebene Situation des Goldenen Pavillons von Kyoto mit seinem schwarzen Lackboden über einem dunklen Teich. Sehr verschieden davon erscheint die Arbeit *The Matter of Black 1. 2. 3.* von 1981 (KAT. Nr. 83), in der dem waagrechten Ölspiegel zwei tiefschwarze, nahezu quadratische „Reliefs" an der Wand antworten.

An diesem Umgang mit Formen und Material zeigt sich eine dem abendländischen Denken entgegengesetzte Auffassung. Das Material der schwarzen Spiegelflächen ist beliebig und austauschbar. Im Unterschied zu der bereits erwähnten Arbeit von Laib, bei der der Marmor des *Milchsteins* permanent fortbesteht, ist in Haraguchis Werk nur die Idee, der Gedanke, der hinter ihm steht, von Dauer. Indem aber das Kunstwerk jederzeit wieder hergestellt werden kann, ist es unzerstörbar. Es sind allein der Wille und der Entschluss, das Werk erneut zu sehen, entscheidend. Im Unterschied aber zur Conceptual Art in der Definition eines Lawrence Weiner, wonach ein Kunstwerk vom Künstler, jemand anderem oder auch überhaupt nicht realisiert zu werden braucht, verlangt Haraguchis Werk nach der Ausführung. Im Handeln oder Setzen kommt das Werk erst wieder zustande, seine bloße gedankliche Existenz würde nicht genügen.

Mit Erhebung der schwarzen, aber auch grünen und gelegentlich aluminiummetallenen Flächen in die Vertikalität entstehen Werke, deren Typus in der gängigen Nomenklatur kaum fassbar sind. Da alle diese ab 1978 geschaffenen, bis auf wenige mit Polyurethan beschichteten Wandobjekte (KAT. Nr. 73 und viele folgende) eine ausgeprägte Tiefe von zehn Zentimetern und mehr besitzen, handelt es sich deutlich um Körper, also um Reliefs vor der Wand. Da ihre Oberfläche aber zumeist glatt ist, und die Arbeiten zudem kaum haptische Qualität besitzen, scheinen sie eher Tafelbilder zu sein. Aufgrund ihrer unterschiedlichen Positionierung, mal auf dem Boden aufstehend, dann in die Raumecke gedrängt, dann wieder wie ein Gemälde aufgehängt, versetzen sie auch den Betrachter in eine nicht eindeutig zu definierende Situation. In *Untitled* von 1981 (KAT. Nr. 84) erreicht das Werk von 181 x 161 Zentimetern Größe eine Tiefe von 26,5 Zentimeter, ja es löst sich in *Untitled* (KAT. Nr. 85) sogar von der Wand und steht als „Skulptur" im Raum. Aus einem Bildelement, das die Wand definiert, wird ein Objekt, das selbst die raumteilenden Qualitäten einer Wand besitzt. In *Taura No. 6* (KAT. Nr. 156) von 1984 demonstriert der Künstler Möglichkeiten einer freien Setzung von Volumen im Raum. Seine schwarzen Kuben heben sich von den sie umgebenden weißen Wänden ab und artikulieren den Raum. Sie treten in dieselbe Wirklichkeit wie der Betrachter, behaupten sich neben ihm. In den angelegten Spannungen kommt das zum Ausdruck, was Haraguchi im eingangs zitierten Statement geäußert hat: eine Objektivierung aller physischen Erscheinungen samt seiner selbst. In den großflächigen Bildern von 1985–86, *Construction* betitelt (KAT. Nr. 162–164), zieht der Künstler seine Raumerfahrungen in die Fläche zurück, dimensioniert die Arbeit aber so, dass sie nichtsdestotrotz in die Architektur des Ausstellungsraumes eingreift.

Haraguchis Werk der achtziger Jahre kennt neben diesen flächenbetonten „Wandkörpern" auch dreidimensionale Setzungen, die ein körperhaftes Volumen definieren. Zu diesen Werken gehört etwa eine Skulptur von 1982, die aus übereinander geschichteten Stahlplatten besteht (*Untitled*; KAT. Nr. 140). Aus den fünfundzwanzig Lagen entsteht ein Pyramidenstumpf von 73 Zentimetern Höhe und 280 Zentimetern Seitenlänge. Durch die leichte Verjüngung der Platten nach oben hin wirkt die Gesamtform

plastisch. Aus den relativ dünnen Schichten baut sich ein Körper von großer Dichte auf, der das ungeheure Gewicht des Materials gleichsam artikuliert: Man kann sich diese Skulptur, ganz im Unterschied zu den massiven Blöcken eines Richard Serra etwa, als eine Überlagerung von zahlreichen Oberflächen denken, also als ein wiederholtes Ablagern einer jeweils obersten Fläche. Somit wird das Prozessuale, der Aufbau eines Werkes als ein zeitlicher Vorgang, zu einem wichtigen Kriterium der Arbeit, und zugleich wird perspektivisch auch ein möglicher Abbau vorstellbar, durch den das Werk sukzessive aufgelöst wird. Ähnliche Feststellungen ließen sich auch anhand der Arbeit *100, Revised* von 1985–86 (KAT. Nr. 160) treffen, in der Haraguchi eine Pyramide aus Holzbalken und Winkeln aus Kupferblech baut.

1988 zeigt Haraguchi in einer Ausstellung der Akira Ikeda Gallery in Tokyo vier große Skulpturen aus Stahl, Aluminium und Glas, die einerseits ausgeprägte konstruktive Strukturen erkennen lassen, andererseits aber ihre Ausstrahlung ebenso stark von einer Oberflächenwirkung oder gar deren Glanz beziehen. In *Kiku II* (KAT. Nr. 201) verhüllt ein flaches Lochblech die dennoch erkennbare Struktur, während in *Sakura I* (KAT. Nr. 200) eine von zwei Ansichtsseiten die Konstruktion, die andere dagegen eine „Schauseite" zu sehen gibt, die größtenteils jene mechanisch-tektonische Struktur verbirgt und stattdessen mit spiegelnden Flächen die Umgebung in die Arbeit einbindet. *Kashinoki IV* (KAT. Nr. 203) vereint Struktur und Oberfläche zu einer raumbildenden Einheit. Derselbe Gegensatz wird von Reliefs, die aus diesen großen, komplex gebauten Plastiken in einem Prozess natürlicher Verdichtung hervorzugehen scheinen, nochmals enger zusammengeführt: Aus gebogenen Stahlblechelementen entstehen konstruierte Oberflächen (für die ersten Beispiele aus dem Jahre 1988 siehe KAT. Nr. 204–205). Diesen konstruktiven Charakter ergänzen häufig formale Strukturen, die selbst wiederum als Einkerbungen oder Stanzungen im Blech offensichtlich einem mechanischen Eingriff entstammen. Zudem leben diese Oberflächen von ihrer farbigen Erscheinung.

Zu Beginn der neunziger Jahre fallen eine Reihe von Arbeiten auf, die einen Kreis als Grundform besitzen. Zylinder, Rohre, selbst eine runde Ölwanne (KAT. Nr. 219) bringt Haraguchi nun hervor. Am markantesten ist dabei wohl ein Aluminiumzylinder von 125 cm Höhe, der 1990 entstanden ist (KAT. Nr. 222). Die schimmernd glänzende Oberfläche des Aluminiumblechs reflektiert wie in einem matten Spiegel, allerdings verändert und verzerrt durch die Bogenkrümmung, die Umgebung, in die die Plastik gestellt wird. Blickt man in das Innere, so wird die tragende Stahlkonstruktion sichtbar. Bei aller Illusion, die die Spiegelwirkungen in den Arbeiten von Haraguchi hervorrufen können, fehlt ihnen nie das Moment der Rationalität, sind sie doch in ihren baulichen Grundlagen vom Betrachter stets durchschaubar. Das physisch entgegengesetzte Werk ist in *Untitled, FBS* (KAT. Nr. 224) zu erblicken. Hier rollt der Künstler eine dicke Gummimatte zu einem Zylinder von 280 cm Durchmesser. Das enorme Gewicht des Materials wirkt trotz der Hohlform lastend schwer. Kein Glanz an der Oberfläche nimmt ihm etwas von seiner Massivität, die melancholische Schwere ausdrückt. Der heiterste Kreis zeigt sich hingegen in einem 26 Meter im Umfang messenden Ring von farbigen Stahlplatten (KAT. Nr. 226). Wie ein Reigen sich drehender Figuren strahlt der unendliche Kreis Bewegung und Leichtigkeit aus.

Haraguchi setzt den Kreis, diese Form größtmöglicher Einheit und Geschlossenheit, auch zum Umschreiben eines Ortes oder zur Definition eines Raumes ein, um die Unterscheidung von innen und außen thematisch werden zu lassen. Besonders anschaulich geschieht dies bei der Setzung, in der er einen 260 cm hohen Stahlzylinder von zweieinhalb Metern Durchmesser leicht über dem Boden schwebend installiert (KAT. Nr. 233). Hier gibt es ein klar definiertes Außen, das mit einem Innen korreliert, das nicht einsehbar ist, wohl aber erkennbar und vorstellbar. Dem konkret Fassbaren steht ein unsichtbar Imaginäres gegenüber.

1992 stirbt Ikuko Sakata, Haraguchis Frau. Es entstehen keine Arbeiten in diesem Jahr. Erst im folgenden Jahr zeigt der Künstler in der New Yorker Dependance der Akira Ikeda Gallery eine Serie gleichförmiger, leicht gebogener Stahlbleche auf Aluminiumrahmen, die alle schwarz lackiert sind (KAT. Nr. 238–250). Die Reliefs gleichen Schilden, die sich aus der Wand in den Raum dehnen. Das Ensemble dieser schweigenden schwarzen Zeichen, von denen ein jedes dem Balken für eine lange musikalische Pause gleicht, wirkt wie ein Requiem.

Neben einer Reihe sehr ähnlicher Werke aus den folgenden Jahren wird diese Grundform des stehenden Rechtecks auf ganz andere Weise auch von einer Arbeit realisiert, die an Haraguchis Aktion von 1975/76 anzuknüpfen scheint. Damals wurden mit Hilfe von Stahlplatten unterschiedliche Raumdefinitionen ausprobiert, 1996 wird in *14 Boards* (KAT. Nr. 276) mittels ähnlich geformter Papptafeln eine bestimmte einmalige Anordnung fixiert. Ebenso lapidar tritt auch die Arbeit *L* aus demselben Jahr (KAT. Nr. 277) auf, eine fünfeinhalb Meter langer Winkel, der die Wand zu durchschneiden scheint und mit dem der Künstler eine seiner *documenta*-Arbeiten aufgreift. Und immer wieder installiert Haraguchi seine spiegelnde, schwarze Wanne mit Altöl. Er wechselt die Position vom Zentrum an den Rand des Raumes, die Form vom Rechteck über den Kreis zum Quadrat, lotet Möglichkeiten der Kombination mit Wandbildern oder raumteilenden Stahlplatten aus, aber immer bleibt als bestimmende Idee jene Problematisierung des Raumes wirksam, die schon in seiner ersten Installation Mitte der siebziger Jahre zu erfahren war. Der Vorgang gleicht der mehrmaligen Wiederaufführung eines Stückes, die aufgrund der veränderten Umstände von Raum, Ort und Zeit stets etwas Neues ergibt. Wie nach dem Ritual in einem Zen-Garten handelt Haraguchi in andächtiger Wiederholung und versucht darin das Neue erstehen zu lassen. In Zirkeln scheint sich nun sein Werk zu bewegen, wenn er auch die frühe Flugzeugarbeit der sechziger Jahre über dreißig Jahre später nochmals aufgreift und gewandelt wiederentstehen lässt (KAT. Nr. 287) – ein schwarzes Fragment, ein Schatten von eindringlicher Präsenz.

1. The World, Me, and My Work

Me and the World

Time and space – boundless and vaguely defined ... Moving from one moment to the next, from one place to the next ... I only want to look at things, the world, not focus on anything, not make any connections. Just watch, observe, touch, feel, and pick up; only this elementary process explains me and conveys my message to the world.

The Other Place

The process of creating a work of art is an attempt to find out who I am, to understand the system of myself. Encountering things, things left or discarded on the side of the street. Observing them for a while, touching and feeling them. Then picking them up and bringing them to another place – a moment that changes everything: different moods, different scenes, different sounds, different conditions in a different rhythm. A dramatic moment! Yet there is no clear answer, no definition, no evident truth. Moreover, there is no logical relationship between the things and me. They remain as they were before I came across them.

Scale of One to One

There will always be a gap between me, the work, and the world. These things can never get closer to each other. The only possibility is the process of witnessing them. Simply watching, no judgement-making. Only straightforward seeing – seeing something as it really is: I call this the scale of one to one. No imaginary paradise on a scale of one to one thousand or one to one hundred. Simply seeing, nothing else. Only the scale of one to one allows the world to be like it really is. No coming closer, no distancing – just being the way it is.

Facing the World

The work of art results from the gap between me and the world, or the gap between me and myself. Therefore, the work always faces the world, the age, and the political system, and it also faces me who is closely bound to the world.

2. Roots

The Climate and Landscape of Japan

In the small island-empire of Japan, where I was born and raised, the four seasons of spring, summer, autumn, and winter are especially beautiful. The vegetation is unique and the climate is characteristic. Even frost damage and typhoons cannot get the better of Japan's blessings. The different seasons are full of variety and constant change.

The Spirit of Traditional Culture

Noh and other art forms: Noh is one of the leading traditional arts of Japan. It is a kind of dance, composed of tranquil, stylised gestures which are quite different from Western dance forms. Often the silence is suddenly broken by the sharp sounds of flutes and the violent beating of drums. However, Noh derives its special intensity from the controlled movements of its players.

Haiku poetry and the tea ceremony: haikus and tea rooms represent the great world of the imagination on a small scale – but the ideas touch on the universe.

Controlled, stylised forms of representation – such as the typical low-angled camera shots of Yasujiro Ozu or the sharp contrast of light and shadow in the black-and-white films of Akira Kurosawa – are quite eloquent and allow more emotions. They represent the modern age in the form of Japanese aesthetics living in the present.

The intensity that is hidden in silence: material, light, sound, stretched in time and space, evoke the perception, the thinking, and the spirit beyond reality. Creating a work of art means translating these elements into self-expression. So-called reality is only the tip of the iceberg. What is crucial is what we cannot see. This is hidden in the banal, in quiet everyday things.

Ukiyo-e woodblock prints: boldly abstracted landscapes, such as those appearing in the works of Katsu-shika Hokusai, show how the artist saw the world. This differs fundamentally from the idea that we are part of the world. The desire to intensify the world dramatically. The world exists only because I exist. The will to transform the world, the visible and invisible world.

My Work

My metal pools filled with oil are often classified as Western Minimal Art. This is a mistake, because my works should be seen in the context of Japanese scenery. The oil reflects the surrounding interior, the roof, the pillars, and even the visitors present. The installation in the floor exists in three dimensions, just like me. Installing it differently can change its expression like a living creature. It is essential to know the make-up of the materials and to feel the atmosphere of the place. Then the work will seem real, as if it were there. Nothing comes out of just looking at it. One shouldn't be fooled by the superficial reality of things.

Society saves useful things and throws away useless things. Every person adheres to the common systems of language and signs, as well as generally valid meanings. But I attach a greater importance to those things which are thought to be useless and are thrown away, and I respect them more.

3. Japan: An Island Floating in the Western World

Japanese Tradition

Japan has a unique and glorious past of cultural achievements such as Noh, *ukiyo-e*, and the tea ceremony. However, these art forms have lost their original importance and spirit. Defeated in the Second World War, Japan devoted itself to conforming to Western culture. To compete with the West, it was neces-sary to incorporate new ideas that were not originally Japanese. To achieve this, Japanese tradition was put aside and preserved in exile. With the progress of technology, it became more difficult for Japan to stop the process. In the end, only the Japanese spirit was left in its authentic form.

Japan Today

So how about Japan today? Everything is concentrated in a few conurbations, everything crowded in very small living spaces, thus giving many people a very limited horizon. The Japanese try to believe in something collective which has long since become an illusion, but it is no longer possible to support common values and ideas. In Japan today there is no longer a tradition or history. Our unique way of thinking, looking at the world, ideas of nature, and other cultural contexts have been lost in the process. Instead we orient ourselves on the principle of trial and error. So the last fifty years could be called a big experiment. (I seek the abstract in my works, for there is something absolute which can only be shaped in the climate of the undefined. So even for me the last five decades have been a big experiment.)

Japan versus Western Rationalism

Unlike the Western world, Japan does not have its own history or social order. The reason why Japan was never very conscious of its world or inner being is that a spirit which flourishes on rich ground does not need rationalism. This is paralleled in the language and the basic concepts of the Japanese, in the sphere of self, as well as in the only vaguely developed understanding of time and space. The beauty of the Japanese seasons is also unique in their coexistence with the lushness of nature. In the West, however, the harvest only comes from what was planted – this difference also created quite diverse basic approaches.

New Tendencies of the Japanese Spirit

Japan does not live in real time. We have to realise that it exists in a virtual world. Yet we cannot rewind the last fifty years. Only after going through a long process of experience and exchange will Japan be able to start rebuilding its own culture. But it will not be a matter of us Japanese applying Western forms of behaviour or of finding an identity. We have to realise that there are fundamental differences in our thought, religion, and philosophy. But just as much at issue is the recognition of the differences between the Japanese, between me and the other, the uniqueness of individuals. We have very different views. That is why I think the concept of utopia is hypocrisy.

4. My Stance

Discovering Inability

The terms "A-4E Skyhawk" or "Viking" which are used in two of my titles are symbols of malice, harm, and violence; they are weapons and instruments of death. The pieces entitled *A-4E Skyhawk* of 1969 (CAT. No. 24) and *Black Viking S-3* of 2000 (CAT. No. 287) consist of only parts of aircraft tails. They thus represent the inability, unfitness of non-functioning aircraft. Society usually tries to eliminate anything that is harmful or violent and replace them with safe and pleasant things. I mistrust and question such a society.

The *Air Pipes* (CAT. Nos. 13–23), created in the same period and also metaphors for inability, are a counterpart to *A-4E Skyhawk*. For these air pipes are merely concrete forms and thus totally useless. It is precisely the repression by society, the era, and the political system, as well as the need to react to it which compel me to face contemporary art.

A Place without Beginning or End

The material factors of a work, the act of creating it, and the time and place of its creation are unique and transitory. There is only one life, and likewise there is only one art. Only the continuing process counts, not the results. That is why I constantly move to another place and repeat an action on many occasions. A series of improvisations without beginning or end. From one moment to the next. Facing the moment and recognising existence in it. Deeper and deeper, for that is where the world is.

A thing has its special value in every place and at every time. The work is like a living creature. It changes, and it faces me independently. Yet I never take the initiative; I just keep on moving to the next state. My concept is to consistently reproduce the same thing in constant repetition.

(Translated from the Japanese by Rise Wada)

1. Die Welt, das Ich und das Werk

Ich und die Welt

Raum und Zeit – grenzenlos und unbestimmt … Tastend von Augenblick zu Augenblick, von Ort zu Ort. Ich möchte die Dinge, die Welt einfach nur anschauen, nichts darin fokussieren, keine Zusammenhänge stiften. Nur betrachten, beobachten, berühren, spüren und auflesen: Dies allein schon beschreibt auch mich, vermittelt etwas von mir an die Welt.

Der andere Ort

Der Schaffensprozess eines Kunstwerkes ist ein Versuch, zu begreifen, wer ich bin, das System des Selbst zu verstehen. Auf Dinge stoßen, liegen gelassene, weggeworfene Dinge am Straßenrand, sie erblicken, eine Weile beobachten, berühren, fühlen und dann auflesen und sie an einen anderen Ort bringen – ein Moment, in dem sich alles wandelt: andere Stimmungen, andere Landschaften, andere Geräusche, andere Zustände in einem anderen Rhythmus. Ein dramatischer Augenblick! Dennoch, es gibt keine eindeutige Antwort, keine Definitionen, keine evident gewordene Wahrheit. Ebenso wenig besteht eine logische Beziehung zwischen den Dingen und mir. Sie bleiben für immer das, was sie schon gewesen sind, bevor ich ihnen begegnet bin.

Das Eins-zu-eins-Verhältnis

Die Diskrepanz zwischen mir, dem Werk und der Welt bleibt bestehen. Eine Annäherung ist ausgeschlossen. Möglich ist allein der Vorgang des Erblickens. Nur betrachten, nicht werten. Nur direktes Erblicken – etwas erblicken als das, was es ist: Dies bezeichne ich als Eins-zu-eins-Verhältnis. Kein fingiertes Paradies mit falschen Maßstäben wie eins zu tausend oder eins zu hundert. Bloßes Erblicken, nichts weiter. Nur das Eins-zu-eins-Verhältnis lässt die Welt so sein, wie sie ist. Keine Annäherung, keine Distanzierung – einfach nur so sein.

Die Welt als Gegenüber

Das Kunstwerk entsteht aus der Diskrepanz zwischen mir und der Welt, beziehungsweise aus der Diskrepanz zwischen mir und mir selbst. Insofern steht es der Welt, der Epoche, dem politischen System gegenüber, beziehungsweise mir selbst, der ich eng mit dieser Welt verbunden bin.

2. Wurzeln

Das Klima und die Landschaft Japans

In dem kleinen Inselreich Japan, in dem ich geboren und aufgewachsen bin, entfalten sich die vier Jahreszeiten Frühling, Sommer, Herbst und Winter besonders schön. Das Land besitzt eine ganz eigene Vegetation und ein spezifisches Klima. Selbst Frostschäden und Taifune kommen gegen seine Segnungen nicht an. Der Wechsel der Jahreszeiten hat viele unterschiedliche Gesichter und vollzieht sich in stetigem Wandel.

Der Geist der traditionellen Kultur

Nô und andere Kunstformen: Nô ist eine der führenden traditionellen Künste Japans und ist eine Art Tanz. Es besteht aus ruhigen, stilisierten Gesten, die sich von westlichen Bewegungsformen deutlich unterscheiden. Oft wird die Stille von scharfen Flötentönen und heftigen Trommelschlägen jäh zerrissen. Seine besondere Intensität aber bezieht Nô von den kontrollierten Bewegungen seiner Darsteller.

Haiku-Dichtung und Teezeremonie: Haikus und Teeräume repräsentieren das große Reich der Imagination in einer jeweils kleinen Welt – aber die Vorstellungen rühren an das Universum.

Kontrollierte, stilisierte Darstellungsformen, wie beispielsweise die für Yasujiro Ozu typischen tiefen Kameraeinstellungen oder der scharfe Kontrast von Licht und Schatten in Akira Kurosawas Schwarzweißfilmen, sind eher eloquent und lassen viel mehr Empfindungen zu. Sie repräsentieren die Moderne in Form einer japanischen Ästhetik, die in der Gegenwart lebt.

Die im Stillen verborgene Intensität: Materie, Licht, Klang, ausgedehnt in Raum und Zeit, evozieren die Wahrnehmung, das Denken, den Geist jenseits der Wirklichkeit. Die Erschaffung eines Kunstwerkes bedeutet, diese Elemente in eine Selbstdarstellung zu bringen, sie zu übersetzen. Die sogenannte Wirklichkeit ist nur die Spitze des Eisberges. Das Entscheidende liegt im Unsichtbaren. Es verbirgt sich gerade im Banalen, in den stillen Dingen des Alltags.

Die Holzschnitte des Ukiyo-e: Die gegenüber der Realität stark abgewandelten Landschaften etwa in den Bildern von Katsushika Hokusai zeigen, wie der Künstler die Welt gesehen hat. Dies unterscheidet sich fundamental von der Idee, selbst ein Teil der Welt zu sein. Der Wunsch, die Welt dramatisch zu steigern. Die Welt existiert nur, weil ich existiere. Der Wille, die Welt zu transformieren, die sichtbare und die unsichtbare Welt.

Meine Arbeiten

Meine mit Öl gefüllten Metallwannen werden oft der westlichen Minimal Art zugeordnet. Das ist ein Irrtum. Denn meine Werke sind vor dem Hintergrund einer japanischen Szenerie zu sehen. Das Öl reflektiert das umgebende Interieur, die Decke, die Stützen und sogar die anwesenden Besucher. Die Installation am Boden ist eine dreidimensionale Existenz, genau wie ich. Durch verschiedene Platzierungen kann sie wie ein Lebewesen ihren Ausdruck verändern. Wichtig ist, die Beschaffenheit des Materials zu kennen und die Atmosphäre des Ortes zu spüren. Das Werk wirkt dann real, als sei es da. Von bloßem Sehen ergibt sich nichts. Man sollte sich nicht auf den äußeren Schein der Dinge verlassen.

Die Gesellschaft hebt nützliche Dinge auf, wirft nutzlose Dinge weg. Jeder hält sich an das gemeinsame Sprach- und Zeichensystem sowie an die allgemein geltenden Bedeutungen. Ich hingegen messe gerade den nutzlosen, weggeworfenen Dingen eine größere Bedeutung bei und achte sie höher.

3. Japan, eine in der westlichen Welt treibende Insel

Die japanische Tradition

Japan verfügte einst über einzigartige, grandiose kulturelle Errungenschaften wie Nô, Ukiyo-e und die Teezeremonie. Doch inzwischen haben diese Kunstformen ihre ursprüngliche Bedeutung, gleichsam ihre Seele verloren. Als Verlierer des Zweiten Weltkrieges war Japan angestrengt darum bemüht, sich der abendländischen Kultur anzupassen. Um mit dem Westen mitzuhalten, war man gezwungen,

Neues zu integrieren, Dinge, die es zuvor in Japan nicht gegeben hatte. Dazu mussten die eigenen Traditionen erst einmal beiseite geschoben werden. Eine Konservierung durch Verbannung. Und mit fortschreitender Technik wurde es immer unmöglicher, diese Woge der Erneuerung aufzuhalten. Schließlich ist einzig der Geist des Japanischen in authentischer Form übrig geblieben.

Japan heute

Wie sieht das Japan der Gegenwart aus? Alles drängt sich auf engem Raum, einige wenige Ballungs-gebiete eröffnen den vielen Menschen jeweils einen nur sehr begrenzten Horizont. Man versucht, an etwas Kollektives zu glauben, das längst zur Illusion geworden ist. Es ist nicht mehr möglich, gemein-same Werte und Ideen aufrechtzuerhalten. Im heutigen Japan gibt es keine Tradition und keine Geschichte mehr. Die eigene Geisteshaltung, Weltanschauung, Naturvorstellung sowie andere kultu-relle Kontexte sind im Zuge der Entwicklung auf der Strecke geblieben. Stattdessen orientiert man sich nach dem Prinzip von Versuch und Irrtum. Das Nachkriegsjapan der letzten fünfzig Jahre lässt sich als ein einzige gigantisches Experiment bezeichnen. (Ich suche in meinen Werken das Abstrakte, denn es gibt etwas Absolutes, das sich nur im Klima des Unbestimmten gestalten lässt. Insofern waren auch für mich die letzten fünf Jahrzehnte ein Experimentierfeld.)

Japan versus westlicher Rationalismus

Im Gegensatz zur westlichen Welt besitzt Japan keine eigene Geschichte und gesellschaftliche Ordnung. Der Grund, weshalb Japan sich seiner Welt oder seinem innersten Wesen nie bewusst gewesen ist, liegt darin, dass der Geist, der auf einem reichen Boden gedeiht, keines Rationalismus bedarf. Das zeigt sich sowohl in der Sprache und den Grundbegriffen des Japanischen als auch in der Sphäre des Selbst sowie in einer nur sehr vage ausgeprägten Auffassung von Raum und Zeit. Zu der Freigebigkeit und dem Reichtum der japanischen Natur kommen noch die Jahreszeiten in ihrer einzigartigen Schönheit hinzu, während man im Westen nur erntet, was man gesät hat – auch dies ein Unterschied, der völlig anders-artige Grundvorstellungen erzeugt.

Neue Tendenzen des japanischen Geistes

Japan hat kein Dasein in der wirklichen Zeit. Wir müssen begreifen, dass es das Japanische nur in vir-tueller Form gibt. Jedoch lassen sich die letzten fünfzig Jahre nicht einfach zurückspulen. Erst nach einem langen Weg der Erfahrungen und des Austausches wird Japan wieder eine eigene Kultur entwi-ckeln können. Dabei wird es für uns Japaner nicht um westliche Formen der Identitätsfindung und des Handelns gehen. Wir müssen uns die fundamentalen Differenzen des Denkens, der religiösen und philosophischen Anschauungen klar machen. Genauso gilt es aber, die Unterschiede unter uns Japa-nern, zwischen mir und dem Anderen zu erkennen, die Einzigartigkeit des Individuums wahrzunehmen. Die Ansichten sind sehr verschieden. Deshalb halte ich einfache Utopien für Heuchelei.

4. Mein Standpunkt

Die Unfähigkeit entdecken

Die von mir in zwei Titeln verwendeten Bezeichnungen A-4E Skyhawk und Viking S-3 symbolisieren das Giftige, Schädliche und Gewalttätige. Hinter diesen Namen stehen Waffen, Tötungsinstrumente. Die dazu-

gehörigen Arbeiten *A-4E Skyhawk* von 1969 (KAT. Nr. 24) und *Black Viking S-3* von 2000 (KAT. Nr. 287) bestehen jedoch nur aus Flugzeugheckteilen. Sie verkörpern damit Unfähigkeit, das Untaugliche von nicht funktionierenden Flugzeugen. Die Gesellschaft pflegt im Allgemeinen, schädliche und gewalttätige Dinge zu eliminieren und durch sichere und angenehme Dinge zu ersetzen. Ich misstraue aber einer solchen Gesellschaft und stelle sie in Frage.

Ein Pendant zu *A-4E Skyhawk* bilden die *Air Pipes* (KAT. Nr. 13–23), Werke aus derselben Zeit und ebenso Metaphern der Unfähigkeit. Denn diese Air Pipes (Lüftungsrohre) erweisen sich als bloße konkrete Formen und damit als völlig nutzlos. Gerade die Repression durch die Gesellschaft, die Epoche und das politische System sowie die Notwendigkeit, darauf zu reagieren, veranlassen mich zu einer Kunst im Sinne der Moderne.

Ein Ort ohne Anfang und Ende

Die materiellen Faktoren eines Werkes, der Schaffensakt sowie Zeit und Ort seines Entstehens sind einmalig und vergänglich. Es gibt nur ein Leben und ebenso auch nur eine Kunst. Allein der fortwährende Prozess zählt, nicht die Ergebnisse. Deshalb wechsle ich stets den Ort und wiederhole eine Aktion bei vielen Gelegenheiten. Eine Folge von Improvisationen ohne Anfang und Ende. Von Augenblick zu Augenblick. Sich dem Augenblick stellen und in ihm die Existenz erkennen. Immer tiefer und tiefer, denn erst dort liegt die Welt.

Alles hat an jedem Ort und zu jedem Zeitpunkt einen eigenen Wert. Das Werk ist wie ein lebendiges Wesen. Es verändert sich, und es stellt sich mir eigenmächtig gegenüber. Nie ergreife ich die Initiative, sondern gehe einfach immer nur zum nächsten Zustand über. Mein Konzept besteht darin, in ständiger Wiederholung stets dasselbe zu erschaffen.

(Übersetzung aus dem Japanischen von Sabine Mangold)

CATALOGUE I KATALOG

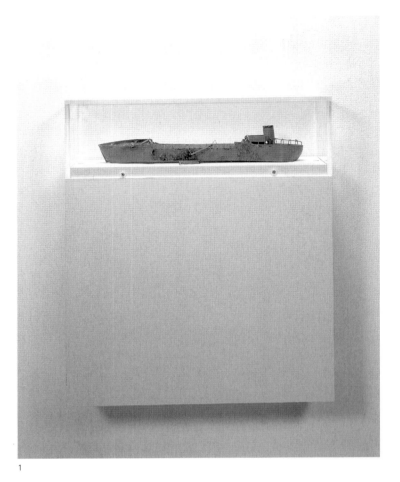
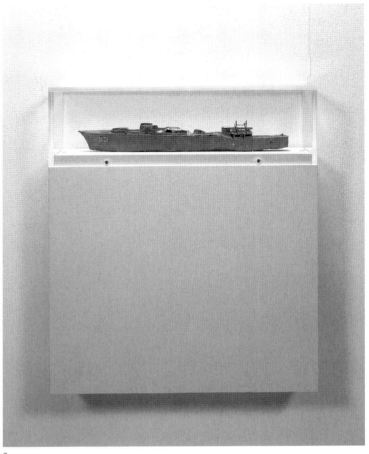

1 3

1 2
Ship 1 Ship 2
1963–65 1963–65
Lacquer on paper, lacquer on plywood, and plexiglas I Paper, lacquer on plywood, and plexiglas I
Lack auf Papier, Lack auf Sperrholz und Plexiglas Papier, Lack auf Sperrholz und Plexiglas
54 x 46 x 15 cm 54 x 62 x 15 cm
Akira Ikeda Gallery, Japan Akira Ikeda Gallery, Japan

Exhibitions I Ausstellungen Exhibition I Ausstellung
1996–97 Akira Ikeda Gallery, Taura, Yokosuka 1996–97 Akira Ikeda Gallery, Taura, Yokosuka
2001 *Noriyuki Haraguchi. Elemente der*
Wahrnehmung. Arbeiten 1963–2001, Städtische
Galerie im Lenbachhaus, Munich I München

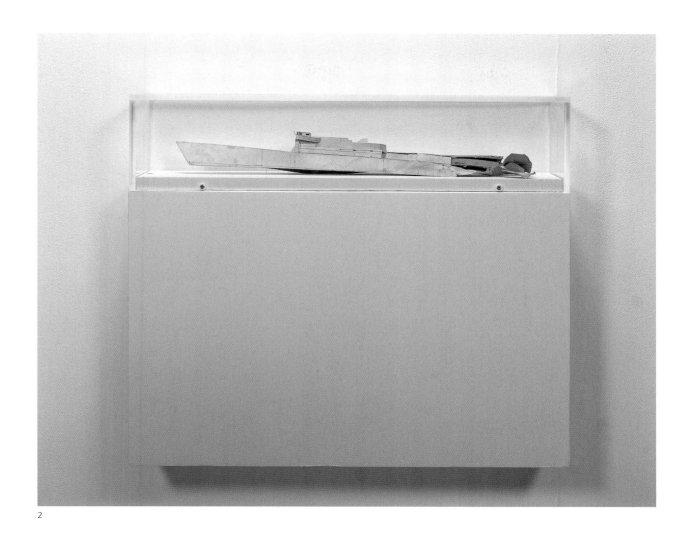

2

3
Ship 3
1963–65
Lacquer on paper, lacquer on plywood, and plexiglas l
Lack auf Papier, Lack auf Sperrholz und Plexiglas
54 x 46 x 15 cm
Akira Ikeda Gallery, Japan

Exhibition l Ausstellung
1996–97 Akira Ikeda Gallery, Taura, Yokosuka

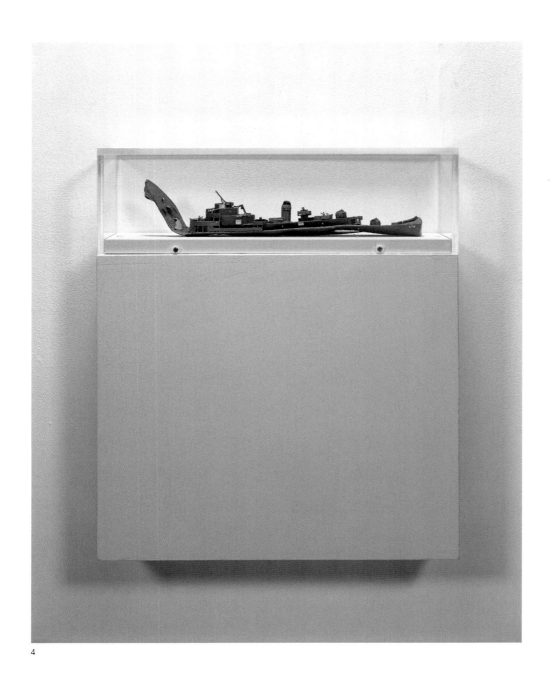

4

4
Ship 4
1963–65
Lacquer on paper, lacquer on plywood, and plexiglas l
Lack auf Papier, Lack auf Sperrholz und Plexiglas
54 x 46 x 15 cm
Akira Ikeda Gallery, Japan

Exhibition l Ausstellung
1996–97 Akira Ikeda Gallery, Taura, Yokosuka

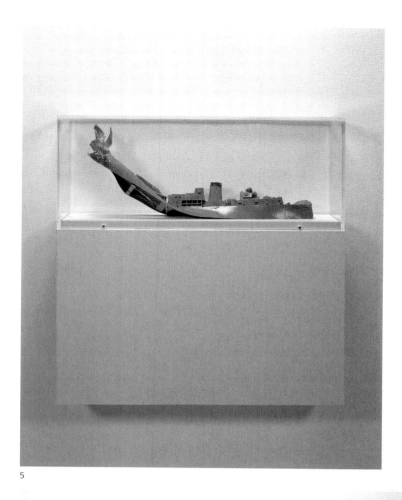

5

5
Ship 5
1963–65
Lacquer on paper, lacquer on plywood, and plexiglas I
Lack auf Papier, Lack auf Sperrholz und Plexiglas
66 x 64 x 18 cm
Akira Ikeda Gallery, Japan

Exhibitions I Ausstellungen
1996–97 Akira Ikeda Gallery, Taura, Yokosuka
2001 *Noriyuki Haraguchi. Elemente der
Wahrnehmung. Arbeiten 1963–2001*, Städtische
Galerie im Lenbachhaus, Munich I München

6
Submarine 1
1963–65
Lacquer on paper, lacquer on plywood, and plexiglas I
Lack auf Papier, Lack auf Sperrholz und Plexiglas
54 x 122 x 15 cm
Akira Ikeda Gallery, Japan

Exhibitions I Ausstellungen
1996–97 Akira Ikeda Gallery, Taura, Yokosuka
2001 *Noriyuki Haraguchi. Elemente der
Wahrnehmung. Arbeiten 1963–2001*, Städtische
Galerie im Lenbachhaus, Munich I München

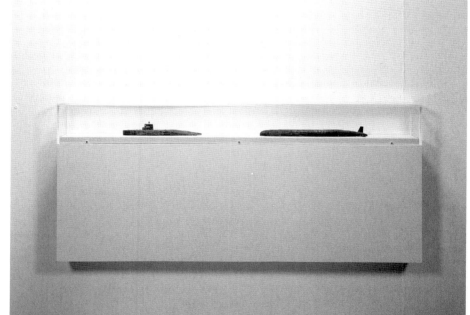

6

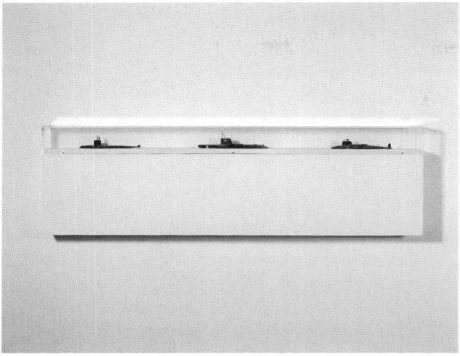

7

7
Submarine 2
1963–65
Lacquer on paper and on plastic, lacquer on plywood,
and plexiglas | Lack auf Papier und auf Kunststoff,
Lack auf Sperrholz und Plexiglas
54 x 182 x 15 cm
Akira Ikeda Gallery, Japan

Exhibition | Ausstellung
2001 *In Time*, Akira Ikeda Gallery, Taura, Yokosuka

8
Tsumu 147
1966
Mixed media | Verschiedene Materialien
134 x 170 cm
Collection of the artist | Besitz des Künstlers

Exhibition | Ausstellung
1966 *7th Contemporary Art Exhibition of Japan*,
Tokyo Metropolitan Art Museum

Bibliography
Asahi Journal, Cover

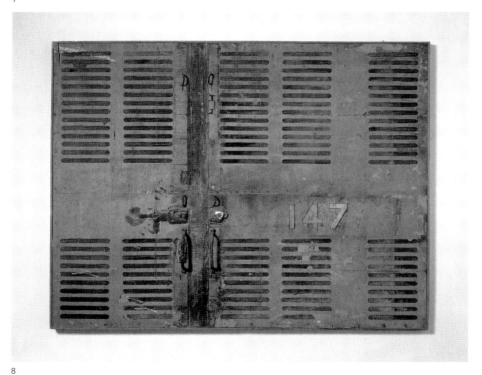

8

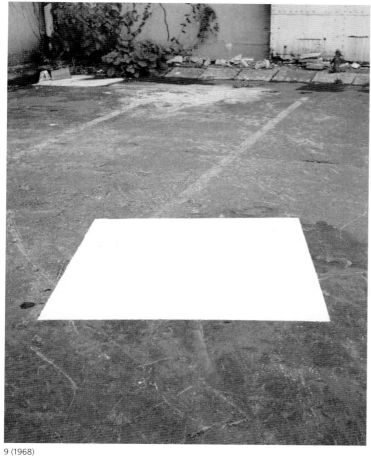

9 (1968)

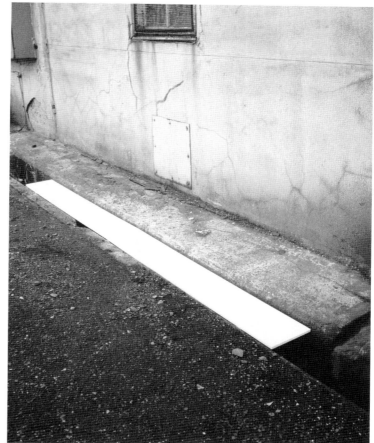

10 (1968)

9
Untitled
1968/2000
Temporary work I Temporäre Arbeit
Acrylic on concrete floor I Acryl auf Betonboden
130 x 130 cm

Exhibitions I Ausstellungen
1968 *1st Apple in Space*, Hibiya Gallery, Tokyo
2000 Taura Sea Port, Yokosuka

Bibliography
*Matter and Perception, 1970: Mono-ha
and the Search for Fundamentals* (The Museum
of Fine Arts, Gifu; Hiroshima City Museum of
Contemporary Art; Kitakyushu Municipal Museum
of Art, Fukuoka; The Museum of Modern Art,
Urawa, 1995): Cat. 68-1

10
Untitled 1, Untitled 2
1968/2000
Temporary work I Temporäre Arbeit
Enamel on plywood over a ditch I
Emaillack auf Sperrholz über einem Graben
Two pieces, each I Zwei Teile jeweils:
184.5 x 29 x 1.5 cm (1968)
Together I Zusammen: 369 x 29 x 1.5 cm (1968)

Exhibitions I Ausstellungen
1968 *Nippon Kama-Itachi*, Yokohama Citizens' Gallery
2000 Taura Sea Port, Yokosuka

Bibliography
Matter and Perception (see No. 9): Cat. 68-3

11

12

11
Untitled 4
1968
Temporary reproducible work I
Temporäre, wiederherstellbare Arbeit
Acrylic on plywood I Acryl auf Sperrholz
160 x 120 x 36 cm
Certificate with instructions and signature
held by artist I Zertifikat mit Konstruktionsanleitung
und Signatur im Besitz des Künstlers

Bibliography
Matter and Perception (see No. 9): Cat. 68-9

12
Untitled 5
1968
Temporary reproducible work I
Temporäre, wiederherstellbare Arbeit
Acrylic on plywood I Acryl auf Sperrholz
160 x 120 x 36 cm
Certificate with instructions and signature
held by artist I Zertifikat mit Konstruktionsanleitung
und Signatur im Besitz des Künstlers

Bibliography
Matter and Perception (see No. 9): Cat. 68-10

13
Air Pipe (White Series)
1968
Enamel on canvas I Emaillack auf Leinwand
359 x 94 x 2 cm
Gallery Gen, Tokyo

Exhibitions I Ausstellungen
1968 *Nippon Kama-Itachi*, Yokohama Citizens' Gallery
1968 Muramatsu Gallery, Tokyo
1994 Akira Ikeda Gallery, Tokyo

Bibliography
Matter and Perception (see No. 9): Cat. 68-2

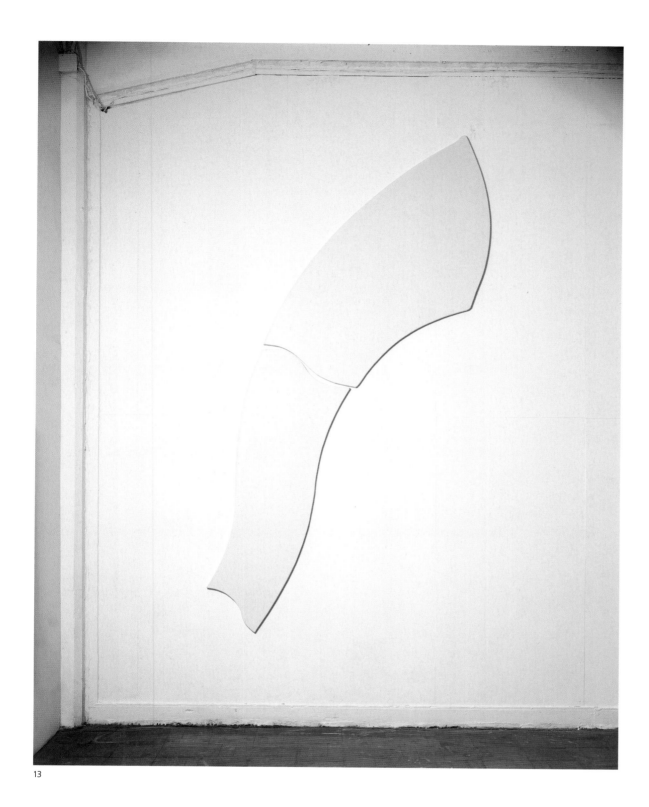

13

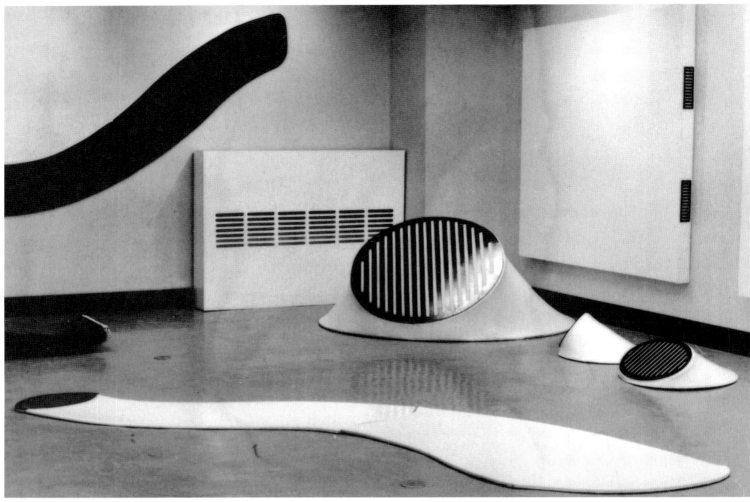

16, 15, 14, 17
13

<table>
<tr><td>

14

Air Pipe 1

1968

Temporary reproducible work I
Temporäre, wiederherstellbare Arbeit
Aluminium on canvas mounted on plywood I
Aluminium auf Leinwand über Sperrholz
90 x 270 x 140 cm
Certificate with instructions and signature
held by artist I Zertifikat mit Konstruktionsanleitung
und Signatur im Besitz des Künstlers

Exhibition I Ausstellung
1968 Muramatsu Gallery, Tokyo

Bibliography
Matter and Perception (see No. 9): Cat. 68-4

</td><td>

15

Air Pipe 2

1968

Temporary reproducible work I
Temporäre, wiederherstellbare Arbeit
Enamel on plywood I Emaillack auf Sperrholz
110 x 160 x 30 cm
Certificate with instructions and signature
held by artist I Zertifikat mit Konstruktionsanleitung
und Signatur im Besitz des Künstlers

Exhibition I Ausstellung
1968 Muramatsu Gallery, Tokyo

Bibliography
Matter and Perception (see No. 9): Cat. 68-5

</td><td>

16

Air Pipe 3

1968

Temporary reproducible work I
Temporäre, wiederherstellbare Arbeit
Acrylic on canvas mounted on plywood I
Acryl auf Leinwand über Sperrholz
50 x 400 x 2 cm
Certificate with instructions and signature
held by artist I Zertifikat mit Produktionsanleitung
und Signatur im Besitz des Künstlers

Exhibition I Ausstellung
1968 Muramatsu Gallery, Tokyo

Bibliography
Matter and Perception (see No. 9): Cat. 68-6

</td></tr>
</table>

44

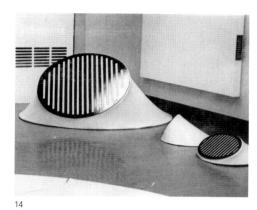 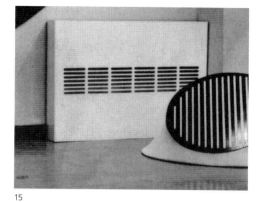

14 15 16

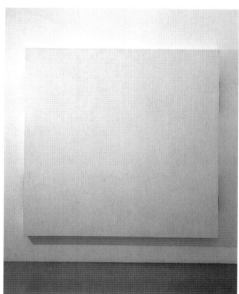 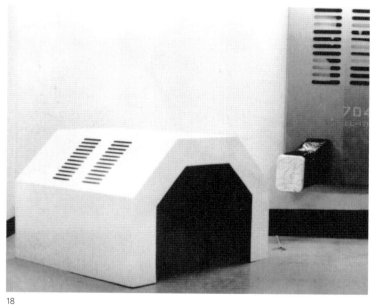

17 18

17
Air Pipe 4
1968
Reproduced in 1995 I 1995 wiederhergestellt
Acrylic and copper on canvas I Acryl und Kupfer
auf Leinwand
205 x 205 x 11 cm
Akira Ikeda Gallery, Japan

Exhibitions I Ausstellungen
1968 Muramatsu Gallery, Tokyo
1996 *Pino Pascali, Jiro Takamatsu, Noriyuki
Haraguchi*, Akira Ikeda Gallery, Tokyo

Bibliography
Matter and Perception (see No. 9): Cat. 68-7

18
Air Pipe 5
1968
Temporary reproducible work I
Temporäre, wiederherstellbare Arbeit
Enamel and aluminium on plywood I Emaillack
und Aluminium auf Sperrholz
90 x 120 x 150 cm
Certificate with instructions and signature
held by artist I Zertifikat mit Konstruktionsanleitung
und Signatur im Besitz des Künstlers

Exhibition I Ausstellung
1968 Muramatsu Gallery, Tokyo

Bibliography
Matter and Perception (see No. 9): Cat. 68-8

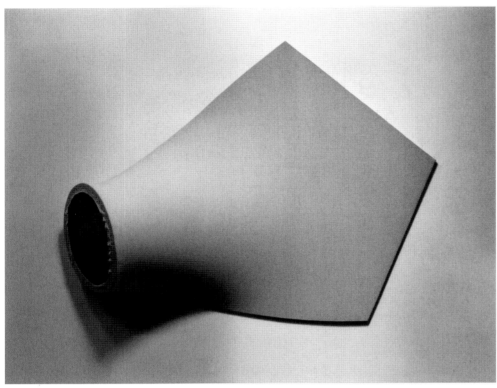

19

19
Air Pipe A (White Series)
1969
Reproduced in 1995 | 1995 wiederhergestellt
Canvas mounted on plywood |
Leinwand über Sperrholz
120 x 152 x 31 cm
Gallery Gen, Tokyo

Exhibitions | Ausstellungen
1969 *5th International Young Artists Exhibition*,
Seibu Department Store, Tokyo
1969 *2nd Apple in Space*, Muramatsu Gallery, Tokyo
1995 Hotel & Art AMBIK Contemporary Art, Atami

Bibliography
Matter and Perception (see No. 9): Cat. 69-1

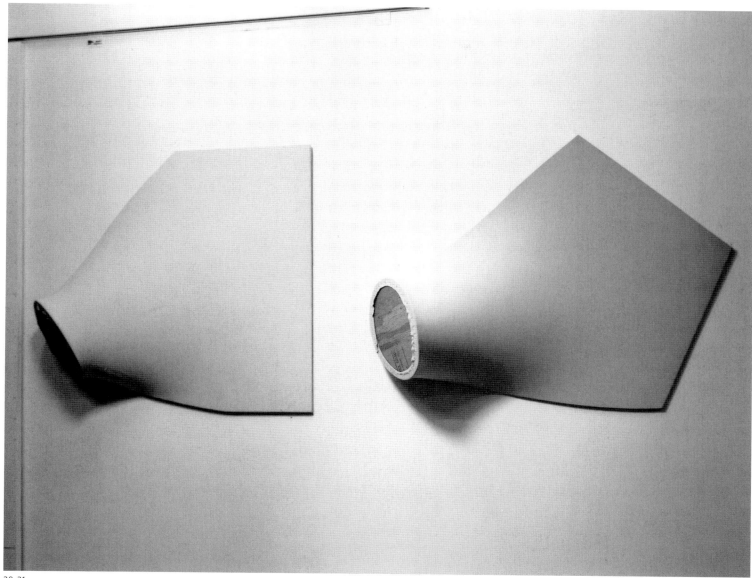

20, 21

20
Air Pipe B (White Series)
1969
Canvas mounted on plywood l
Leinwand über Sperrholz
120 x 152 x 31 cm
Gallery Gen, Tokyo

Bibliography
Matter and Perception (see No. 9): Cat. 69-2

21
Air Pipe C (White Series)
1969
Canvas mounted on plywood l
Leinwand über Sperrholz
136 x 155 x 25 cm
Gallery Gen, Tokyo

Exhibition l Ausstellung
1969 *5th International Young Artists Exhibition*,
Seibu Department Store, Tokyo

Bibliography
Matter and Perception (see No. 9): Cat. 69-3

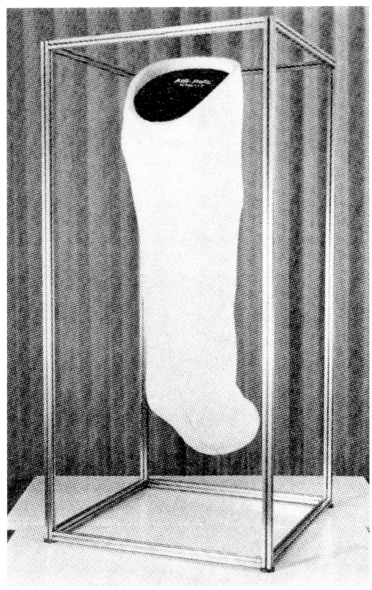

22

22
Air Pipe, Inability (White Series)
1969
Temporary work | Temporäre Arbeit
Polyurethane foam and aluminium |
Polyurethan-Schaumstoff und Aluminium
180 x 90 x 90 cm

Exhibition | Ausstellung
1969 *4th Japan Art Festival*, The National Museum
of Modern Art, Tokyo (Award of Excellence)

Bibliography
Japan Art Festival Prize Winners (January 1970)
Matter and Perception (see No. 9): Cat. 69-5

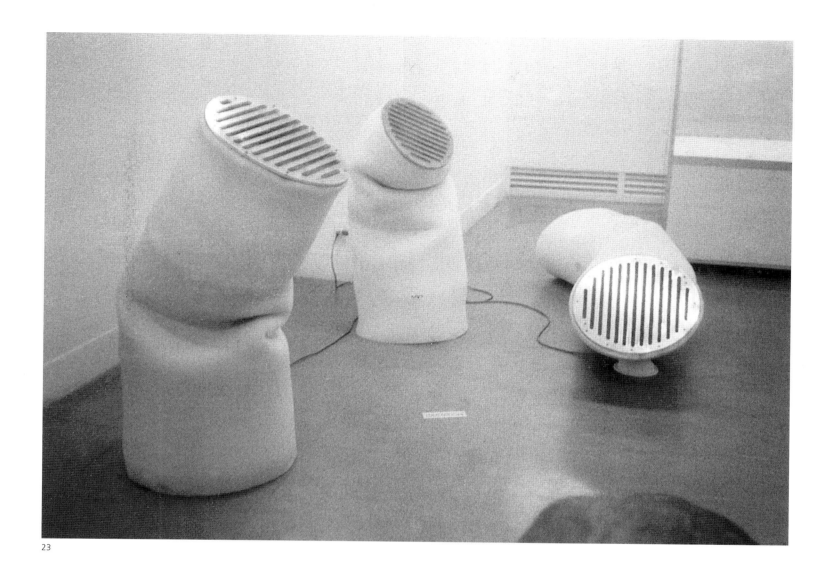

23

23
Air Pipe, Inability I
1969
Temporary reproducible work I
Temporäre, wiederherstellbare Arbeit
Polyurethane foam and aluminium I
Polyurethan-Schaumstoff und Aluminium
Three pieces, each I Drei Teile jeweils: 100 x ∅ 40 cm
Installation: 180 x 180 cm
Certificate with instructions and signature
held by artist I Zertifikat mit Konstruktionsanleitung
und Signatur im Besitz des Künstlers

Exhibition I Ausstellung
1969 *2nd Apple in Space*, Muramatsu Gallery, Tokyo

Bibliography
Matter and Perception (see No. 9): Cat. 69-6

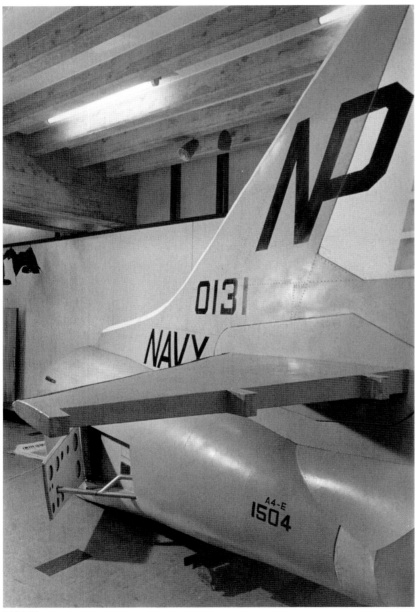

24 (1969)

24
A-4E Skyhawk
1969
Reproduced in 1995 | 1995 wiederhergestellt
Wood | Holz
444.5 x 542.5 x 352 cm
Akira Ikeda Gallery, Japan

Exhibitions | Ausstellungen
1969 *3 Artists*, Akiyama Gallery, Tokyo
1996 Akira Ikeda Gallery, Taura, Yokosuka

Bibliography
Matter and Perception (see No. 9): Cat. 69-4

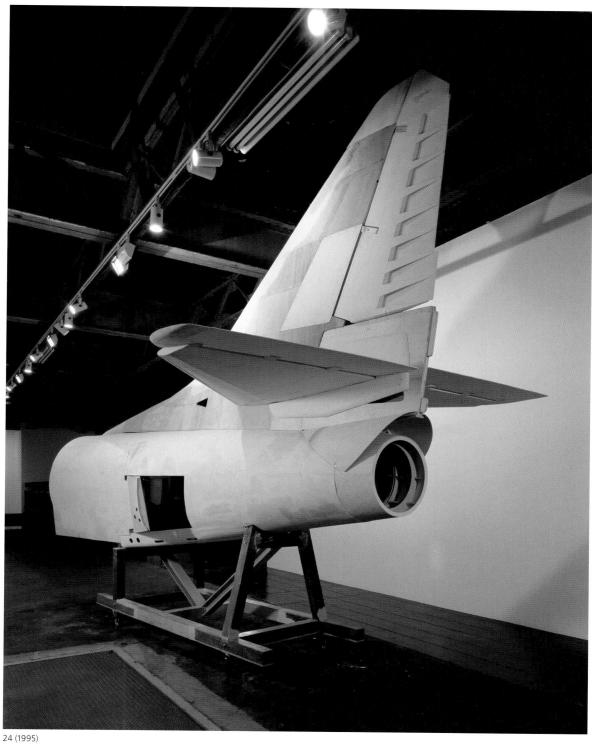

24 (1995)

25
Mechanic Eros
1969
Temporary work I Temporäre Arbeit
Steel pole, steel pipe, strobe light, wire, and dry
leaves with oil I Stahlmast, Stahlrohr, Stroboskoplicht,
Draht und getrocknete Blätter mit Öl
Steel pole I Stahlmast: 240 x ∅30 cm
Installation: 2.4 x 4 x 7 m

Exhibition I Ausstellung
1969 Tamura Gallery, Tokyo

Bibliography
"The Collected Works from 1970", in *Bijutsu-Techo*,
Yearbook (January 1971): 1–48
Toshiaki Minemura, "What was 'Mono-ha'?", in
Mono-ha (Kamakura Gallery, Tokyo, 1986)
Matter and Perception (see No. 9): Cat. 69–8

26
Communications
1969
Temporary work I Temporäre Arbeit
Steel pipes, plastic, meteorological balloons,
and polyurethane I Stahlrohre, Kunststoff,
Wetterballone und Polyurethan
Two steel pipes I Zwei Stahlrohre: 300 x ∅27 cm,
400 x ∅5 cm
Two balloons I Zwei Ballone: ∅150 cm
Installation: 300 x 400 x 300 cm

A steel pipe extending from the floor to the ceiling
was crossed at a right angle by another steel pipe
at ceiling height. A plastic cube and a meteorological
balloon, which was covered with a white polyur-
ethane form, were suspended from the intersection.
A sphere constructed in the same way lay on
the floor.

An der Verbindungsstelle zweier Stahlrohre befestigt,
die ein raumhohes stehendes T bildeten, hingen
ein Würfel aus Kunststoff sowie ein von einer weißen
Polyurethan-Schale umgebener Wetterballon von
der Decke herab. Eine in derselben Weise gefertigte
Kugel lag auf dem Boden.

Exhibition I Ausstellung
1969 *Trends in Contemporary Art*, The National
Museum of Modern Art, Kyoto

Bibliography
Matter and Perception (see No. 9): Cat. 69-7

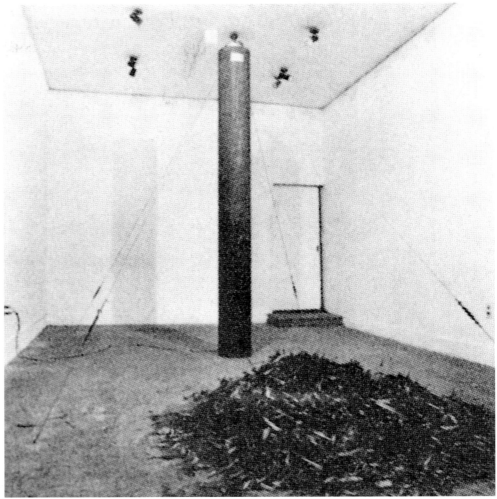

25

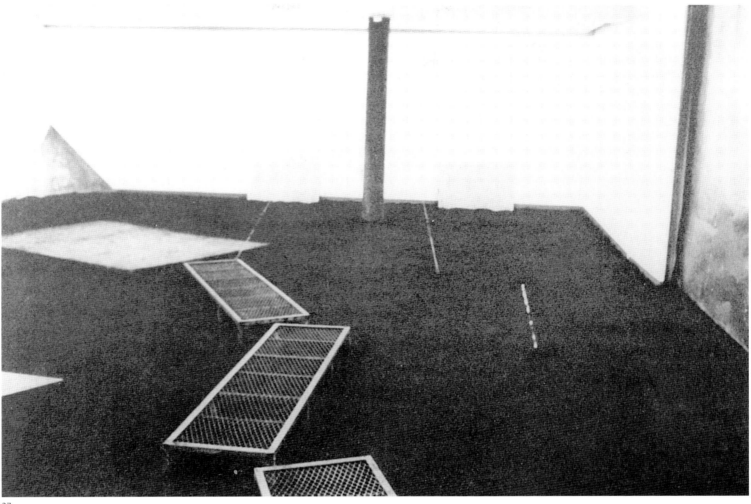

27

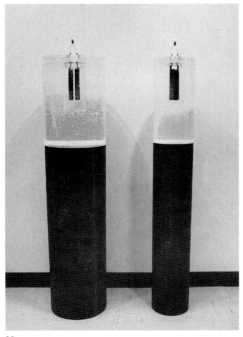

28

27
Apple in Space – Iron Room
(Noriyuki Haraguchi with I mit Mitsunori Kurashige,
Roku Suganuma, Akito Uzawa, Eishi Yamamoto)
1970
Temporary work I Temporäre Arbeit
Haraguchi: Steel pipes, iron sand, steel plate,
and steel gratings I Stahlrohre, Eisensand, Stahlplatte
und Stahlgitter
Other artists I Übrige Künstler: Ball bearings,
fluorescent lights, and more I Kugellagerkugeln,
Leuchtstoffröhren und anderes
Dimensions unknown I Maße unbekannt

Exhibition I Ausstellung
1970 *3rd Apple in Space*, American Center Tokyo

Bibliography
Joseph Love, "Tokyo Letter", in *Art International*
XIV, 10 (Christmas 1970): 88–91
Matter and Perception (see No. 9): Cat. 70-9

28
Battery
1970
Temporary reproducible work I
Temporäre, wiederherstellbare Arbeit
Steel, carbon electrodes, light bulbs, plexiglas,
and water I Stahl, Kohlenstoffelektroden,
Glühbirnen, Plexiglas und Wasser
Two pieces I Zwei Teile: 150 x Ø40 cm, 150 x Ø25 cm
Certificate with instructions and signature
held by artist I Zertifikat mit Konstruktionsanleitung
und Signatur im Besitz des Künstlers

Exhibition I Ausstellung
1970 *Opening*, Tokiwa Gallery, Tokyo

Bibliography
Matter and Perception (see No. 9): Cat. 70-1

29 (1995)

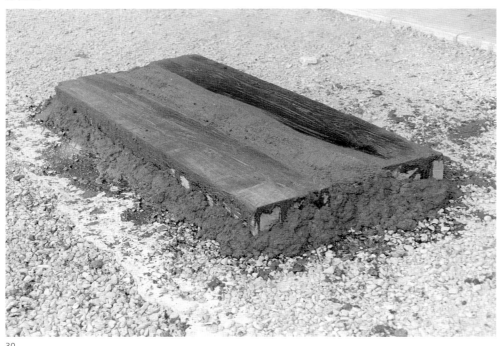

30

29
Untitled
1970
Reproduced in 1995 | 1995 wiederhergestellt
Concrete blocks, sand, and oil | Betonsteine, Sand
und Öl
30 x 150 x 210 cm
Akira Ikeda Gallery, Japan

Exhibitions | Ausstellungen
1970 Nihon University (exhibited unofficially |
inoffiziell ausgestellt)
1995 *Matter and Perception, 1970: Mono-ha
and the Search for Fundamentals*, The Museum
of Fine Arts, Gifu; Hiroshima City Museum
of Contemporary Art; Kitakyushu Municipal Museum
of Art, Fukuoka; The Museum of Modern Art,
Urawa (Cat. 70-2)
1996 *Japon 1970. Matière et perception. Le Mono-
ha et la recherche des fondements de l'art*,
Musée d'Art moderne de Saint-Etienne (Cat., text
by Miyako Okubo: 28–33)

Bibliography
Noriyuki Haraguchi, 1970–1993 (Akira Ikeda Gallery,
New York, 1993): Cat. 2

30
Untitled
1970
Temporary reproducible work |
Temporäre, wiederherstellbare Arbeit
Wood, sand, and oil | Holz, Sand und Öl
18 x 105 x 180 cm
Certificate with instructions and signature held
by private collector, Japan | Zertifikat mit Produktions-
anleitung und Signatur im Besitz einer japanischen
Privatsammlung

Exhibitions | Ausstellungen
1970 Nihon University (exhibited unofficially |
inoffiziell ausgestellt)
1995 *Japanese Culture: The Fifty Postwar Years*,
Meguro Museum of Art, Tokyo; Hiroshima City
Museum of Contemporary Art; Hyogo Prefectural
Museum of Modern Art; Fukuoka Prefectural
Museum of Art

Bibliography
Noriyuki Haraguchi, 1970–1993 (see No. 29): Cat. 1
Matter and Perception (see No. 9): Cat. 70-3

31 (2000)

31
Untitled
1970/2000
Temporary reproducible work I
Temporäre, wiederherstellbare Arbeit
Wax and water on the floor I Wachs und Wasser
auf dem Boden
67 x 92 cm (1970)
Certificate with instructions and signature
held by artist I Zertifikat mit Produktionsanleitung
und Signatur im Besitz des Künstlers

Exhibition I Ausstellung
1970 Nihon University (exhibited unofficially I
inoffiziell ausgestellt)

Remade in 2000 in the artist's studio I
2000 erneut realisiert im Atelier des Künstlers

Bibliography
Matter and Perception (see No. 9): Cat. 70-5

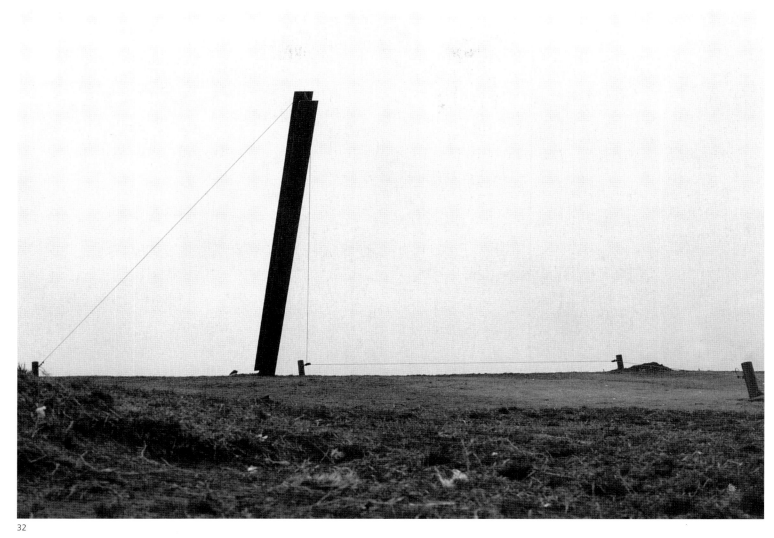

32

32
I-Beam and Wire Rope
1970
Temporary work I Temporäre Arbeit
Steel I-beam, steel cable and steel poles I
I-Träger aus Stahl, Drahtseil und Stahlpflöcke
Steel beam I Stahlträger: 700 x 40 x 40 cm
Steel cable I Drahtseil: 40 m

Exhibition I Ausstellung
1970 Open Field Festival, Tokyu Kodomo Land,
Yokohama

Bibliography
Noriyuki Haraguchi / Takashi Hayami, "Conversation
to the Present Day: How to Handle Things",
in *Mizue* 885 (December 1978): 82–89
Yasuhiro Yurugi, in *Trends of Contemporary
Japanese Art, 1970–1984: Universality/Individuality*
(Tokyo Metropolitan Art Museum, 1984): 9–11
Matter and Perception (see No. 9): Cat. 70-4

33
Untitled
1970
Reproduced in 1995 I 1995 wiederhergestellt
Canvas sheet, steel I-beam, and steel cable I
Leinwandtuch, I-Träger aus Stahl und Drahtseil
35 x 600 x 65 cm
Akira Ikeda Gallery, Japan

Exhibitions I Ausstellungen
1970 Nihon University (exhibited unofficially I
inoffiziell ausgestellt)
1995 *Matter and Perception, 1970: Mono-ha
and the Search for Fundamentals*, The Museum
of Fine Arts, Gifu; Hiroshima City Museum of
Contemporary Art; Kitakyushu Municipal Museum
of Art, Fukuoka; The Museum of Modern Art,
Urawa (Cat. 70-8)
1997 *Cravity: Axis of Contemporary Art*,
The National Museum of Art, Osaka (Cat.: 156)

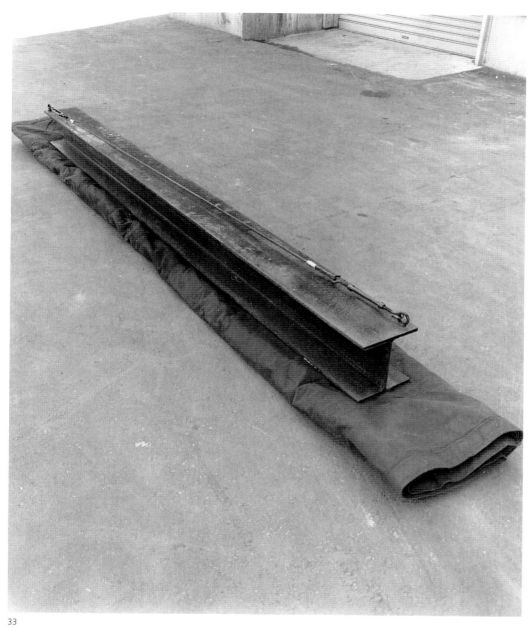

33

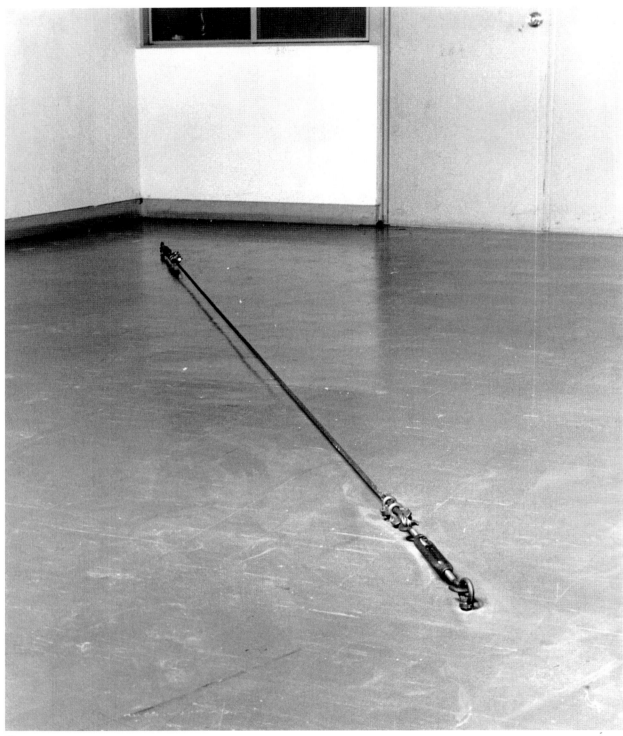

34

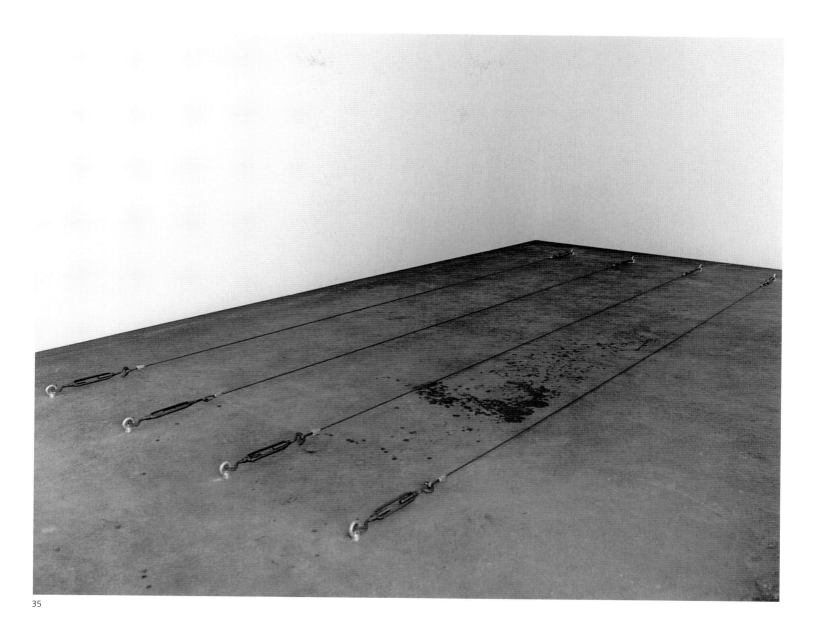

35

34
Untitled (Wire Rope I)
1970
Temporary reproducible work I
Temporäre, wiederherstellbare Arbeit
Steel cable I Drahtseil
400 cm
Certificate with instructions and signature
held by artist I Zertifikat mit Produktionsanleitung
und Signatur im Besitz des Künstlers

Exhibition I Ausstellung
1970 Nihon University (exhibited unofficially I
inoffiziell ausgestellt)

Bibliography
Matter and Perception (see No. 9): Cat. 70-6

35
Untitled (Wire Rope III)
1970
Reproduced in 1995 I 1995 wiederhergestellt
Steel cable I Drahtseil
Four pieces, each I Vier Teile jeweils: 400 cm
Akira Ikeda Gallery, Japan

Exhibitions I Ausstellungen
1970 Nihon University (exhibited unofficially I
inoffiziell ausgestellt)
1995 Hotel & Art AMBIK Contemporary Art, Atami

36

36
Material Territory
(formerly | vormals: Material Concern)
1970
Temporary reproducible work |
Temporäre, wiederherstellbare Arbeit
Steel, iron sand, and cement | Stahl, Eisensand
und Zement
150 x 400 x 10 cm
Certificate with instructions and signature
held by artist | Zertifikat mit Konstruktionsanleitung
und Signatur im Besitz des Künstlers

Exhibitions | Ausstellungen
1970 Tamura Gallery, Tokyo
1995 Hotel & Art AMBIK Contemporary Art, Atami

Bibliography
Takahiko Okada, "On the Quotation of Things", in
Bijutsu-Techo, Yearbook (January 1972): 2–13
Yurugi, in *Contemporary Japanese Art* (see No. 32)
Matter and Perception (see No. 9): Cat. 70-10

37

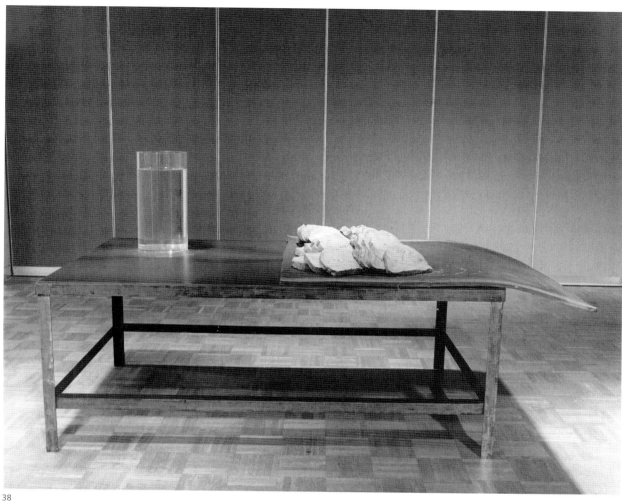

38

37
Untitled
1971
Temporary work I Temporäre Arbeit
Clay mixed with oil I Ton mit Öl
Several pieces in different sizes I
Mehrere Teile in verschiedenen Größen

Exhibitions I Ausstellungen
1971 *Word and Image*, Pinar Gallery, Tokyo

Bibliography
Matter and Perception (see No. 9): Cat. 71-1

38
Untitled
1971
Reproduced in 1972 I 1972 wiederhergestellt
Steel, rubber, clay mixed with oil, plexiglas,
and water I Stahl, Gummi, Ton mit Öl, Plexiglas
und Wasser
92 x 233 x 61 cm
Kamakura Gallery, Tokyo

Exhibitions I Ausstellungen
1971 *3 Artists*, Gallery Iteza, Kyoto
1972 *Sinkers and Springs*, American Center Tokyo
1995 Hotel & Art AMBIK Contemporary Art, Atami

Bibliography
"Thought of 1972: Review and Works", in *Bijutsu-
Techo*, Yearbook (January 1972): 78
Matter and Perception (see No. 9): Cat. 71-3

39
Seven Steel Plates (Preposition II – Material Territory,
Revised Buttai)
1971
Temporary work I Temporäre Arbeit
Iron plates I Eisenplatten
Seven pieces in different sizes I Sieben Platten
in verschiedenen Größen

Exhibition I Ausstellung
1971 *10th Contemporary Art Exhibition of Japan*,
Tokyo Metropolitan Art Museum

Bibliography
Okada, "Things" (see No. 36)
Haraguchi, 1970–1977 (publ. by the artist, 1977)
Haraguchi/Hayami, "Conversation" (see No. 32)
Yurugi, in *Contemporary Japanese Art* (see No. 32)
Matter and Perception (see No. 9): Cat. 71-2

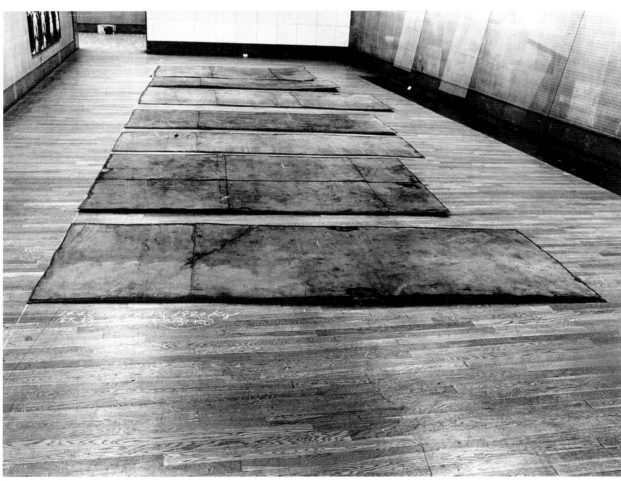

39

40

40
Matter and Mind
1971
Reproduced in 1992 | 1992 wiederhergestellt
Steel plates, steel, and oil | Stahlplatten, Stahl und Öl
Oil table | Öltisch: 88 x 168 x 240 cm
Akira Ikeda Gallery, Japan

Exhibitions | Ausstellungen
1971 Tamura Gallery, Tokyo
1992 *Joseph Beuys, Piero Manzoni, Noriyuki
Haraguchi*, Akira Ikeda Gallery, Tokyo (Cat.)
1993 *Noriyuki Haraguchi: Matter and Mind*,
Akira Ikeda Gallery, New York (Cat. 3 in *Noriyuki
Haraguchi, 1970–1993*)

1995 *Matter and Perception, 1970: Mono-ha
and the Search for Fundamentals*, The Museum
of Fine Arts, Gifu; Hiroshima City Museum
of Contemporary Art; Kitakyushu Municipal Museum
of Art, Fukuoka; The Museum of Modern Art,
Urawa (Cat. 71-4)
1996 *Japon 1970. Matière et perception. Le Mono-ha
et la recherche des fondements de l'art*, Musée d'Art
moderne de Saint-Etienne (Cat., text by Miyako
Okubo: 28–33)

41

41
L-Shaped Steel – Horizontal
1972
Reproduced in 1996 I 1996 wiederhergestellt
Angle steel I Winkelstahl
20 x 500 x 20 cm
Akira Ikeda Gallery, Japan

Exhibitions I Ausstellungen
1972 *Contemporary Artists '72*, Yokohama Citizens'
Gallery
1996 *Japon 1970. Matière et perception. Le Mono-ha
et la recherche des fondements de l'art*, Musee d'Art
moderne de Saint-Etienne (Cat., text by Miyako
Okubo: 28–33)

Bibliography
Haraguchi/Hayami, "Conversation" (see No. 32)
Matter and Perception (see No. 9): Cat. 72-9

42
Untitled
1972
Steel plates I Stahlplatten
Eight plates, each I Acht Platten jeweils:
190 x 23 x 3 cm
Collection of the artist I Besitz des Künstlers

Exhibition I Ausstellung
1972 *Contemporary Artists '72*, Yokohama Citizens'
Gallery

Bibliography
Artists Today's Exhibition, 1964–89 (Yokohama
Citizens' Gallery, 1990): 54
Matter and Perception (see No. 9): Cat. 72-10

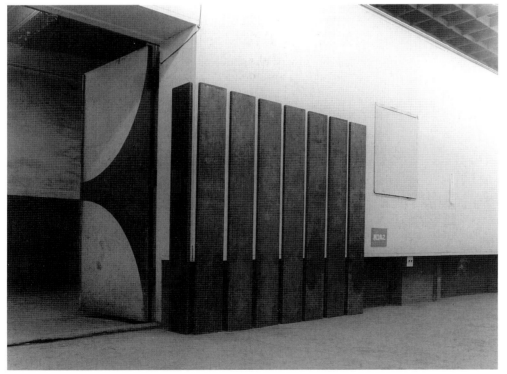

42

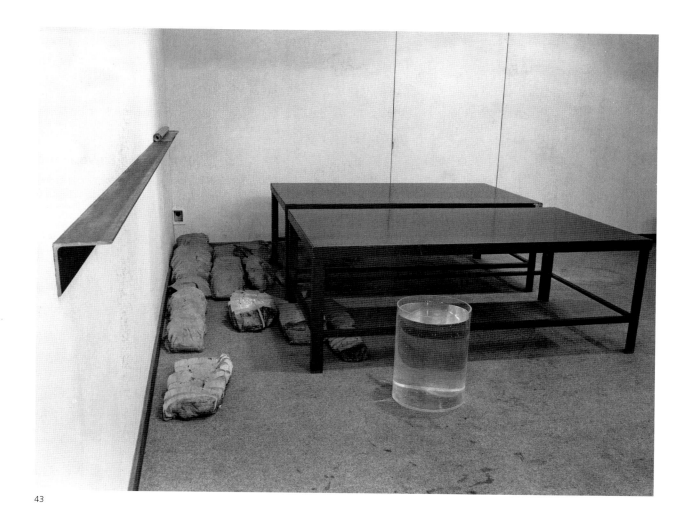

43

43
Untitled
1972
Reproduced in 1995 I 1995 wiederhergestellt
Angle steel, sheet lead, clay mixed with oil,
steel, plexiglas, and water I Winkelstahl, Bleiblech,
Ton mit Öl, Stahl, Plexiglas und Wasser
110 x 300 x 400 cm
Akira Ikeda Gallery, Japan

Exhibition I Ausstellung
1972 Sato Gallery, Tokyo
1995 Hotel & Art AMBIK Contemporary Art, Atami

Bibliography
Toshiaki Minemura, "Review", in *Bijutsu-Techo*
(March 1972): 318–319
Haraguchi, 1970–1993 (see No. 29): Cat. 4
Contemporary Japanese Art (see No. 32): 71
Matter and Perception (see No. 9): Cat. 72-1

44

44
Untitled
1972
Reproduced in 1986 I 1986 wiederhergestellt
Steel and plexiglas I Stahl und Plexiglas
88 x 290 x 258 cm
Akira Ikeda Gallery, Japan

Exhibitions I Ausstellungen
1972 *Sinkers and Springs*, American Center Tokyo
1986 *Mono-ha*, Kamakura Gallery, Tokyo
(with I mit Noboru Takayama, Koji Enokura)

Bibliography
Haraguchi, 1970–1977 (see No. 39)
"Concerning 'Mono-ha'", in *Mizue* 944
(autumn 1987): 102–105
Matter and Perception (see No. 9): Cat. 72-2

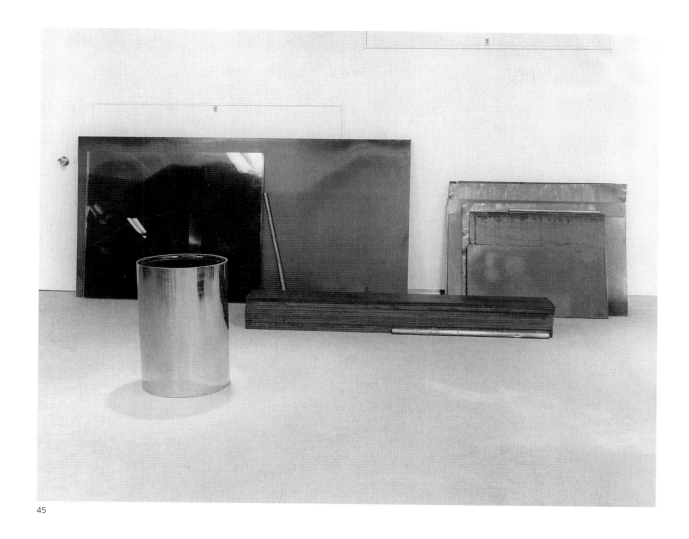

45

45
Untitled
1972
Temporary reproducible work I
Temporäre, wiederherstellbare Arbeit
Steel plates, plexiglas, oil, and sheet lead I
Stahlplatten, Plexiglas, Öl und Bleiblech
120 x 370 x 220 cm
Certificate with instructions and signature held by I
Zertifikat mit Konstruktionsanleitung und Signatur
im Besitz der Akira Ikeda Gallery, Japan

Exhibition I Ausstellung
1972 *Sinkers and Springs*, American Center Tokyo

Bibliography
Toshiaki Minemura, "Composition of Photographs:
Contemporary Art '72", in *Bijutsu-Techo*, Yearbook
(January 1973): 41–109
Matter and Perception (see No. 9): Cat. 72-3

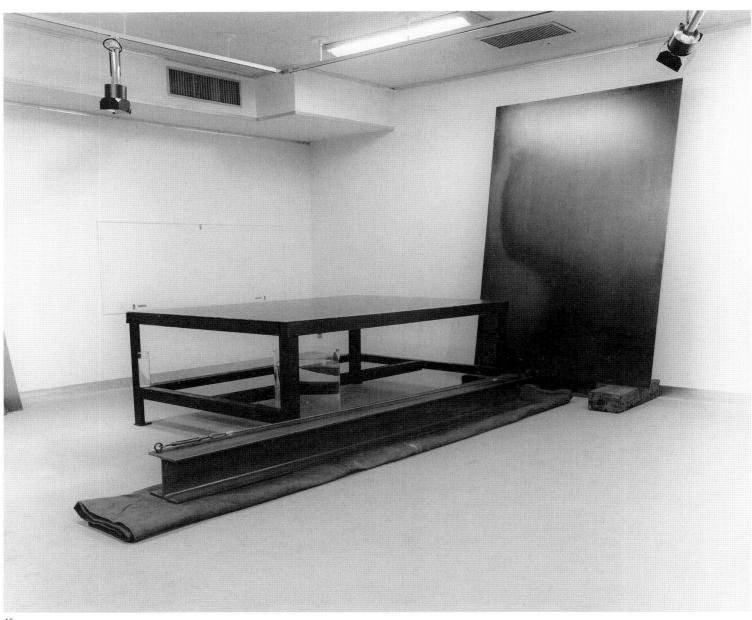

46

46
Untitled
1972
Reproduced in 1995 I 1995 wiederhergestellt
Steel, plexiglas, water, wood, steel plate, canvas
sheet, steel I-beam, and steel cable I Stahl,
Plexiglas, Wasser, Holz, Stahlplatte, Leinwandtuch,
I-Träger aus Stahl und Drahtseil
224 x 219 x 450 cm
Akira Ikeda Gallery, Japan

Exhibitions I Ausstellungen
1972 *Sinkers and Springs*, American Center Tokyo
1995 Hotel & Art AMBIK Contemporary Art, Atami

Bibliography
Haraguchi, 1970–1977 (see No. 39)
Matter and Perception (see No. 9): Cat. 72-4

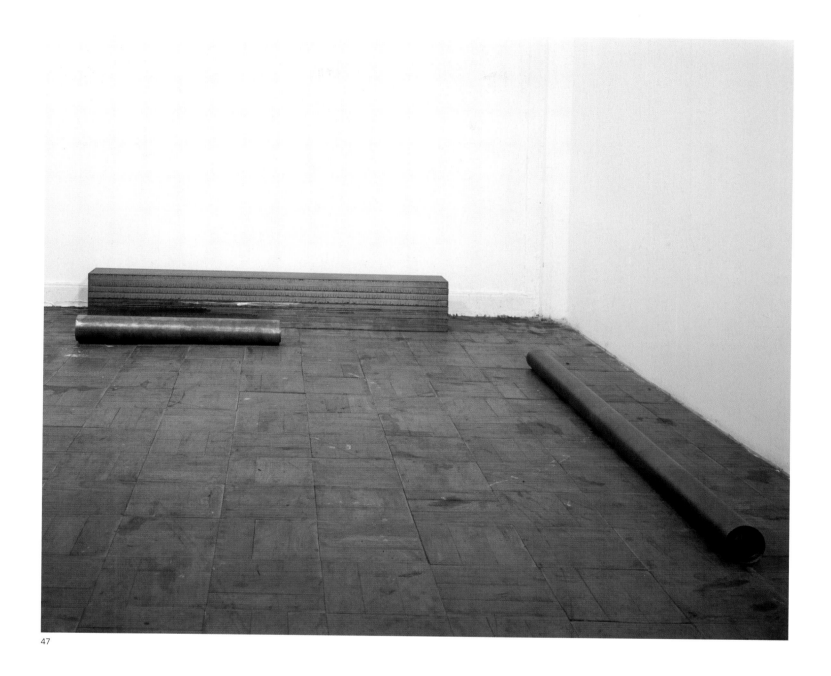

47

47
Untitled (or Iron Plate)
1972
Steel plates and sheet lead I Stahlplatten
und Bleiblech
Eight steel plates, each I Acht Stahlplatten jeweils:
180 x 25 x 3 cm
Two rolls of lead I Zwei Blechrollen: 13 x 100 x 13 cm,
10 x 250 x 10 cm
Gallery Gen, Tokyo

Exhibition I Ausstellung
1972 Gin Gallery, Tokyo

Bibliography
Matter and Perception (see No. 9): Cat. 72-5

48

48
Untitled
1973
Temporary work I Temporäre Arbeit
Canvas sheets I Leinwandtücher
230 x 500 cm

Exhibition I Ausstellung
1973 Gallery Iteza, Kyoto

Bibliography
"Review", in *Bijutsu-Techo* (April 1973): 308
Matter and Perception (see No. 9): Cat. 73-1

50, 49

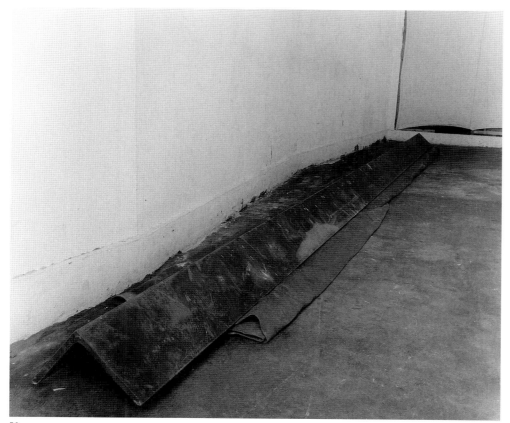

50

49
Untitled (Wall · Sheet)
1973
Temporary work I Temporäre Arbeit
Canvas sheets I Leinwandtücher
Two pieces I Zwei Teile: 260 x 260 cm, 240 x 270 cm

Exhibition I Ausstellung
1973 Tamura Gallery, Tokyo

Bibliography
"Contemporary Art '73: Record of Works", in *Bijutsu-Techo* (December 1973): 211–242
Matter and Perception (see No. 9): Cat. 73-2

50
Untitled
1973
Canvas sheet and angle steel I Leinwandtuch
und Winkelstahl
400 cm
Private Collection I Privatsammlung, Japan

Exhibition I Ausstellung
1973 Tamura Gallery, Tokyo

Bibliography
"Contemporary Art '73" (see No. 49)
Matter and Perception (see No. 9): Cat. 73-3
Miyako Okubo, in *Japon 1970. Matière et perception.
Le Mono-ha et la recherche des fondements de
l'art* (Musée d'Art moderne de Saint-Etienne, 1996):
28–33

51
Bussei
1973
Reproduced in 1995 | 1995 wiederhergestellt
Steel, steel cable, and plexiglas pole | Stahl, Drahtseil
und Plexiglasstab
Steel table | Stahltisch: 70 x 180 x 150 cm
Pole | Stab: 4 x 150 x 4 cm
Akira Ikeda Gallery, Japan

Exhibitions | Ausstellungen
1973 *8th Japan Art Festival*, Central Art Museum,
Tokyo (Award of Excellence)
1995 Hotel & Art AMBIK Contemporary Art, Atami

Bibliography
Matter and Perception (see No. 9): Cat. 73-4

52
Untitled
1973
Reproduced in 1995 | 1995 wiederhergestellt
Steel, plexiglas, and oil | Stahl, Plexiglas und Öl
110 x 150 x 180 cm
Akira Ikeda Gallery, Japan

Exhibitions | Ausstellungen
1976 *The Biennale of Sydney*, Art Gallery
of New South Wales, Sydney
1995 Hotel & Art AMBIK Contemporary Art, Atami

Bibliography
Matter and Perception (see No. 9): Cat. 73-5

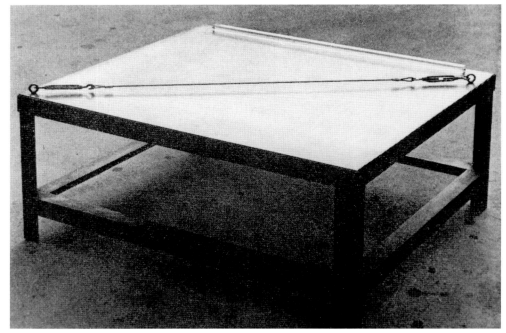
51

53

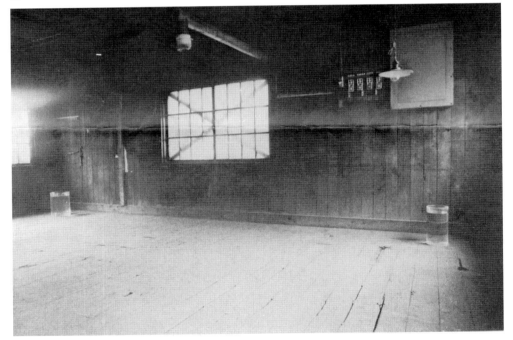

54

53
Untitled (Yokosuka)
1973
Temporary work l Temporäre Arbeit
Oil in a depression of concrete foundations l
Öl in einer Vertiefung von betonierten Fundamenten
4 x 8 m

Exhibition l Ausstellung
1973 *Ten-Ten (Exhibition of Points)*, Taura Sea Port,
Yokosuka

Bibliography
Matter and Perception (see No. 9): Cat. 73-6

54
Yokosuka
1973
Temporary work l Temporäre Arbeit
Plexiglas and water in a shack l Plexiglas und Wasser
in einer Baracke
Room size l Raumgröße: 7 x 7 m

Exhibition l Ausstellung
1973 *Ten-Ten (Exhibition of Points)*, Taura Sea Port,
Yokosuka

Bibliography
Matter and Perception (see No. 9): Cat. 73-7

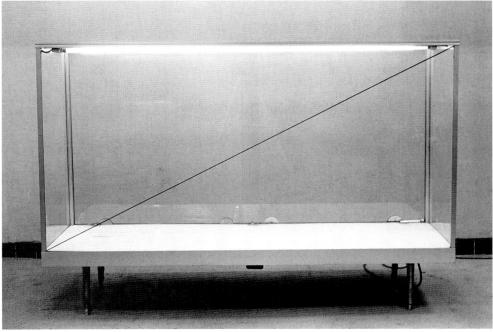

55

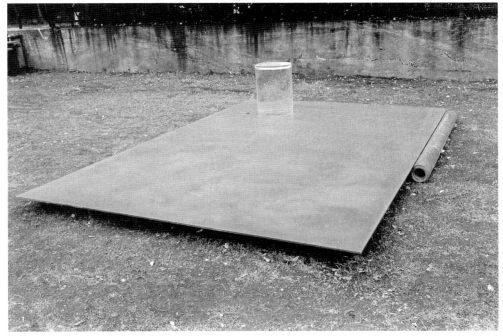

56

55
Untitled
1973
Temporary work I Temporäre Arbeit
Showcase and black tape I Vitrine und
schwarzes Klebeband
120 x 150 x 50 cm

Exhibition I Ausstellung
1973 *Dimensions and Situations*,
Kinokuniya Gallery, Tokyo

Bibliography
Matter and Perception (see No. 9): Cat. 73-8

56
Positioning of Matter (or Materiality)
1973
Temporary work I Temporäre Arbeit
Steel plate, plexiglas, water, and sheet lead I
Stahlplatte, Plexiglas, Wasser und Bleiblech
60 x 210 x 400 cm

Exhibition I Ausstellung
1973 *1st Hakone Open-Air Museum Exhibition*,
Hakone Open-Air Museum

Bibliography
Matter and Perception (see No. 9): Cat. 73-9

57

57
Cylinder 1, 2, 3
1973
Temporary work I Temporäre Arbeit
Plexiglas and oil I Plexiglas und Öl
Three pieces, each I Drei Teile jeweils: 190 x Ø 80 cm

Exhibition I Ausstellung
1973 *5th Modern Sculpture of Japan Exhibition*,
Tokiwa Park, Ube

Bibliography
Joseph Love, "Field Spatial Dialogue", in *Mizue* 823
(November 1973): 15–22
Matter and Perception (see No. 9): Cat. 73-10

58
Untitled
1974
Reproduced in 1995 I 1995 wiederhergestellt
Wood, steel plate, steel, oil, canvas sheet,
and steel I-beam I Holz, Stahlplatte, Stahl, Öl,
Leinwandtuch und I-Träger aus Stahl
Circa 270 x 300 x 500 cm
Collection of the artist I Besitz des Künstlers

Exhibitions I Ausstellungen
1974 *Japan. Tradition und Gegenwart*,
Städtische Kunsthalle Düsseldorf
1995 Hotel & Art AMBIK Contemporary Art, Atami

Bibliography
Haraguchi, 1970–1993 (see No. 29): Cat. 5

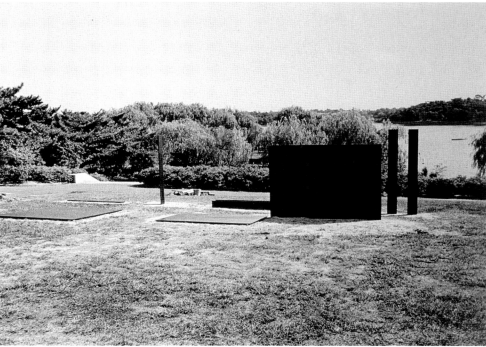

60

59
Untitled
1974–80/1994–95
Temporary work I Temporäre Arbeit
Canvas sheets and wood I Leinwandtücher und Holz
50 x 400 x 700 cm

Two wooden boxes, covered with canvas sheets
and arranged on the floor I Zwei auf dem Boden
stehende Holzkisten, an denen Tücher aus Leinwand
befestigt waren

Exhibitions I Ausstellungen
1994 *Mono-ha*, Kamakura Gallery, Tokyo (with I mit
Noboru Takayama)
1995 Hotel & Art AMBIK Contemporary Art, Atami

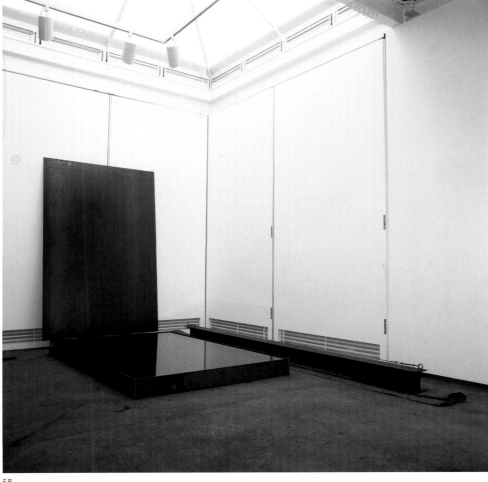

60
Untitled
1975
Temporary work I Temporäre Arbeit
Iron plates I Eisenplatten
Installation I Gesamte Aufstellung: 2 x 8 x 4 m

Exhibition I Ausstellung
1975 *6th Modern Sculpture of Japan Exhibition*,
Tokiwa Park, Ube

61
Untitled A
1975
Temporary work I Temporäre Arbeit
Black tape on a wall I Schwarzes Klebeband
an einer Wand
1380 x 480 cm

Exhibition I Ausstellung
1975 *From Method to Method*, Yokohama
Prefectural Hall Gallery

62
Untitled B
1975
Temporary work I Temporäre Arbeit
Canvas sheets I Leinwandtücher
1380 x 480 cm

Exhibition I Ausstellung
1975 *From Method to Method*, Yokohama
Prefectural Hall Gallery

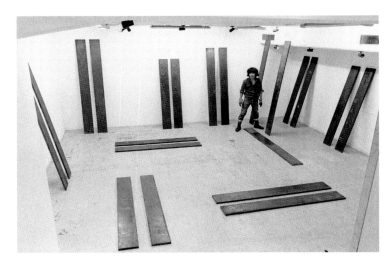 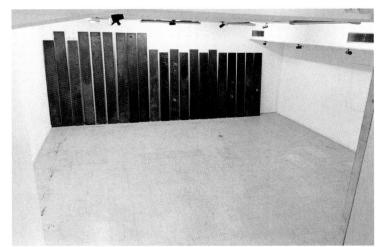

 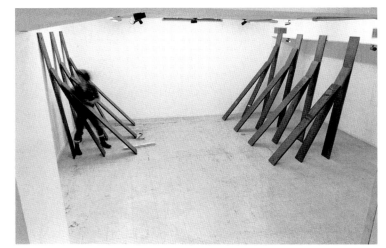

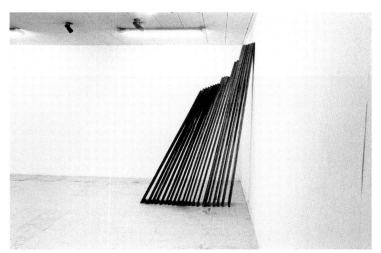 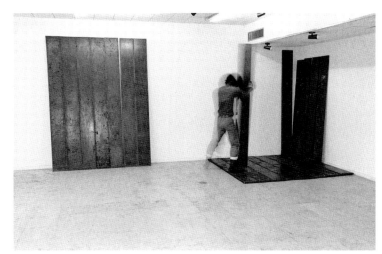

63 (1975)

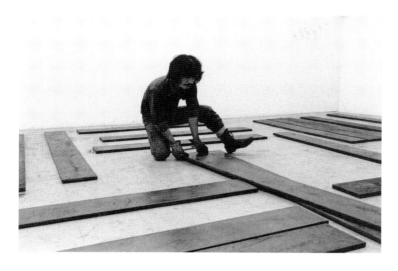

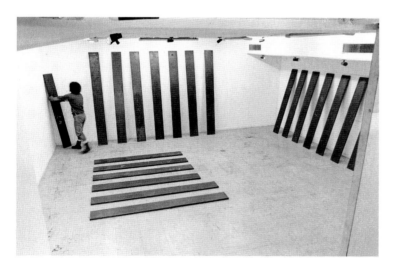

63
Event of the Transfer of Steel
1975–76
Repeated in 1995 I 1995 wiederaufgenommen
Event with steel plates I Aktion mit Stahlplatten
Twenty-seven plates (1975–76) and forty plates (1995),
each I Siebenundzwanzig (1975–76) beziehungsweise
vierzig (1995) Platten jeweils: 180 x 22.5 x 2.4 cm
All steel plates I Sämtliche Stahlplatten: Akira Ikeda
Gallery, Japan

Performances I Aufführungen
1975 Nirenoko Gallery, Tokyo
1976 Maki Gallery, Tokyo
1995 Hotel & Art AMBIK Contemporary Art, Atami

Bibliography
documenta 6 (Kassel, 1977), vol. 1: 186–187

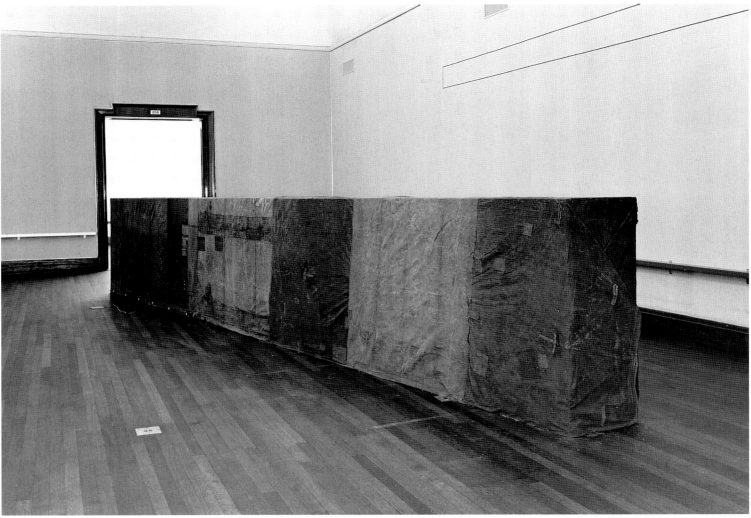

64

64
Title (from Tamura Gallery)
1976
Temporary work I Temporäre Arbeit
Canvas sheets on wood and black tape attached
to a wall I Leinwandtücher über Holz und schwarzes
Klebeband an einer Wand
Canvas object I Leinwandgebilde: 160 x 1200 x 60 cm
Tape I Klebeband: 60 x 1200 cm

Exhibition I Ausstellung
1976 *Kyoto Biennale '76*, Kyoto Municipal Art
Museum

65
Bussei
1977
Iron and oil I Eisen und Öl
30 x 700 x 900 cm
Tehran Museum of Contemporary Art

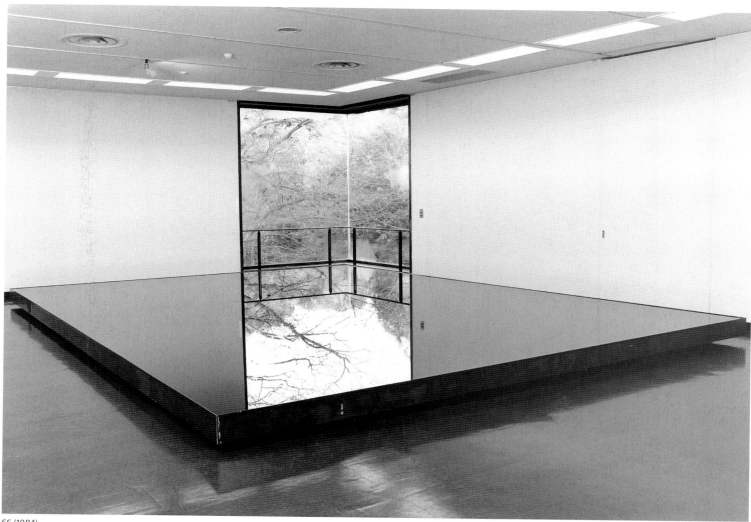

66 (1984)

66
Matter and Mind
(formerly I vormals: Busshitsu (Matter)/Relationship)
1977
Reproduced in 1984 I 1984 wiederhergestellt
Steel, oil, and steel plates I Stahl, Öl und Stahlplatten
Pool of oil I Ölwanne: 18 x 550 x 750 cm
Akira Ikeda Gallery, Japan

Exhibitions I Ausstellungen
1977 *documenta 6*, Kassel (Cat., vol. 1: 186)
1984 *Trends of Contemporary Japanese Art,*
1970–1984: Universality/Individuality,
Tokyo Metropolitan Art Museum (Cat.: 74)
1987 Hoffman Borman Gallery, Santa Monica
1988 San Diego State University Art Gallery
1993 *Noriyuki Haraguchi: Matter and Mind*,
Akira Ikeda Gallery, New York (Cat. 6a–d
in *Noriyuki Haraguchi, 1970–1993*)

Bibliography
Noriyuki Haraguchi: Works 1981–1986
(Akira Ikeda Gallery, Nagoya, 1986)

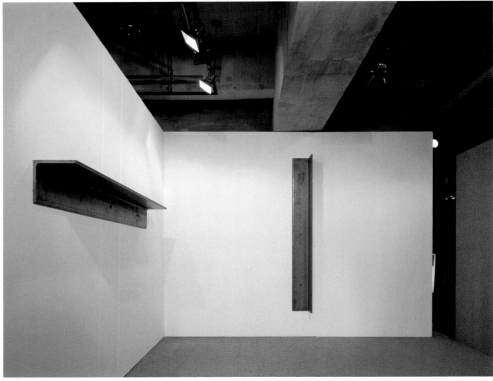

67

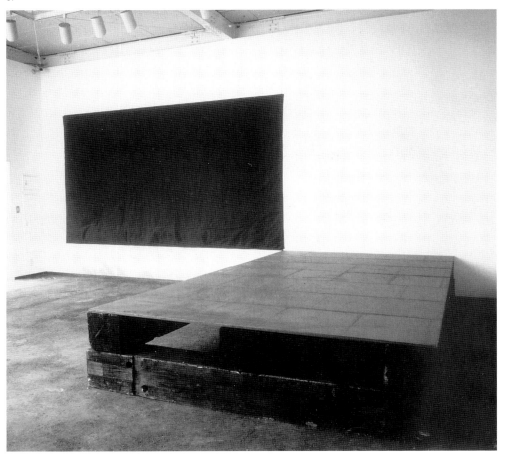

68

67
Matter (documenta 6)
1977
Reproduced in 1991 I 1991 wiederhergestellt
Angle steel I Winkelstahl
Two pieces I zwei Teile: 20 x 20 x 400 cm,
300 x 20 x 20 cm
Collection of the artist I Besitz des Künstlers

Exhibitions I Ausstellungen
1977 *documenta 6*, Kassel (not in Cat.)
1991 *70s–80s Contemporary Art*, Kamakura Gallery,
Tokyo

68
Steel and Sheet
1977
Reproduced in 1995 I 1995 wiederhergestellt
Sheet, wood, and iron plates I Tuch, Holz
und Eisenplatten
Wood and iron I Holz und Eisen: 60 x 240 x 420 cm
Sheet I Tuch: 210 x 420 cm
Akira Ikeda Gallery, Japan

Exhibitions I Ausstellungen
1978 Galerie Alfred Schmela, Düsseldorf
1995 Hotel & Art AMBIK Contemporary Art, Atami

69
Horizontal & Vertical
1977
Reproduced in 1995 I 1995 wiederhergestellt
Iron, oil, and iron plate(s; 1977) I Eisen, Öl
und Eisenplatte(n; 1977)
Pool of oil I Ölwanne: 28 x 246 x 490 cm (1995)
Iron plate I Eisenplatte: 246 x 246 x 1.2 cm (1995)
Installation: 351.5 x 246 x 490 cm (1995)
Akira Ikeda Gallery, Japan

Exhibitions I Ausstellungen
1977 *Biennale de Paris*, Musée national
d'art moderne, Paris (Cat.: 46–47)
1995 Hotel & Art AMBIK Contemporary Art, Atami
1995 Akira Ikeda Gallery, Nagoya (Cat.)

Bibliography
Haraguchi, 1970–1993 (see No. 29): Cat. 7

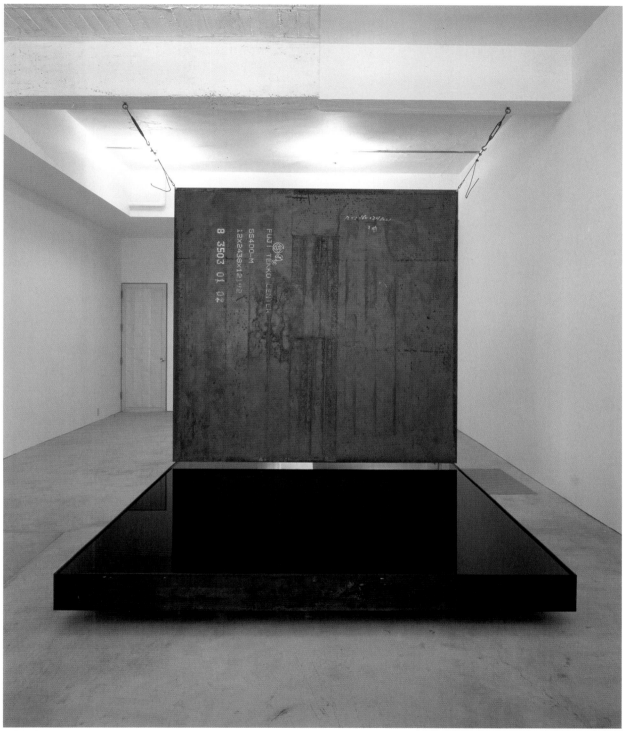

69 (1995)

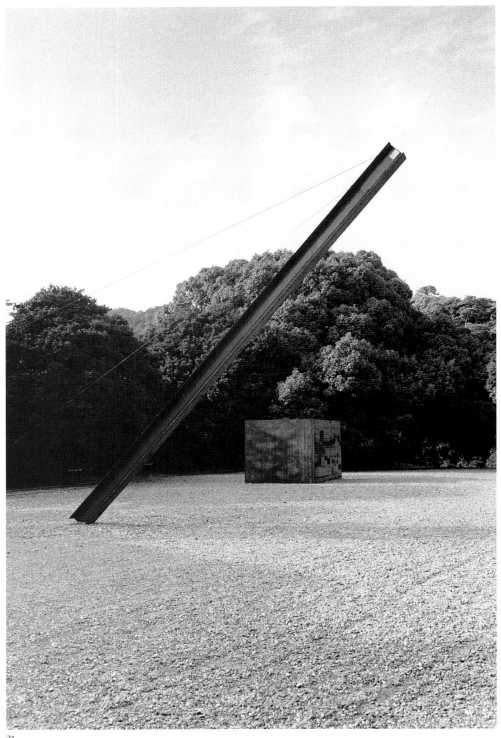

71

70
Work SP-5
1978
Temporary work I Temporäre Arbeit
Steel I Stahl
Ø 250 cm, ring width I Ringstärke 3 cm

Exhibition I Ausstellung
1979 Sakura Gallery, Nagoya

71
Untitled
1978
Steel I-beam and steel cable I I-Träger aus Stahl
und Drahtseil
I-beam I I-Träger: 900 x 40 x 40 cm
Steel cable I Drahtseil: 40 m
Private collection I Privatsammlung, Japan

Exhibition I Ausstellung
1978 *6th Contemporary Sculpture Exhibition*,
Suma Detached Palace Garden, Kobe

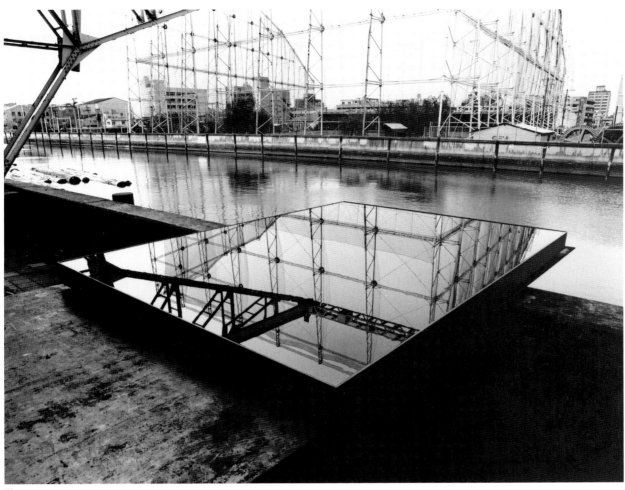

72

72
Matter (Kiba) No. 7
1978
Temporary reproducible work I
Temporäre, wiederherstellbare Arbeit
Steel and oil I Stahl und Öl
27 x 300 x 400 cm
Certificate with instructions and signature
held by artist I Zertifikat mit Konstruktionsanleitung
und Signatur im Besitz des Künstlers

Presentation I Präsentation
1978 installed in a factory in Kiba, Tokyo I aufgestellt
in einer Fabrik in Kiba, Tokyo

Bibliography
Ryukou Tsushin
Haraguchi, 1970–1993 (see No. 29): Kat. 8

75

73
Untitled (a)
1978
Temporary reproducible work |
Temporäre, wiederherstellbare Arbeit
Aluminium honeycomb panels |
Verbundplatten aus Aluminium mit Wabenkern
240 x 240 x 10 cm
Certificate with instructions and signature
held by artist | Zertifikat mit Konstruktionsanleitung
und Signatur im Besitz des Künstlers

Exhibition | Ausstellung
1979 Sakura Gallery, Nagoya

Bibliography
Haraguchi, 1970–1993 (see No. 29): Cat. 9

74
Work S-3
1978
Temporary reproducible work |
Temporäre, wiederherstellbare Arbeit
Aluminium honeycomb panels |
Verbundplatten aus Aluminium mit Wabenkern
180 x 180 x 10 cm
Certificate with instructions and signature
held by artist | Zertifikat mit Konstruktionsanleitung
und Signatur im Besitz des Künstlers

Exhibition | Ausstellung
1979 Sakura Gallery, Nagoya

Bibliography
Haraguchi, 1970–1993 (see No. 29): Cat. 10

75
Untitled
1979
Polyurethane on aluminium honeycomb panel |
Polyurethan auf Verbundplatte aus Aluminium
mit Wabenkern
180 x 90 cm
Akira Ikeda Gallery, Japan

Exhibitions | Ausstellungen
1992 *Nagoya Contemporary Art Fair V*,
Nagoya City Gallery
2001 *In Time*, Akira Ikeda Gallery, Taura, Yokosuka

76

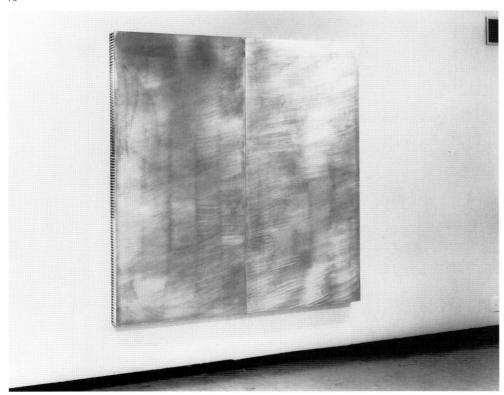

74

76
Work
1979
Polyurethane on aluminium honeycomb panel I
Polyurethan auf Verbundplatte aus Aluminium
mit Wabenkern
122 x 122 x 12.5 cm
Collection of the artist I Besitz des Künstlers

Exhibitions I Ausstellungen
1979 Koh Gallery, Tokyo
1980 Annely Juda Fine Art, London

Bibliography
Haraguchi, 1970–1993 (see No. 29): Cat. 11

77
Untitled
1979
Polyurethane on aluminium honeycomb panel I
Polyurethan auf Verbundplatte aus Aluminium
mit Wabenkern
120 x 113 x 10.5 cm
Collection of the artist I Besitz des Künstlers

Exhibitions I Ausstellungen
1980 Annely Juda Fine Art, London
1985 Karin Bolz Galerie, Mülheim an der Ruhr

78
Untitled Cat. 2
1979
Polyurethane on aluminium honeycomb panels I
Polyurethan auf Verbundplatten aus Aluminium
mit Wabenkern
220 x 220 x 10 cm
Collection of the artist I Besitz des Künstlers

Exhibitions I Ausstellungen
1980 Annely Juda Fine Art, London
1981 Sakura Gallery, Nagoya

79
Work S-2
1979
Polyurethane on aluminium honeycomb panel I
Polyurethan auf Verbundplatte aus Aluminium
mit Wabenkern
30 x 240 x 10 cm
Collection of the artist I Besitz des Künstlers

Exhibition I Ausstellung
1981 Sakura Gallery, Nagoya

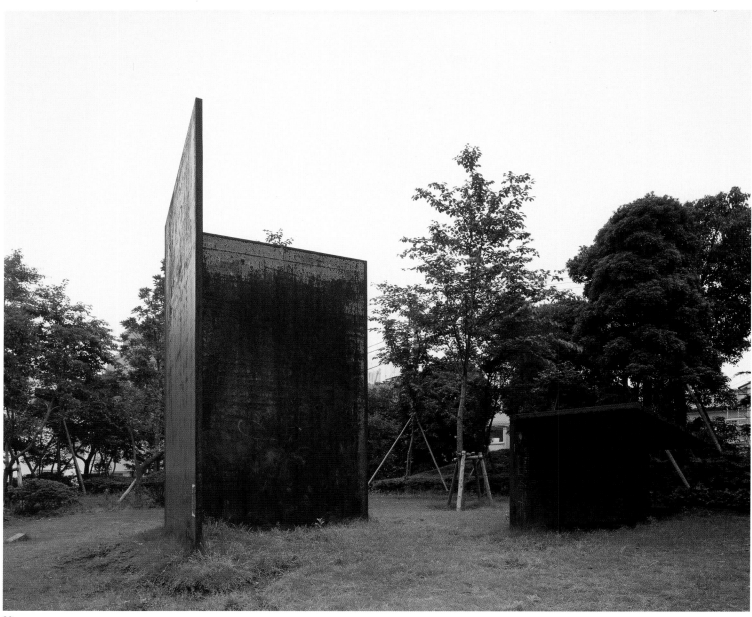

80

80
Protyle-Process
1980
Destroyed I Zerstört
Corten steel I Corten-Stahl
Two pieces I Zwei Teile: 350 x 240 x 240 cm,
120 x 120 x 700 cm
Formerly I Ehemals Showa University Hospital, Tokyo

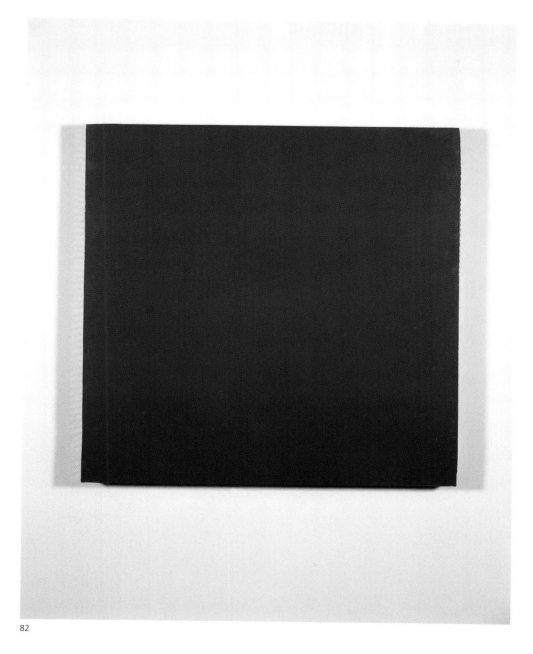

81
Untitled
1980
Polyurethane on aluminium honeycomb panel I
Polyurethan auf Verbundplatte aus Aluminium
mit Wabenkern
122 x 122 x 10 cm
Collection of the artist I Besitz des Künstlers

82
Untitled
1980
Green polyurethane on aluminium honeycomb panel I
Grünes Polyurethan auf Verbundplatte aus Aluminium
mit Wabenkern
122 x 123 x 11 cm
Private collection I Privatsammlung, Japan

82

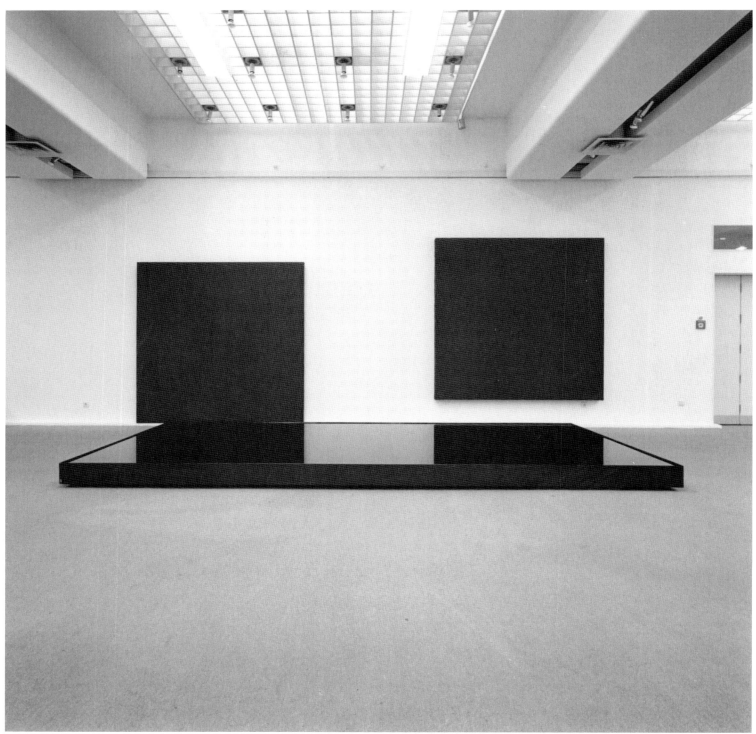

83

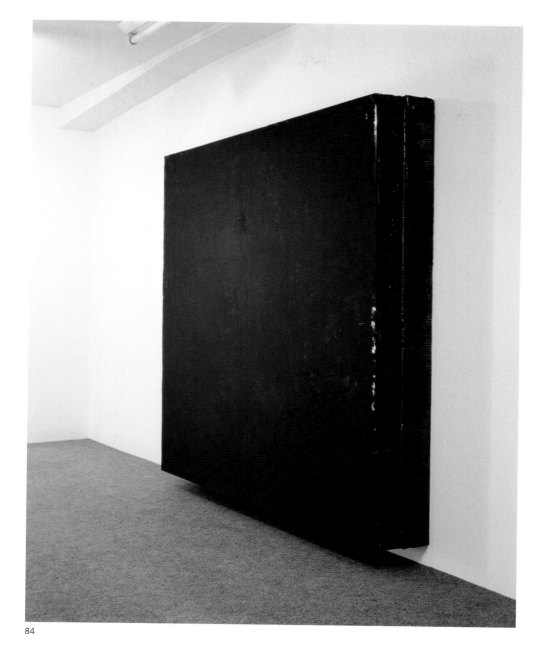

84

83
The Matter of Black 1. 2. 3.
1981
Black polyurethane on aluminium honeycomb panels, iron, and oil I Schwarzes Polyurethan auf Verbundplatten aus Aluminium mit Wabenkern, Eisen und Öl
Two coated panels I Zwei beschichtete Platten: 240 x 250 x 10 cm, 240 x 250 x 13 cm
Pool of oil I Ölwanne: 18 x 500 x 250 cm
Akira Ikeda Gallery, Japan

Exhibitions I Ausstellungen
1981 *Schwarz*, Städtische Kunsthalle Düsseldorf
2001 Galerie Hans Mayer, Berlin

Bibliography
Works 1981–1986 (see No. 66)
Haraguchi, 1970–1993 (see No. 29): Cat. 12

84
Untitled
1981
Black polyurethane on cardboard honeycomb panels I Schwarzes Polyurethan auf Verbundplatten aus Pappe mit Wabenkern
181 x 161 x 26.5 cm
Private collection I Privatsammlung, Japan

Exhibition I Ausstellung
1981 Akira Ikeda Gallery, Nagoya (not in Cat.)

85
Untitled
1981
Black polyurethane on cardboard honeycomb panels I Schwarzes Polyurethan auf Verbundplatten aus Pappe mit Wabenkern
181 x 179.5 x 23.5 cm
Private collection I Privatsammlung, Japan

Exhibition I Ausstellung
1981 Akira Ikeda Gallery, Nagoya (Cat.)

86
Untitled
1981
Black polyurethane on cardboard honeycomb panels I Schwarzes Polyurethan auf Verbundplatten aus Pappe mit Wabenkern
120 x 120 x 33 cm
Private collection I Privatsammlung, Japan

Exhibition I Ausstellung
1981 Akira Ikeda Gallery, Nagoya (Cat.)

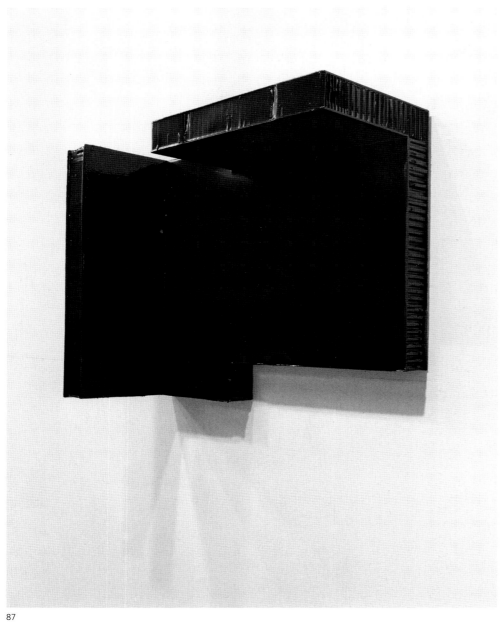

87

87
Untitled
1981
Black polyurethane on aluminium
honeycomb panels I Schwarzes Polyurethan
auf Verbundplatten aus Aluminium
mit Wabenkern
120 x 100 x 50 cm
Collection of the artist I Besitz des Künstlers

88
Untitled AA-1
1981
Green polyurethane on aluminium
honeycomb panel I Grünes Polyurethan
auf Verbundplatte aus Aluminium
mit Wabenkern
122.5 x 122.5 x 11 cm
Muzeum Sztuki w Łodzi

Exhibition I Ausstellung
1981 *Construction in Process: Art of the 70s I*
Konstrukcja w procesie. Sztuka lat 70 tych,
factory I Fabrik in Łódź

89
Untitled AA-2
1981
Green polyurethane on aluminium
honeycomb panel I Grünes Polyurethan
auf Verbundplatte aus Aluminium
mit Wabenkern
122 x 122 x 11 cm
Akira Ikeda Gallery, Japan

90
Untitled AA-3
1981
Green polyurethane on aluminium
honeycomb panel I Grünes Polyurethan
auf Verbundplatte aus Aluminium
mit Wabenkern
123 x 122.5 x 11 cm
Private collection I Privatsammlung, Japan

91
Untitled AA-4
1981
Green polyurethane on aluminium
honeycomb panel I Grünes Polyurethan
auf Verbundplatte aus Aluminium
mit Wabenkern
122.5 x 122.5 x 11 cm
Oita Art Museum

92
Untitled AA-5
1981
Green polyurethane on aluminium
honeycomb panel I Grünes Polyurethan
auf Verbundplatte aus Aluminium
mit Wabenkern
122 x 122 x 11 cm
Akira Ikeda Gallery, Japan

93
Untitled AA-6
1981
Green polyurethane on aluminium
honeycomb panel I Grünes Polyurethan
auf Verbundplatte aus Aluminium
mit Wabenkern
122 x 122 x 11 cm
Private collection I Privatsammlung, Japan

94
Untitled AA-7
1981
Green polyurethane on aluminium
honeycomb panel I Grünes Polyurethan
auf Verbundplatte aus Aluminium
mit Wabenkern
121 x 122 x 11 cm
Private collection I Privatsammlung, Japan

95
Untitled AA-8
1981
Green polyurethane on aluminium
honeycomb panel I Grünes Polyurethan
auf Verbundplatte aus Aluminium
mit Wabenkern
122 x 122 x 13 cm
Akira Ikeda Gallery, Japan

Exhibition I Ausstellung
1981 Sakura Gallery, Nagoya

96
Untitled AA-9
1981
Green polyurethane on aluminium
honeycomb panel I Grünes Polyurethan
auf Verbundplatte aus Aluminium
mit Wabenkern
122.5 x 123 x 13 cm
Muzeum Sztuki w Łodzi

Exhibition I Ausstellung
1981 *Construction in Process: Art of the 70s I*
Konstrukcja w procesie. Sztuka lat 70 tych,
factory I Fabrik in Łódź

97
Untitled AA-10
1981
Green polyurethane on aluminium
honeycomb panel I Grünes Polyurethan
auf Verbundplatte aus Aluminium
mit Wabenkern
112 x 112.5 x 13.5 cm
Private collection I Privatsammlung, Japan

Exhibition I Ausstellung
1981 Sakura Gallery, Nagoya

98
Untitled, AA-11
1981
Green polyurethane on aluminium
honeycomb panel I Grünes Polyurethan
auf Verbundplatte aus Aluminium
mit Wabenkern
122.5 x 122.5 x 13.5 cm
Private collection I Privatsammlung, Japan

99
Untitled AA-12
1981
Green polyurethane on aluminium
honeycomb panel I Grünes Polyurethan
auf Verbundplatte aus Aluminium
mit Wabenkern
122.5 x 122.5 x 13.5 cm
Private collection I Privatsammlung, Japan

Exhibition I Ausstellung
1981 Sakura Gallery, Nagoya

100
Untitled AA-13
1981
Green polyurethane on aluminium
honeycomb panel I Grünes Polyurethan
auf Verbundplatte aus Aluminium
mit Wabenkern
122 x 123 x 13.5 cm
Akira Ikeda Gallery, Japan

Exhibition I Ausstellung
1981 Sakura Gallery, Nagoya

101
Untitled AA-14
1981
Green polyurethane on aluminium
honeycomb panel I Grünes Polyurethan
auf Verbundplatte aus Aluminium
mit Wabenkern
122 x 122 x 13 cm
Private collection I Privatsammlung, Japan

Exhibition I Ausstellung
1981 Sakura Gallery, Nagoya

102
Untitled AA-15
1981
Green polyurethane on aluminium
honeycomb panel I Grünes Polyurethan
auf Verbundplatte aus Aluminium
mit Wabenkern
122 x 122 x 13.5 cm
Private collection I Privatsammlung, Japan

Exhibition I Ausstellung
1981 Sakura Gallery, Nagoya

103
Untitled AA-16
1981
Green polyurethane on aluminium
honeycomb panel I Grünes Polyurethan
auf Verbundplatte aus Aluminium
mit Wabenkern
116.5 x 122 x 13.5 cm
Private collection I Privatsammlung, Japan

Exhibition I Ausstellung
1981 Sakura Gallery, Nagoya

104
Untitled AA-17
1981
Green polyurethane on aluminium
honeycomb panel I Grünes Polyurethan
auf Verbundplatte aus Aluminium
mit Wabenkern
111 x 111 x 21 cm
Akira Ikeda Gallery, Japan

Exhibition I Ausstellung
1981 Sakura Gallery, Nagoya

105
Untitled AA-18
1981
Green polyurethane on aluminium
honeycomb panel I Grünes Polyurethan
auf Verbundplatte aus Aluminium
mit Wabenkern
101 x 100 x 19 cm
Akira Ikeda Gallery, Japan

Exhibition I Ausstellung
1981 Sakura Gallery, Nagoya

106
Untitled BA-19
1981
Green polyurethane on aluminium
honeycomb panel I Grünes Polyurethan
auf Verbundplatte aus Aluminium
mit Wabenkern
121.5 x 126 x 10.5 cm
Private collection I Privatsammlung, Japan

107
Untitled BA-20
1981
Green polyurethane on aluminium
honeycomb panel | Grünes Polyurethan
auf Verbundplatte aus Aluminium
mit Wabenkern
117.5 x 122 x 11 cm
Private collection | Privatsammlung, Japan

108
Untitled BA-21
1981
Green polyurethane on aluminium
honeycomb panel | Grünes Polyurethan
auf Verbundplatte aus Aluminium
mit Wabenkern
122 x 123.5 x 11 cm
Private collection | Privatsammlung, Japan

109
Untitled BA-22
1981
Green polyurethane on aluminium
honeycomb panel | Grünes Polyurethan
auf Verbundplatte aus Aluminium
mit Wabenkern
119.5 x 110.5 x 11 cm
Private collection | Privatsammlung, Japan

110
Untitled BA-23
1981
Green polyurethane on aluminium
honeycomb panel | Grünes Polyurethan
auf Verbundplatte aus Aluminium
mit Wabenkern
122 x 130 x 11 cm
Private collection | Privatsammlung, Japan

111
Untitled BA-24
1981
Green polyurethane on aluminium
honeycomb panel | Grünes Polyurethan
auf Verbundplatte aus Aluminium
mit Wabenkern
113.5 x 115.5 x 11 cm
Private collection | Privatsammlung, Japan

112
Untitled BA-25
1981
Green polyurethane on aluminium
honeycomb panel | Grünes Polyurethan
auf Verbundplatte aus Aluminium
mit Wabenkern
119.5 x 111 x 21.5 cm
Private collection | Privatsammlung, Japan

113
Untitled BA-26
1981
Green polyurethane on aluminium
honeycomb panel | Grünes Polyurethan
auf Verbundplatte aus Aluminium
mit Wabenkern
121 x 127 x 21.5 cm
Private collection | Privatsammlung, Japan

114
Untitled BA-27
1981
Green polyurethane on aluminium
honeycomb panel | Grünes Polyurethan
auf Verbundplatte aus Aluminium
mit Wabenkern
122.5 x 108 x 21.5 cm
Akira Ikeda Gallery, Japan

115
Untitled BC-28
1981
Black polyurethane on aluminium
honeycomb panel | Schwarzes Polyurethan
auf Verbundplatte aus Aluminium
mit Wabenkern
120.5 x 127.5 x 11.5 cm
Akira Ikeda Gallery, Japan

116
Untitled AD-29
1981
Black polyurethane on aluminium
honeycomb panel | Schwarzes Polyurethan
auf Verbundplatte aus Aluminium
mit Wabenkern
122 x 122 x 11 cm
Private Collection | Privatsammlung, Japan

Exhibitions | Ausstellungen
1981 Sakura Gallery, Nagoya
1992 *Joseph Beuys, Piero Manzoni, Noriyuki
Haraguchi*, Akira Ikeda Gallery, Tokyo (Cat.)

117
Untitled AC-30
1981
Black polyurethane on aluminium
honeycomb panel | Schwarzes Polyurethan
auf Verbundplatte aus Aluminium
mit Wabenkern
122 x 122.5 x 13.5 cm
Akira Ikeda Gallery, Japan

118
Untitled AD-31
1981
Black polyurethane on aluminium
honeycomb panel I Schwarzes Polyurethan
auf Verbundplatte aus Aluminium
mit Wabenkern
122.5 x 122.5 x 13 cm
Akira Ikeda Gallery, Japan

Exhibition I Ausstellung
1981 Sakura Gallery, Nagoya

119
Untitled AC-32
1981
Black polyurethane on aluminium
honeycomb panel I Schwarzes Polyurethan
auf Verbundplatte aus Aluminium
mit Wabenkern
122.5 x 122.5 x 14 cm
Akira Ikeda Gallery, Japan

120
Untitled AC-33
1981
Black polyurethane on aluminium
honeycomb panel I Schwarzes Polyurethan
auf Verbundplatte aus Aluminium
mit Wabenkern
122.5 x 122.5 x 14 cm
Akira Ikeda Gallery, Japan

121
Untitled BC-34
1981
Black polyurethane on aluminium
honeycomb panel I Schwarzes Polyurethan
auf Verbundplatte aus Aluminium
mit Wabenkern
125 x 123 x 21 cm
Akira Ikeda Gallery, Japan

122
Untitled BD-35
1981
Black polyurethane on aluminium
honeycomb panel I Schwarzes Polyurethan
auf Verbundplatte aus Aluminium
mit Wabenkern
121 x 128 x 21.5 cm
Akira Ikeda Gallery, Japan

123
Untitled CA-36
1981
Green polyurethane on aluminium
honeycomb panel I Grünes Polyurethan
auf Verbundplatte aus Aluminium
mit Wabenkern
183 x 183 x 11 cm
Akira Ikeda Gallery, Japan

Bibliography
Haraguchi, 1970–1993 (see No. 29): Cat. 13

124
Untitled CA-37
1981
Green polyurethane on aluminium
honeycomb panel I Grünes Polyurethan
auf Verbundplatte aus Aluminium
mit Wabenkern
183 x 183 x 15.5 cm
Akira Ikeda Gallery, Japan

125
Untitled CA-38a
1981
Green polyurethane on aluminium
honeycomb panel I Grünes Polyurethan
auf Verbundplatte aus Aluminium
mit Wabenkern
183 x 183 x 11 cm
Akira Ikeda Gallery, Japan

126
Untitled CA-39a
1981
Green polyurethane on aluminium
honeycomb panel I Grünes Polyurethan
auf Verbundplatte aus Aluminium
mit Wabenkern
183 x 183 x 14 cm
Akira Ikeda Gallery, Japan

127
Untitled CD-40
1981
Black polyurethane on aluminium
honeycomb panel I Schwarzes Polyurethan
auf Verbundplatte aus Aluminium
mit Wabenkern
183 x 183 x 14 cm
Akira Ikeda Gallery, Japan

128
Untitled CD-41
1981
Black polyurethane on aluminium
honeycomb panel I Schwarzes Polyurethan
auf Verbundplatte aus Aluminium
mit Wabenkern
183 x 183 x 14 cm
Akira Ikeda Gallery, Japan

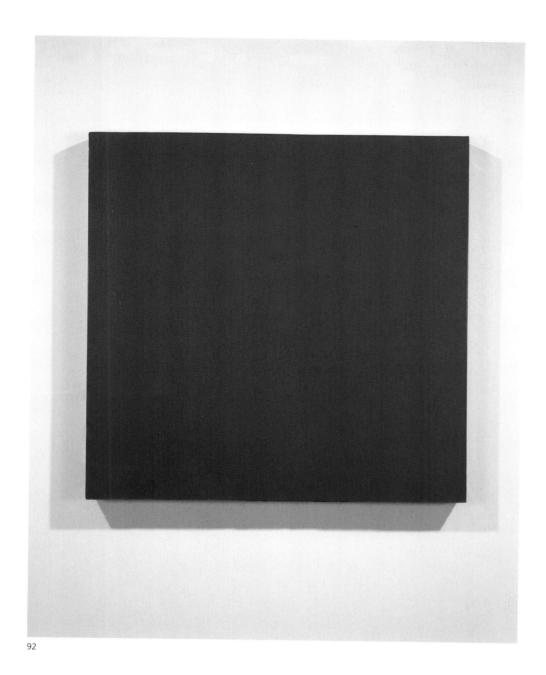

92

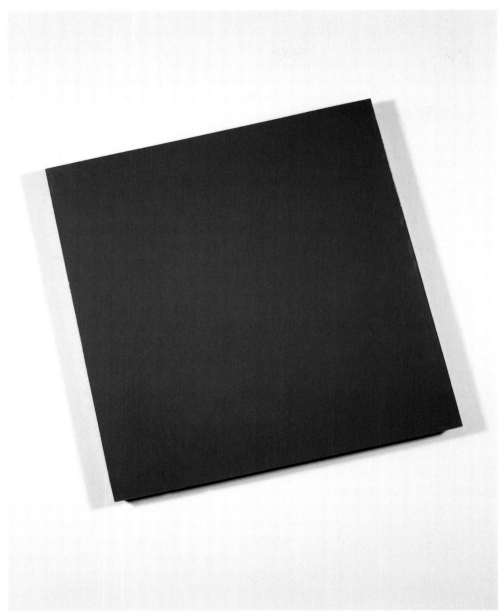

98

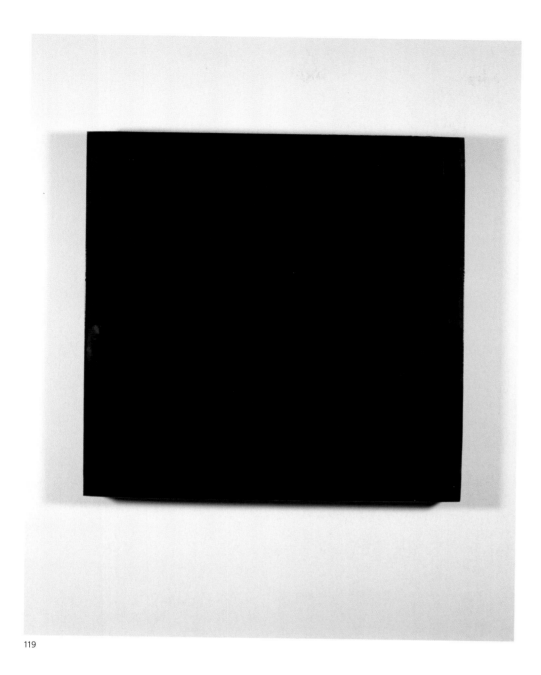

119

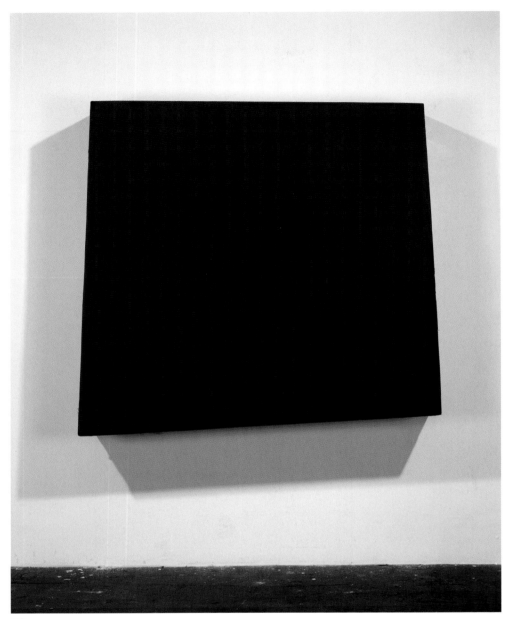

122

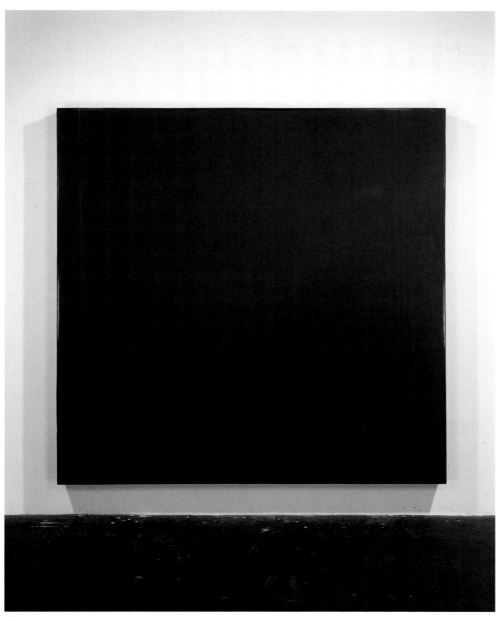

127

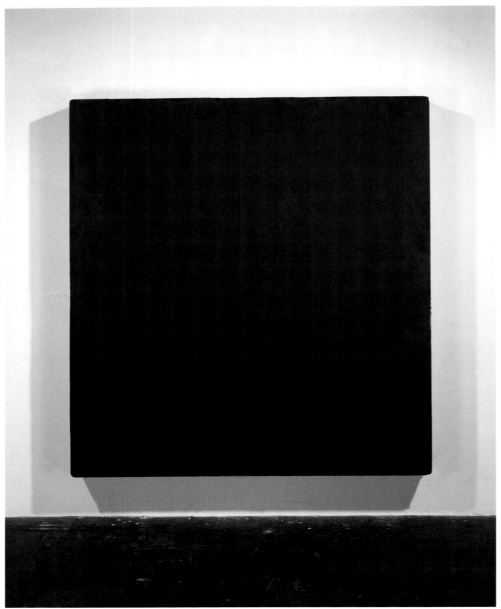

133

129
Untitled
1982
Polyurethane on aluminium honeycomb panel |
Polyurethan auf Verbundplatte aus Aluminium
mit Wabenkern
200 x 200 x 2.5 cm
Akira Ikeda Gallery, Japan

Exhibition | Ausstellung
1982 *A Panorama of Contemporary Art in Japan*,
The Museum of Modern Art, Toyama

130
Untitled
1982
Polyurethane on aluminium honeycomb panel |
Polyurethan auf Verbundplatte aus Aluminium
mit Wabenkern
200 x 200 x 2.5 cm
Akira Ikeda Gallery, Japan

Exhibition | Ausstellung
1982 *A Panorama of Contemporary Art in Japan*,
The Museum of Modern Art, Toyama

131
Untitled
1982
Green polyurethane on aluminium
honeycomb panel | Grünes Polyurethan
auf Verbundplatte aus Aluminium
mit Wabenkern
180 x 180 x 16 cm
Kröller-Müller Museum, Otterlo

Exhibitions | Ausstellungen
1982 Akira Ikeda Gallery, Tokyo
1985 *Summer Show: Frank Stella, Richard Serra,
Jean-Michel Basquiat, Anselm Kiefer, Noriyuki
Haraguchi*, Akira Ikeda Gallery, Tokyo

132
Untitled
1982
Black polyurethane on aluminium
honeycomb panel | Schwarzes Polyurethan
auf Verbundplatte aus Aluminium
mit Wabenkern
240 x 240 x 6.5 cm
Akira Ikeda Gallery, Japan

Exhibitions | Ausstellungen
1982 Akira Ikeda Gallery, Tokyo
1990 Akira Ikeda Gallery, Taura, Yokosuka

Bibliography
Haraguchi, 1970–1993 (see No. 29): Cat. 15

133
Untitled
1982
Black polyurethane on aluminium
honeycomb panel | Schwarzes Polyurethan
auf Verbundplatte aus Aluminium
mit Wabenkern
160 x 180 x 13.5 cm
Akira Ikeda Gallery, Japan

Exhibition | Ausstellung
1982 Akira Ikeda Gallery, Tokyo

Bibliography
Haraguchi, 1970–1993 (see No. 29): Cat. 14

134
Untitled
1982
Black polyurethane on aluminium
honeycomb panel | Schwarzes Polyurethan
auf Verbundplatte aus Aluminium
mit Wabenkern
126.5 x 119 x 13.5 cm
Private collection | Privatsammlung, Japan

Exhibition | Ausstellung
1982 Akira Ikeda Gallery, Tokyo

135
Untitled
1982
Black polyurethane on cardboard
honeycomb panels I Schwarzes Polyurethan
auf Verbundplatten aus Pappe mit Wabenkern
180 x 160 x 23 cm
Akira Ikeda Gallery, Japan

Exhibition I Ausstellung
1982 Akira Ikeda Gallery, Tokyo

136
Untitled
1982
Black polyurethane on cardboard
honeycomb panels I Schwarzes Polyurethan
auf Verbundplatten aus Pappe mit Wabenkern
160 x 180 x 23 cm
Akira Ikeda Gallery, Japan

Exhibition I Ausstellung
1982 Akira Ikeda Gallery, Tokyo

137
Untitled
1982
Black polyurethane on aluminium
honeycomb panels I Schwarzes Polyurethan
auf Verbundplatten aus Aluminium
mit Wabenkern
Two plates, together I Zwei Platten zusammen:
250 x 250 x 10.5 cm
Akira Ikeda Gallery, Japan

Exhibitions I Ausstellungen
1982 Akira Ikeda Gallery, Tokyo
1990 Akira Ikeda Gallery, Taura, Yokosuka

138
Untitled
1982
Black polyurethane on aluminium
honeycomb panels I Schwarzes Polyurethan
auf Verbundplatten aus Aluminium
mit Wabenkern
Four plates, together I Vier Platten zusammen:
249 x 246 x 13.5 cm
Akira Ikeda Gallery, Japan

Exhibitions I Ausstellungen
1982 Akira Ikeda Gallery, Tokyo
1990 Akira Ikeda Gallery, Taura, Yokosuka

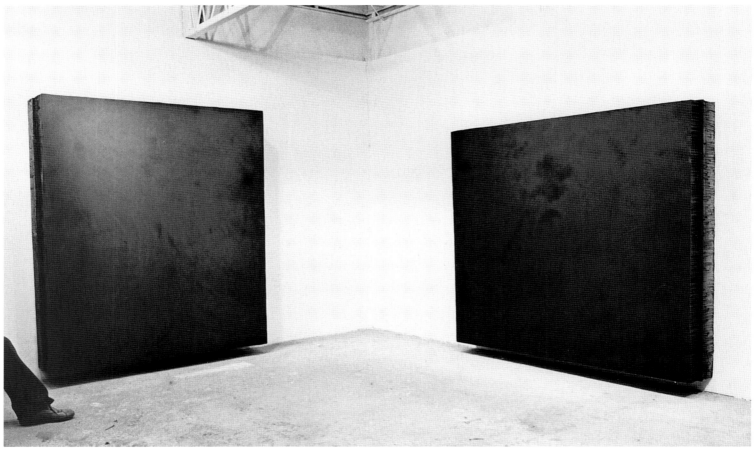

135, 136

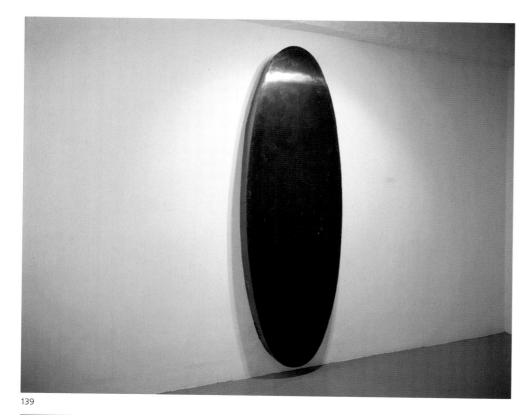

139
Untitled
1982
Black polyurethane on aluminium
honeycomb panel I Schwarzes Polyurethan
auf Verbundplatte aus Aluminium
mit Wabenkern
230 x 47 x 15.5 cm
Private collection I Privatsammlung, Japan

Exhibition I Ausstellung
1982 Akira Ikeda Gallery, Tokyo

139

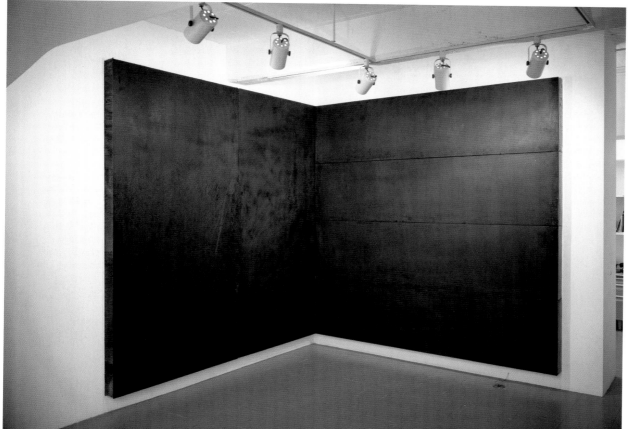

137, 138

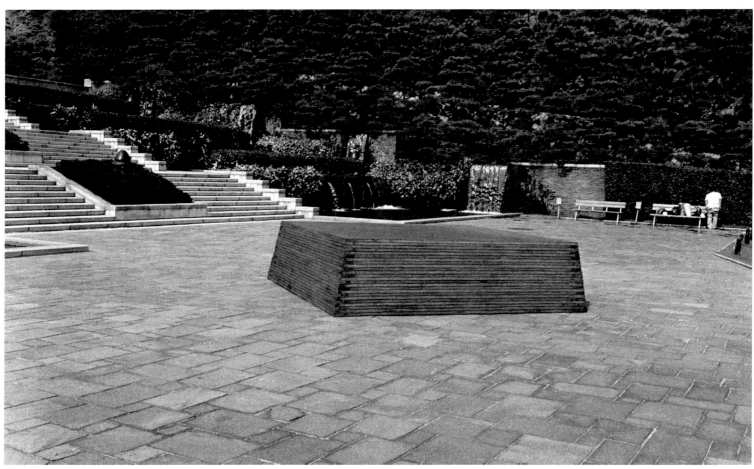

140

140
Untitled
1982
Steel plates I Stahlplatten
73 x 280 x 280 cm
Akira Ikeda Gallery, Japan

Exhibition I Ausstellung
1982 *8th Contemporary Sculpture Exhibition*,
Suma Detached Palace Garden, Kobe

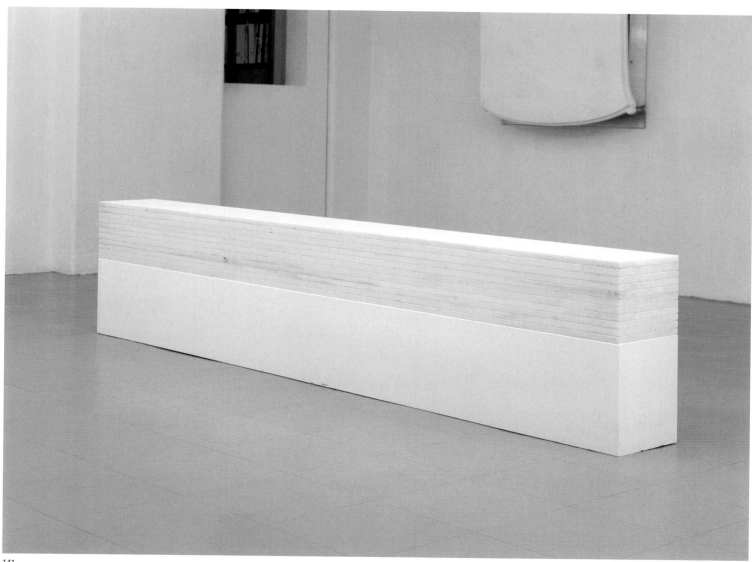

141

141
Untitled
1982
Reproduced in 1993 I 1993 wiederhergestellt
Plaster and marble I Gips und Marmor
52 x 250 x 25 cm
Akira Ikeda Gallery, Japan

Exhibition I Ausstellung
1993 Akira Ikeda Gallery, Tokyo (Cat.)

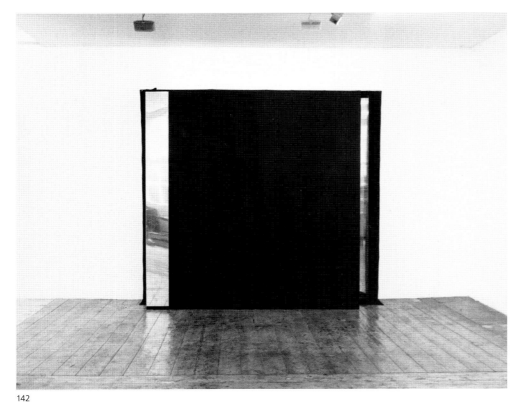

142

142
Untitled No. 1
1983
Dyed canvas and copper on wood l
Gefärbte Leinwand und Kupfer über Holz
259 x 281 x 60.5 cm
Collection of the artist l Besitz des Künstlers

Exhibition l Ausstellung
1983 Juda Rowan Gallery, London

143
Untitled No. 2
1983
Dyed canvas and copper on wood l
Gefärbte Leinwand und Kupfer über Holz
255 x 374 x 57 cm
Akira Ikeda Gallery, Japan

Exhibition l Ausstellung
1983 Juda Rowan Gallery, London

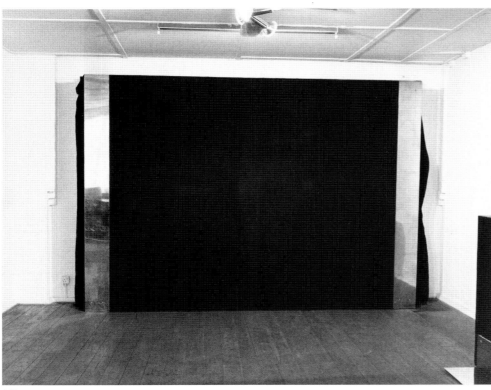

143

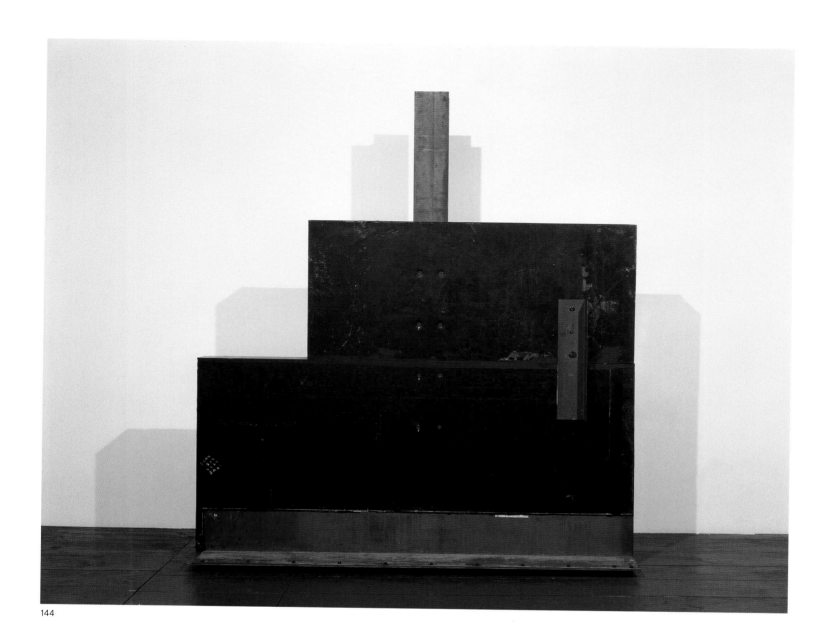

144

144
Untitled No. 3
1983
Reproduced in 1990 I 1990 wiederhergestellt
Tar paper and copper on cardboard honeycomb
panels and steel beam I Teerpappe und Kupfer
auf Verbundplatten aus Pappe mit Wabenkern
und Stahlträger
195 x 268 x 40 cm
Akira Ikeda Gallery, Japan

Exhibitions I Ausstellungen
1983 Juda Rowan Gallery, London
1990 Akira Ikeda Gallery, Taura, Yokosuka

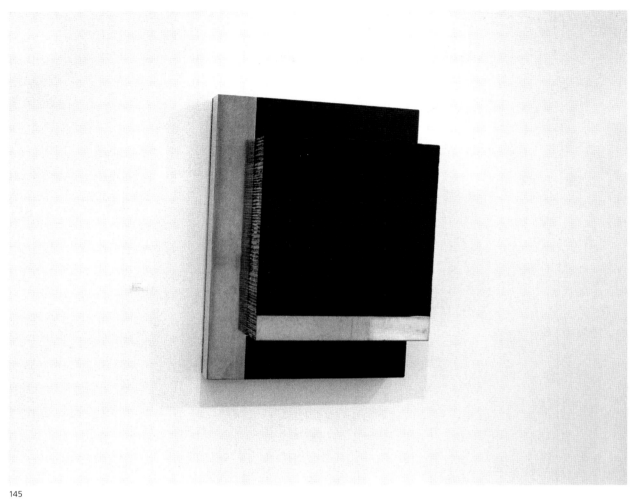

145

145
Untitled
1983
Tar paper and copper on cardboard
honeycomb panels I Teerpappe und Kupfer
auf Verbundplatten aus Pappe mit Wabenkern
70 x 50 x 20 cm
Collection of the artist I Besitz des Künstlers

Exhibition I Ausstellung
1983 Juda Rowan Gallery, London

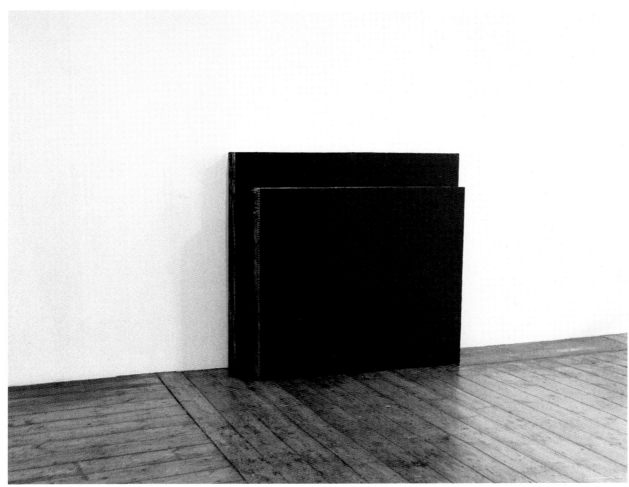

146

146
Untitled
1983
Tar paper on cardboard honeycomb panels I
Teerpappe auf Verbundplatten aus Pappe
mit Wabenkern
100 x 110 x 30 cm
Collection of the artist I Besitz des Künstlers

Exhibition I Ausstellung
1983 Juda Rowan Gallery, London

147

147
Untitled
1983
Temporary work l Temporäre Arbeit
Tar paper on cardboard honeycomb panels
and copper l Teerpappe auf Verbundplatten
aus Pappe mit Wabenkern und Kupfer
180 x 270 x 20 cm

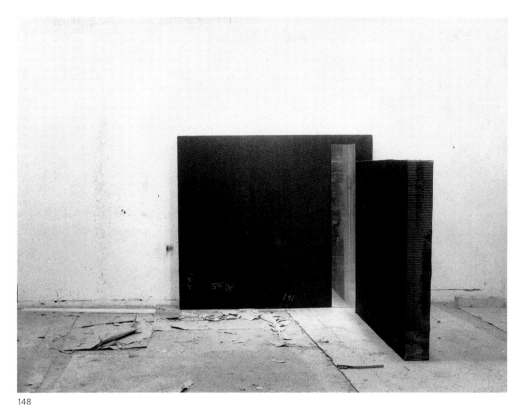

148

148
Untitled
1983
Temporary work | Temporäre Arbeit
Tar paper and copper on cardboard honeycomb
panels | Teerpappe und Kupfer auf Verbundplatten
aus Pappe mit Wabenkern
125 x 135 x 120 cm

149
Untitled
1983
Temporary work | Temporäre Arbeit
Dyed canvas, tar paper, and copper |
Gefärbte Leinwand, Teerpappe und Kupfer
230 x 280 x 50 cm

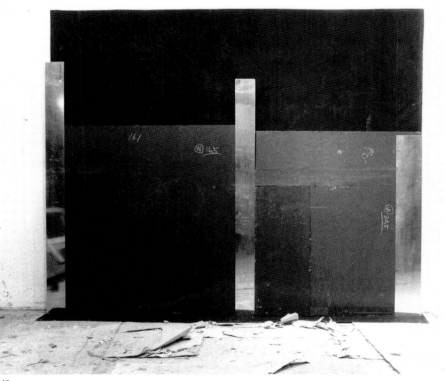

149

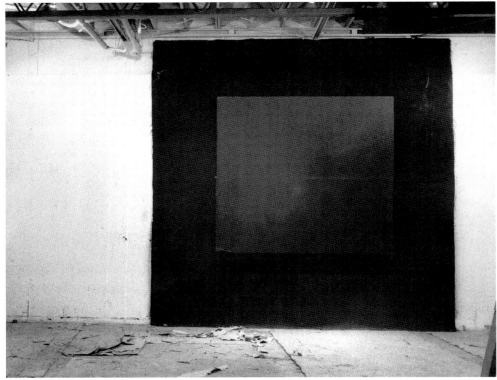

150

150
Untitled
Temporary work I Temporäre Arbeit
1983
Dyed canvas and tar paper I Gefärbte Leinwand
und Teerpappe
240 x 240 x 10 cm

151
Untitled
1983
Temporary work I Temporäre Arbeit
Tar paper I Teerpappe
240 x 135 x 10 cm

152
Bibi No. 7
1984
Black polyurethane and copper on aluminium
honeycomb panels I Schwarzes Polyurethan
und Kupfer auf Verbundplatten aus Aluminium
mit Wabenkern
70 x 75 x 46.5 cm
Private collection I Privatsammlung, Japan

Exhibition I Ausstellung
1984 Akira Ikeda Gallery, Nagoya (Cat.)

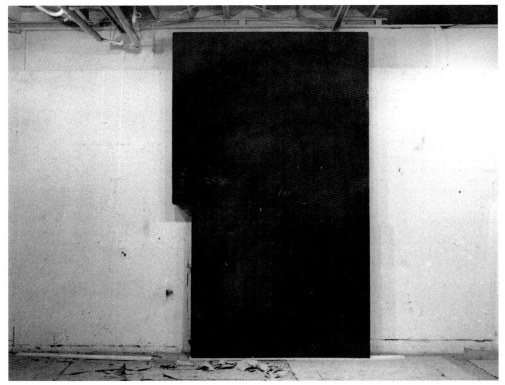

151

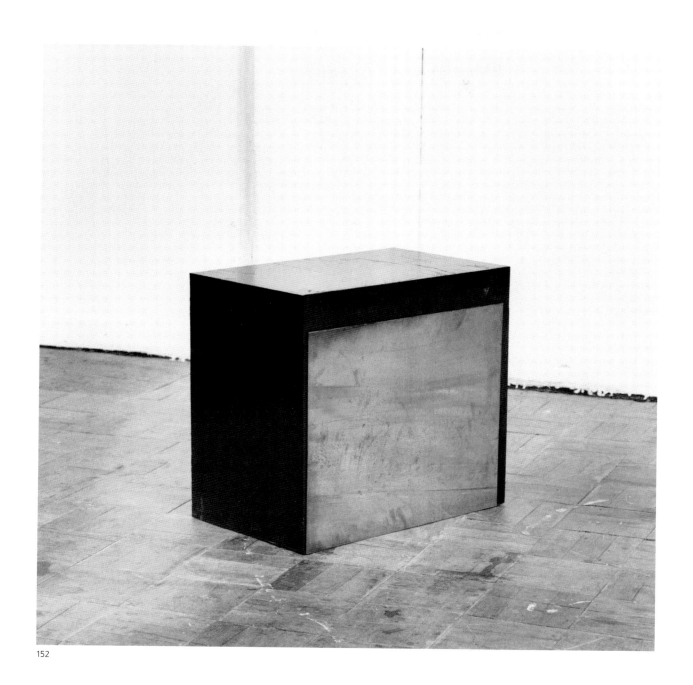

152

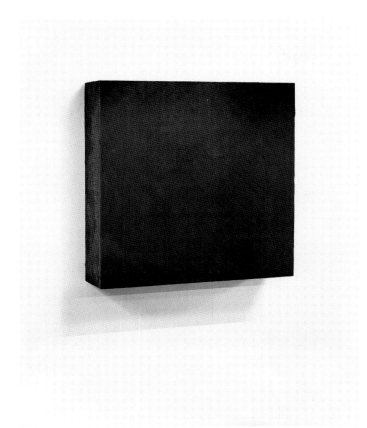

153

153
Taura No. 1a
1984
Black polyurethane on aluminium
honeycomb panels I Schwarzes Polyurethan
auf Verbundplatten aus Aluminium
mit Wabenkern
115 x 116 x 31.5 cm
Akira Ikeda Gallery, Japan

Exhibition I Ausstellung
1984 Akira Ikeda Gallery, Nagoya (Cat.)

154
Taura No. 3
1984
Black polyurethane on aluminium
honeycomb panels I Schwarzes Polyurethan
auf Verbundplatten aus Aluminium
mit Wabenkern
Two coated panels I Zwei beschichtete Platten:
85 x 75 x 15 cm, 28.5 x 106 x 15.5 cm
Private collection I Privatsammlung, Japan

Exhibition I Ausstellung
1984 Akira Ikeda Gallery, Nagoya (Cat.)

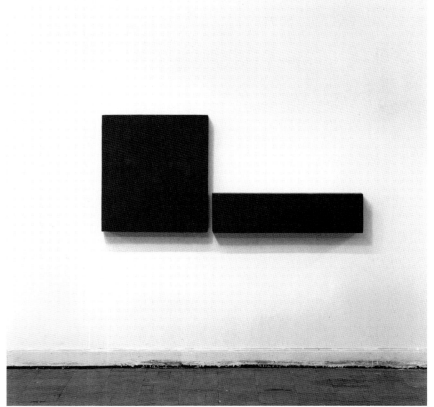

154

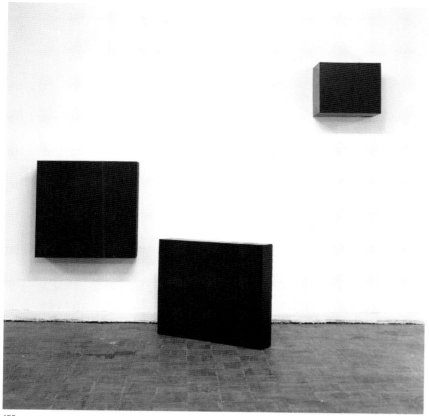

155
Taura No. 5
1984
Black polyurethane on aluminium
honeycomb panels I Schwarzes Polyurethan
auf Verbundplatten aus Aluminium
mit Wabenkern
Three coated panels I Drei beschichtete Platten:
115 x 115.5 x 31 cm, 109.5 x 133 x 20 cm,
60.5 x 71 x 43 cm
Akira Ikeda Gallery, Japan

Exhibitions I Ausstellungen
1984 Akira Ikeda Gallery, Nagoya (Cat.)
1990 Akira Ikeda Gallery, Taura, Yokosuka

156
Taura No. 6
1984
Black polyurethane on aluminium
honeycomb panels I Schwarzes Polyurethan
auf Verbundplatten aus Aluminium
mit Wabenkern
Two coated panels I Zwei beschichtete Platten:
151 x 164.5 x 21 cm, 32.5 x 225 x 31 cm
Akira Ikeda Gallery, Japan

Exhibitions I Ausstellungen
1984 Akira Ikeda Gallery, Nagoya (Cat.)
1990 Akira Ikeda Gallery, Taura, Yokosuka

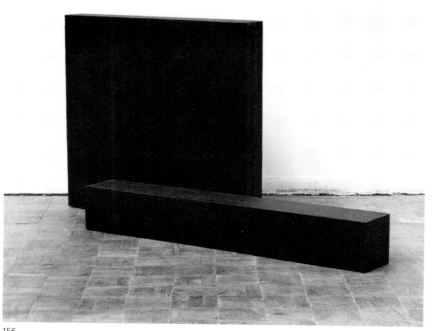

156

157

158

157
Untitled
1984
Collage and drawing on canvas I
Collage und Zeichnung auf Leinwand
227 x 546 cm
Collection of the artist I Besitz des Künstlers

Exhibition I Ausstellung
1984 Akira Ikeda Gallery, Nagoya (Cat.)

158
East
1985
Temporary reproducible work I
Temporäre, wiederherstellbare Arbeit
Mixed media on canvas I Verschiedene Materialien
auf Leinwand
194 x 284 cm
Certificate with instructions and signature
held by artist I Zertifikat mit Konstruktionsanleitung
und Signatur im Besitz des Künstlers

Exhibition I Ausstellung
1985 Akira Ikeda Gallery, Tokyo

159
Untitled
1985
Pastel and rubber on paper mounted on canvas I
Pastell und Gummi auf Papier, aufgezogen
auf Leinwand
138.5 x 78 cm
Private collection I Privatsammlung, Japan

Exhibition I Ausstellung
1985 Akira Ikeda Gallery, Tokyo

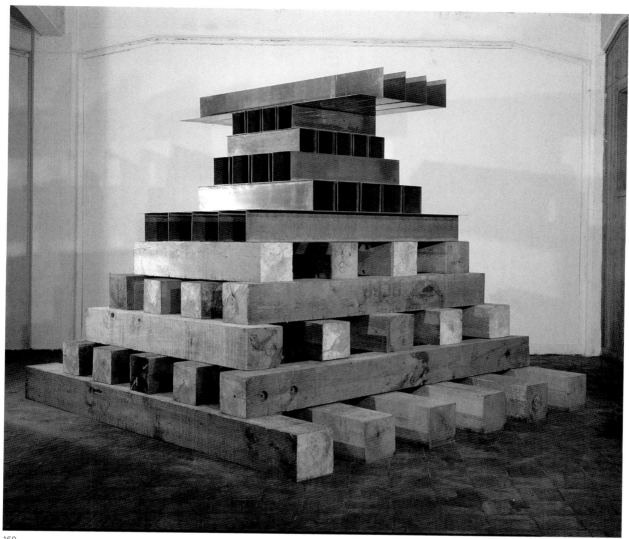

160

160
100, Revised
1985–86
Wood and copper I Holz und Kupfer
297.5 x 390 x 346 cm
Akira Ikeda Gallery, Japan

Exhibition I Ausstellung
1985 Akira Ikeda Gallery, Tokyo

Bibliography
Works 1981–1986 (see No. 66)
Galeries Magazine, International Edition
(February/March 1987): 82

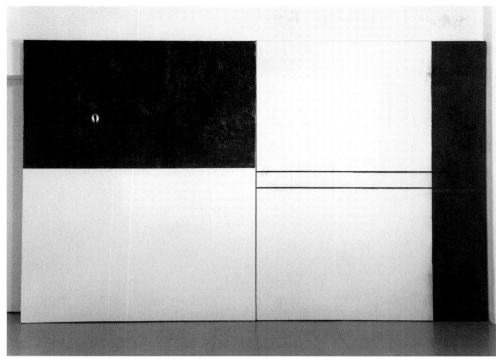

162

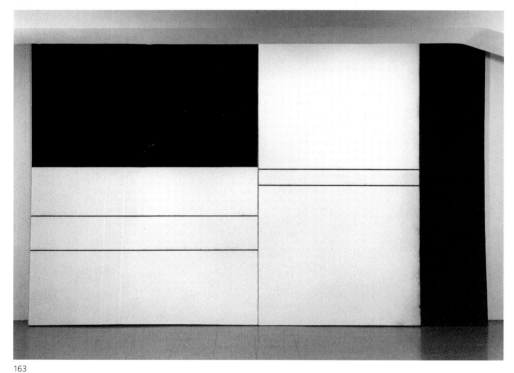

163

161
Untitled
1985
Temporary reproducible work I
Temporäre, wiederherstellbare Arbeit
Charcoal on paper mounted on canvas and copper I
Kohle auf Papier, aufgezogen auf Leinwand,
und Kupfer
Circa 200 x 250 x 200 cm
Certificate with instructions and signature
held by artist I Zertifikat mit Konstruktionsanleitung
und Signatur im Besitz des Künstlers

Exhibition I Ausstellung
1985 Akira Ikeda Gallery, Tokyo

162
Construction I
1985
Pastel and charcoal on paper mounted on canvas I
Pastell und Kohle auf Papier, aufgezogen auf Leinwand
258 x 387 cm
Akira Ikeda Gallery, Japan

Exhibition I Ausstellung
1985 Akira Ikeda Gallery, Tokyo

163
Construction II
1985
Charcoal on paper mounted on canvas I
Kohle auf Papier, aufgezogen auf Leinwand
227 x 363 cm
Akira Ikeda Gallery, Japan

Exhibition I Ausstellung
1985 Akira Ikeda Gallery, Tokyo

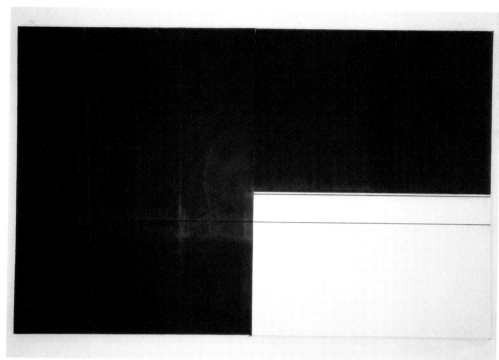

164

164
Construction III
1986
Pastel on paper mounted on canvas |
Pastell auf Papier, aufgezogen auf Leinwand
259 x 388 cm
Private collection | Privatsammlung, Japan

Bibliography
Works 1981–1986 (see No. 66)

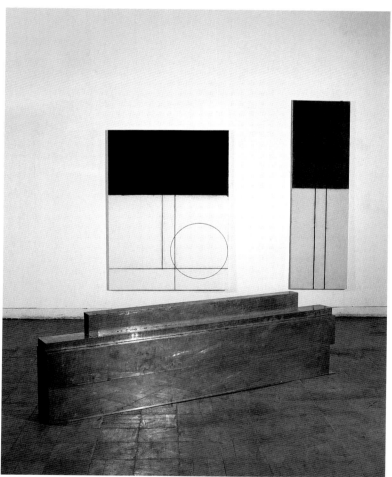

161

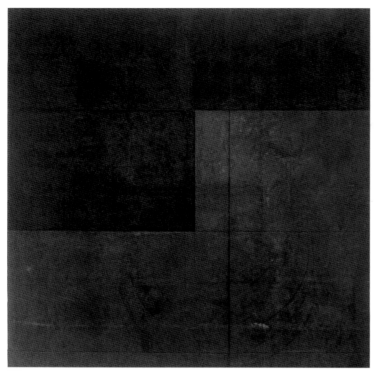

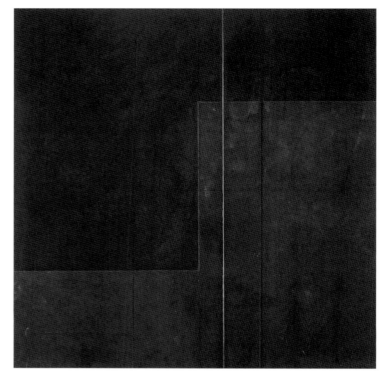

165

166

165
Differences in Distance I
1986
Pastel on canvas sheet I Pastell auf Leinwandtuch
279 x 268 cm
Hoffman Borman Gallery, Santa Monica

Exhibition I Ausstellung
1987 Hoffman Borman Gallery, Santa Monica

Bibliography
Works 1981–1986 (see No. 66)

166
Differences in Distance II
1986
Pastel on canvas sheet I Pastell auf Leinwandtuch
259 x 249 cm
Akira Ikeda Gallery, Japan

Bibliography
Works 1981–1986 (see No. 66)

167

168

167
Differences in Distance III
1986
Pastel on canvas sheet | Pastell auf Leinwandtuch
268 x 279 cm
Akira Ikeda Gallery, Japan

Exhibitions | Ausstellungen
1987 Hoffman Borman Gallery, Santa Monica
1988 San Diego State University Art Gallery

168
Differences in Distance IV
1986
Pastel on canvas sheet | Pastell auf Leinwandtuch
280 x 270 cm
Hoffman Borman Gallery, Santa Monica

Exhibition | Ausstellung
1987 Hoffman Borman Gallery, Santa Monica

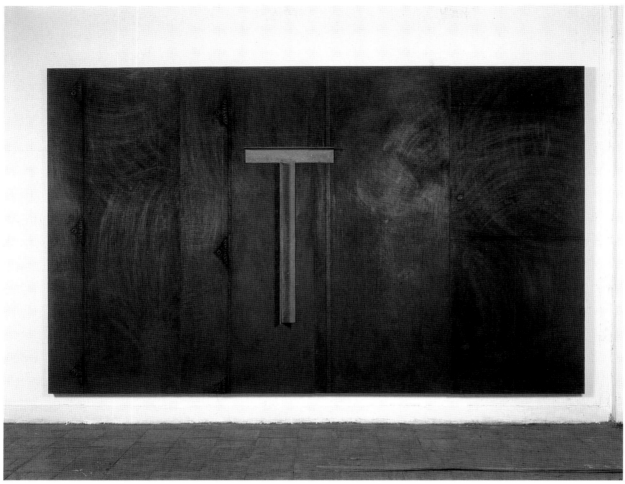

169

169
Untitled
1986
Pastel and angle steel on canvas sheets I
Pastell und Winkelstahl auf Leinwandtüchern
230 x 364 cm
Akira Ikeda Gallery, Japan

Exhibitions I Ausstellungen
1987 Maki Gallery, Tokyo
1987 *Toyama Now '87*, The Museum of Modern Art,
Toyama
1990 Akira Ikeda Gallery, Taura, Yokosuka

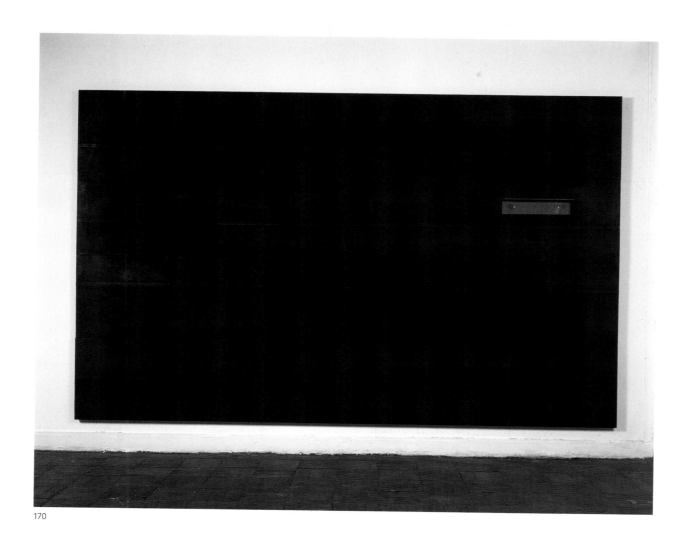

170

170
Untitled
1986
Pastel and angle steel on canvas sheets I
Pastell und Winkelstahl auf Leinwandtüchern
230.5 x 364 cm
Akira Ikeda Gallery, Japan

Exhibitions I Ausstellungen
1987 Maki Gallery, Tokyo
1990 Akira Ikeda Gallery, Taura, Yokosuka

171
Untitled
1986
Pastel, rubber, and paper on canvas sheet I
Pastell, Gummi und Papier auf Leinwandtuch
321 x 215.5 cm
Akira Ikeda Gallery, Japan

172

173

172
Weathered I
1986
Pastel and Indian ink on canvas sheet l
Pastell und Tusche auf Leinwandtuch
356.5 x 243 cm
Akira Ikeda Gallery, Japan

Bibliography
Works 1981–1986 (see No. 66)

173
Weathered II
1986
Pastel and Indian ink on canvas sheet l
Pastell und Tusche auf Leinwandtuch
411.5 x 265 cm
Akira Ikeda Gallery, Japan

Bibliography
Works 1981–1986 (see No. 66)

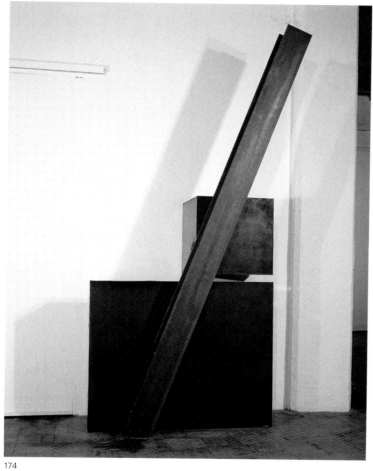

174

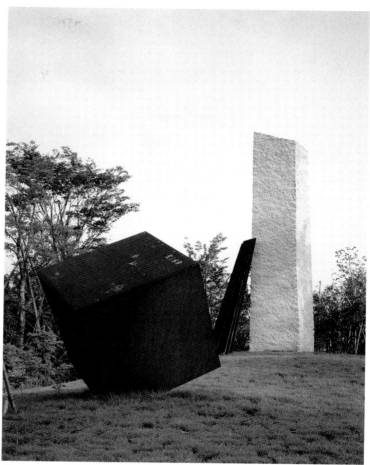

175

174
Shinan-Fu
1986
Black polyurethane on aluminium honeycomb
panels and steel I-beam I Schwarzes Polyurethan
auf Verbundplatten aus Aluminium mit Wabenkern
und I-Träger aus Stahl
311 x 162 x 79.5 cm
Akira Ikeda Gallery, Japan

Exhibition I Ausstellung
1986 *Dispersed Core*, Akira Ikeda Gallery, Tokyo

Bibliography
Works 1981–1986 (see No. 66)

175
Space – Mass
1986
Stone and corten steel I Stein und Corten-Stahl
Stone I Stein: 550 x 150 x 150 cm
Steel plates, each I Stahlplatten jeweils:
circa 200 x 24 x 3 cm
Steel cube I Stahlkubus: 190 x 150 x 150 cm
Chougo High School, Kanagawa

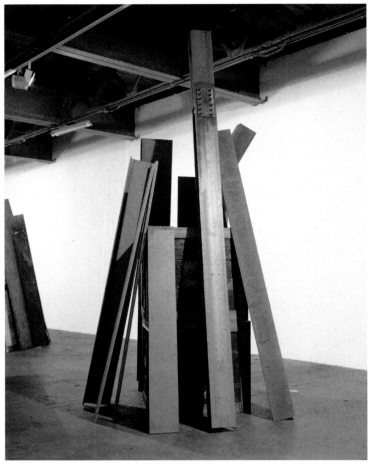

176

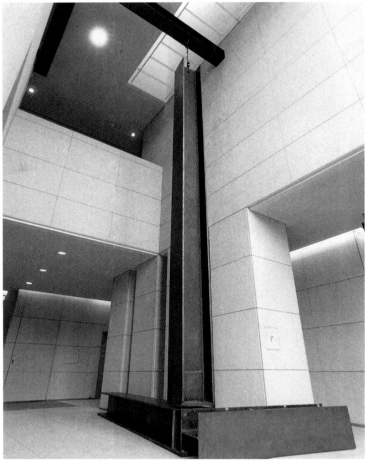

177

176
Untitled
1986–90
Temporary reproducible work l
Temporäre, wiederherstellbare Arbeit
Wood, angle steel, and steel plates l
Holz, Winkelstahl und Stahlplatten
176.5 x 92 x 92 cm
Certificate with instructions and signature
held by artist l Zertifikat mit Konstruktionsanleitung
und Signatur im Besitz des Künstlers

Exhibition l Ausstellung
1990 Akira Ikeda Gallery, Taura, Yokosuka

177
An Interest in Structure
1987
Steel I-beams l I-Träger aus Stahl
722 x 636 x 435 cm
Meguro Museum of Art, Tokyo

Bibliography
Mainichi Newspaper (28 May 1987)

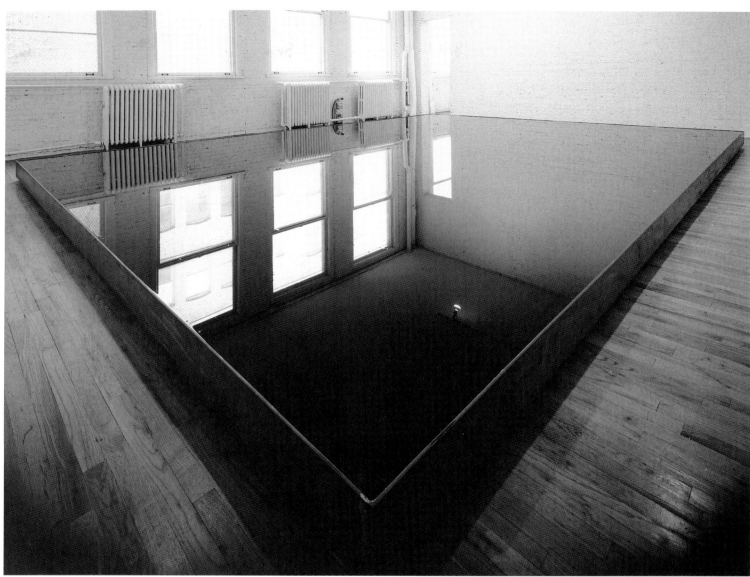

178

178
Bussei No. 10
1987
Steel and oil I Stahl und Öl
18 x 545 x 724 cm
Akira Ikeda Gallery, Japan

Exhibitions I Ausstellungen
1988 (C)Overt: A Series of Exhibitions, P.S.1,
New York
1993 Noriyuki Haraguchi: Matter and Mind,
Akira Ikeda Gallery, New York (Cat. 16 in
Noriyuki Haraguchi, 1970–1993)

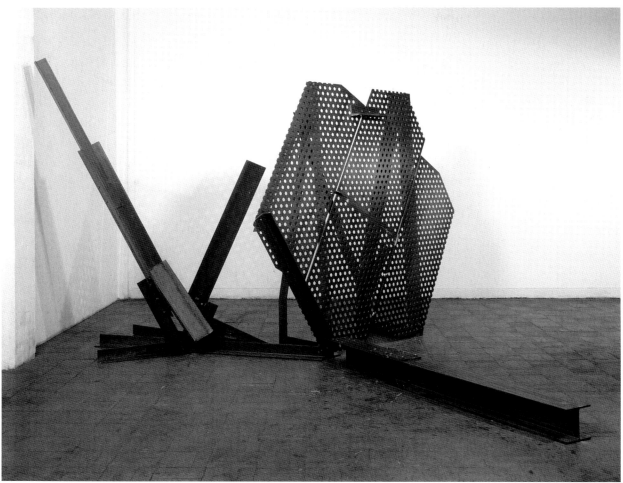

179

179
Untitled
1987
Temporary reproducible work I
Temporäre, wiederherstellbare Arbeit
Angle steel, perforated steel plates, steel I-beam,
and steel plate I Winkelstahl, Lochplatten aus Stahl,
I-Träger aus Stahl und Stahlplatte
257 x 400 x 480 cm
Certificate with instructions and signature held by I
Zertifikat mit Konstruktionsanleitung und Signatur
im Besitz der Akira Ikeda Gallery, Japan

Exhibition I Ausstellung
1987 Gallery Gen, Tokyo

180
Vanished Spring
1987
Temporary reproducible work I
Temporäre, wiederherstellbare Arbeit
Wood and steel I Holz und Stahl
320 x 200 x 186 cm
Certificate with instructions and signature held by I
Zertifikat mit Konstruktionsanleitung und Signatur
im Besitz der Akira Ikeda Gallery, Japan

Exhibition I Ausstellung
1988 Akira Ikeda Gallery, Tokyo

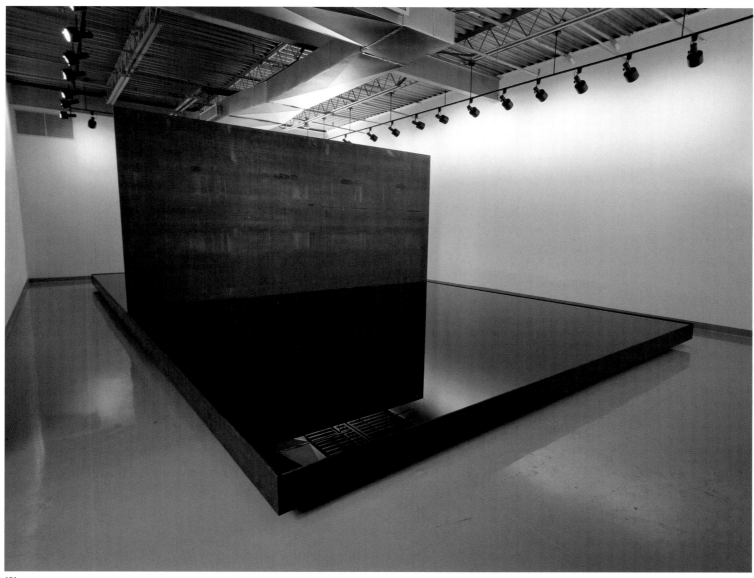

181

181
Bussei with Bisecting Steel
1987
Steel, oil, and steel plate I Stahl, Öl und Stahlplatte
Pool of oil I Ölwanne: 18 x 480 x 840 cm
Steel plate I Stahlplatte: 265 x 480 x 1.3 cm
Akira Ikeda Gallery, Japan

Exhibition I Ausstellung
1987 Judson Art Warehouse Viewing Gallery,
New York (Cat.)

Bibliography
Haraguchi, 1970–1993 (see No. 29): Cat. 17

182

182
R I
1987
Pastel on canvas sheet I Pastell auf Leinwandtuch
259 x 249 cm
Akira Ikeda Gallery, Japan

Exhibitions I Ausstellungen
1987 Hoffman Borman Gallery, Santa Monica
1988 San Diego State University Art Gallery

183
R II
1987
Pastel on canvas sheet I Pastell auf Leinwandtuch
259 x 249 cm
Hoffman Borman Gallery, Santa Monica

Exhibition I Ausstellung
1987 Hoffman Borman Gallery, Santa Monica

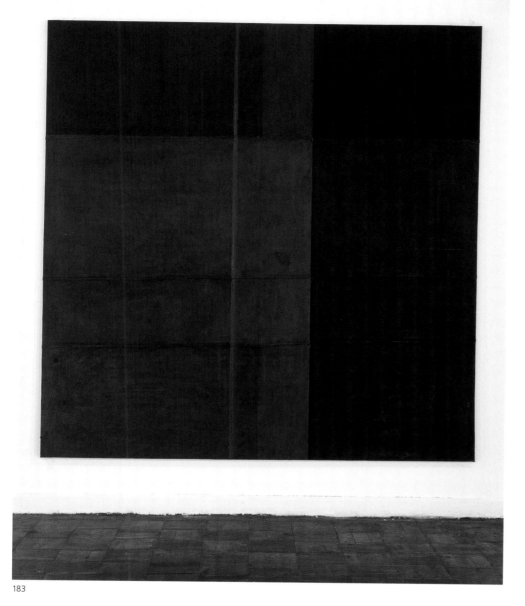

183

184
Waterway
1987
Pastel on canvas sheet | Pastell auf Leinwandtuch
259 x 253 cm
Akira Ikeda Gallery, Japan

1987 Hoffman Borman Gallery, Santa Monica
1988 San Diego State University Art Gallery

185
Climate 4
1987
Pastel on canvas sheet | Pastell auf Leinwandtuch
277.5 x 190.5 cm
Akira Ikeda Gallery, Japan

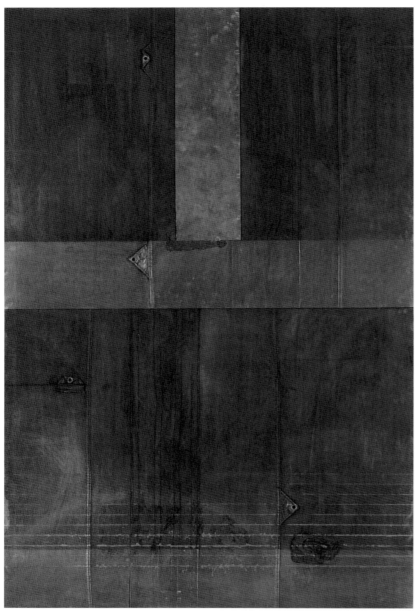

186

186
Untitled T-1
1987
Pastel and rubber on canvas sheet I Pastell und
Gummi auf Leinwandtuch
292 x 194 cm
The Museum of Modern Art, Toyama

Exhibition I Ausstellung
1987 *Toyama Now '87*, The Museum of Modern Art,
Toyama

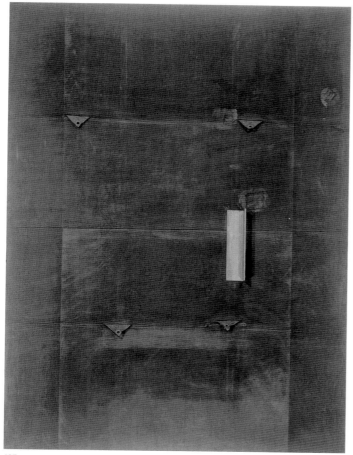

187

188

187
Untitled T-2
1987
Pastel and angle steel on canvas sheet I Pastell und
Winkelstahl auf Leinwandtuch
261 x 194 cm
Private collection I Privatsammlung, Japan

Exhibition I Ausstellung
1987 *Toyama Now '87*, The Museum of Modern Art,
Toyama

188
Untitled T-3
1987
Pastel, oil, and rubber on canvas sheet I Pastell, Öl
und Gummi auf Leinwandtuch
230 x 182 cm
Private collection I Privatsammlung, Japan

Exhibition I Ausstellung
1987 *Toyama Now '87*, The Museum of Modern Art,
Toyama

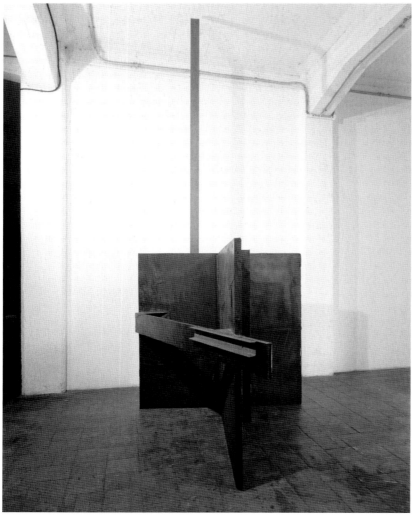

190

189
Untitled T-4
1987
Pastel and rubber on canvas sheet I Pastell und
Gummi auf Leinwandtuch
247 x 182 cm
Akira Ikeda Gallery, Japan

Exhibition I Ausstellung
1987 Gallery Te, Tokyo (with I mit Naoyoshi Hikosaka)

190
Untitled MT-5, Renewed
1987
Rubber plates and steel I Gummiplatten und Stahl
455.5 x 185 x 220 cm
Akira Ikeda Gallery, Japan

Exhibitions I Ausstellungen
1987 *Toyama Now '87*, The Museum of Modern Art,
Toyama
1990 Akira Ikeda Gallery, Taura, Yokosuka

191, 192

191
Sound T-4
1987
Pastel and rubber on canvas sheet I Pastell und
Gummi auf Leinwandtuch
521 x 380 cm
Private collection I Privatsammlung, Japan

Exhibition I Ausstellung
1987 *Toyama Now '87*, The Museum of Modern Art,
Toyama

192
Heat
1987
Pastel and rubber on canvas sheet I Pastell und
Gummi auf Leinwandtuch
521 x 380 cm
Akira Ikeda Gallery, Japan

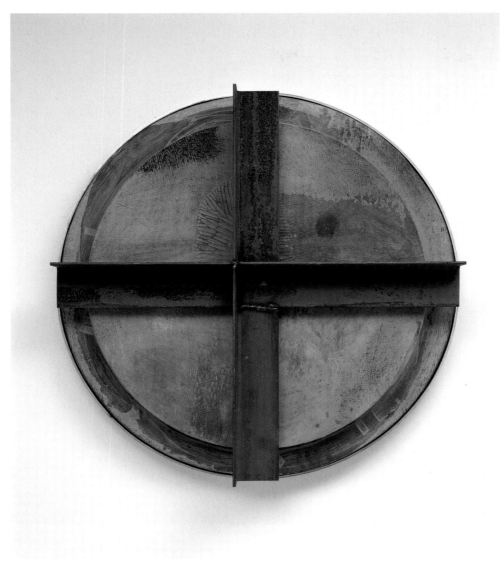

194

193
Untitled
1987
Temporary reproducible work I
Temporäre, wiederherstellbare Arbeit
Pastel, acrylic, and steel on cloth mounted
on a cardboard honeycomb panel I Pastell,
Acryl und Stahl auf Stoff über Verbundplatte
aus Pappe mit Wabenkern
⌀ 74 cm x 31 cm
Certificate with instructions and signature
held by private collector, Japan I Zertifikat mit
Konstruktionsanleitung und Signatur im Besitz
einer japanischen Privatsammlung

Exhibition I Ausstellung
1987 *Relief & Sculpture*, Akira Ikeda Gallery, Nagoya

194
Untitled
1987
Mixed media I Verschiedene Materialien
⌀ 93 cm x 28 cm
Private collection I Privatsammlung, Japan

Exhibition I Ausstellung
1987 *Relief & Sculpture*, Akira Ikeda Gallery, Nagoya

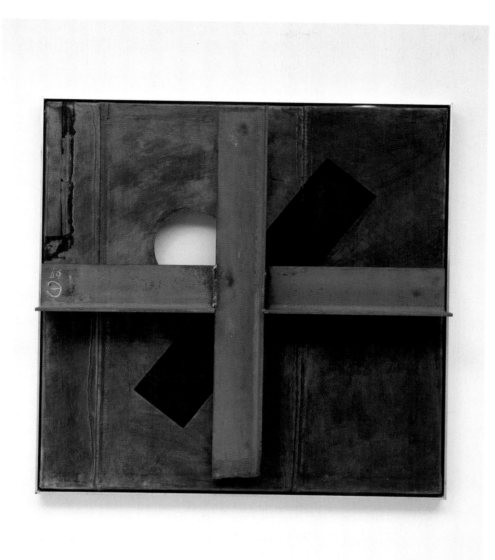

195

195
Untitled
1987
Mixed media | Verschiedene Materialien
88 x 88 x 21 cm
Private collection | Privatsammlung, Japan

Exhibition | Ausstellung
1987 *Relief & Sculpture*, Akira Ikeda Gallery,
Nagoya

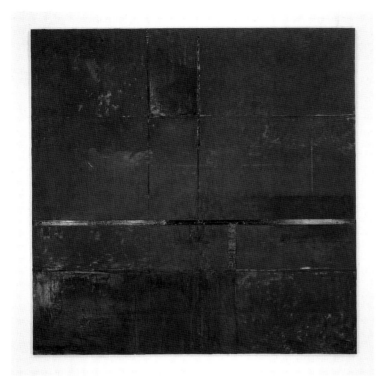 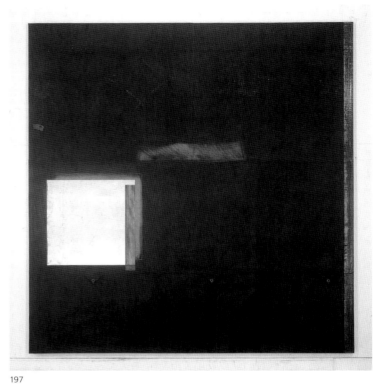

196

197

196
Differences in Distance V
1987
Black polyurethane and silicone rubber
on canvas sheet I Schwarzes Polyurethan
und Silikon-Gummi auf Leinwandtuch
279 x 268 cm
Akira Ikeda Gallery, Japan

Exhibition I Ausstellung
1988 San Diego State University Art Gallery

197
Differences in Distance VI
1988
Pastel, silicone rubber, and aluminium
on canvas sheet I Pastell, Silikon-Gummi
und Aluminium auf Leinwandtuch
280 x 266 cm
Akira Ikeda Gallery, Japan

Exhibition I Ausstellung
1988 San Diego State University Art Gallery

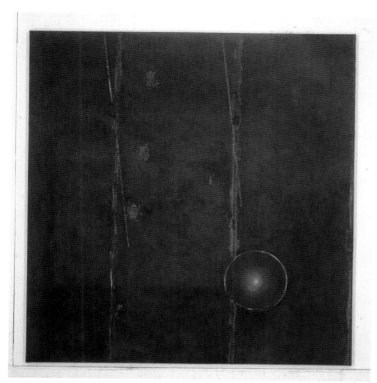

198

198
Differences in Distance VII
1988
Pastel, silicone rubber, and aluminium
on canvas sheet I Pastell, Silikon-Gummi
und Aluminium auf Leinwandtuch
280 x 266 cm
Akira Ikeda Gallery, Japan

Exhibition I Ausstellung
1988 San Diego State University Art Gallery

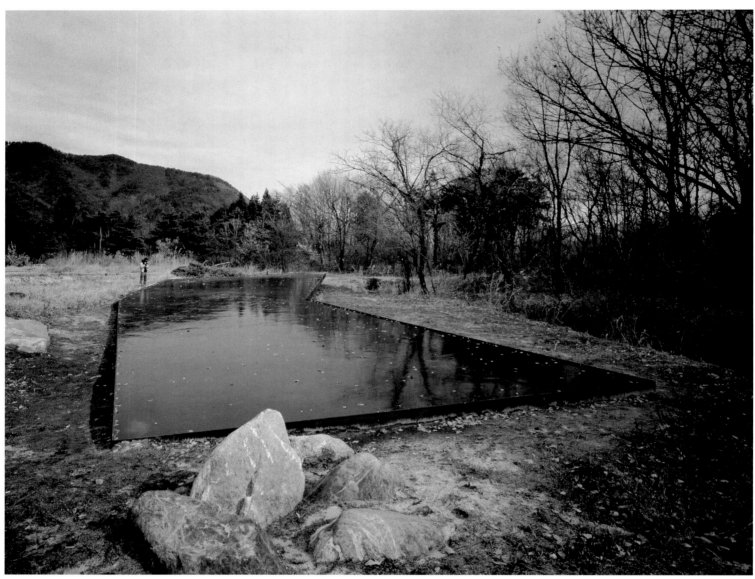

199

199
Bussei No. 11, Hakushu
1988
Steel and water I Stahl und Wasser
30 x 1150 x 2900 cm
Owned by the artist I Eigentum des Künstlers

Installed on the occasion of the *Summer Art Festival
in Hakushu '88*, Kitakoma-gun, remaining
permanently I Aufgestellt anlässlich des *Summer
Art Festival in Hakushu '88*, Kitakoma-gun,
zum dauerhaften Verbleib

Other exhibitions I Weitere Ausstellungen
1989–96 *Summer Art Festival in Hakushu '89, '90,
'91, '92, '93, '94, '95, '96*, Kitakoma-gun

Bibliography
Haraguchi, 1970–1993 (see No. 29): Cat. 18

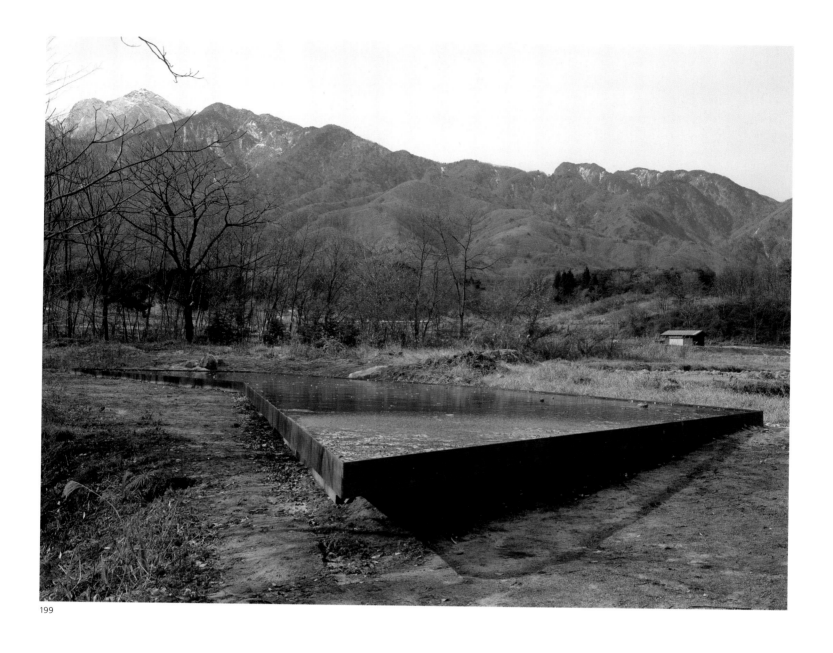

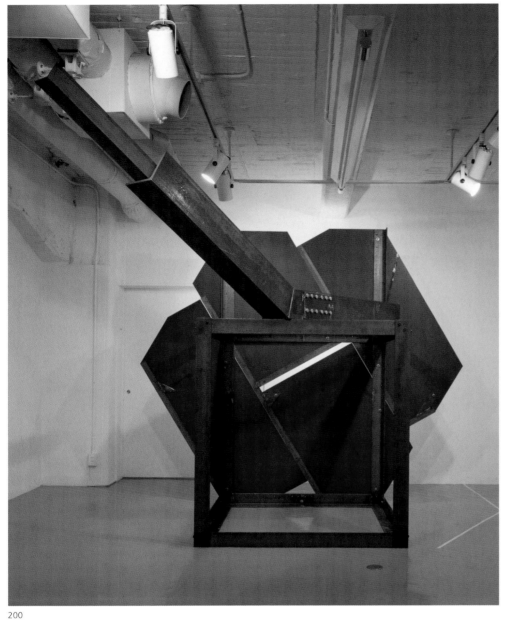

200
Sakura I
1988
Temporary reproducible work I
Temporäre, wiederherstellbare Arbeit
Angle steel, steel plates, glass, and aluminium I
Winkelstahl, Stahlplatten, Glas und Aluminium
257 x 268 x 285 cm
Certificate with instructions and signature held by I
Zertifikat mit Konstruktionsanleitung und Signatur
im Besitz der Akira Ikeda Gallery, Japan

Exhibition I Ausstellung
1988 Akira Ikeda Gallery, Tokyo

200

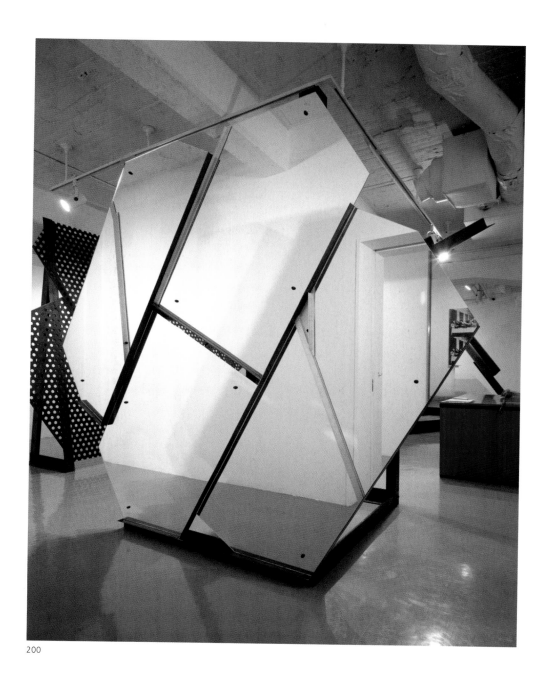

200

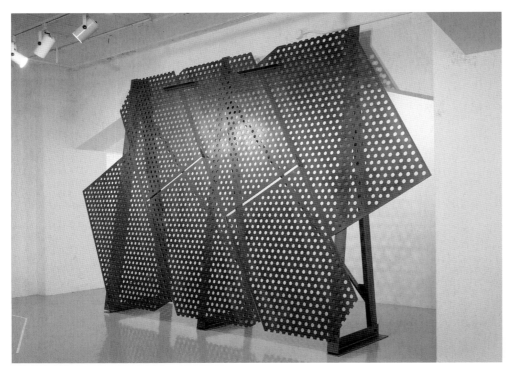

201

201
Kiku II
1988
Temporary reproducible work I
Temporäre, wiederherstellbare Arbeit
Angle steel and perforated steel plates I Winkelstahl
und Lochplatten aus Stahl
266 x 422 x 80 cm
Certificate with instructions and signature held by I
Zertifikat mit Konstruktionsanleitung und Signatur
im Besitz der Akira Ikeda Gallery, Japan

Exhibition I Ausstellung
1988 Akira Ikeda Gallery, Tokyo

202
Yanagi III
1988
Temporary reproducible work I
Temporäre, wiederherstellbare Arbeit
Steel I-beams, angle steel, and steel plates I
I-Träger aus Stahl, Winkelstahl und Stahlplatten
Two parts I Zwei Teile: 149 x 425 cm,
239 x 438 cm
Certificate with instructions and signature held by I
Zertifikat mit Konstruktionsanleitung und Signatur
im Besitz der Akira Ikeda Gallery, Japan

Exhibition I Ausstellung
1988 Akira Ikeda Gallery, Tokyo

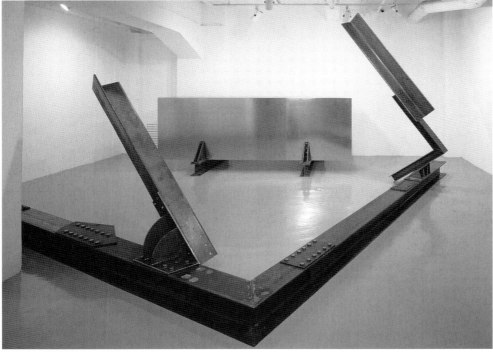

203
202

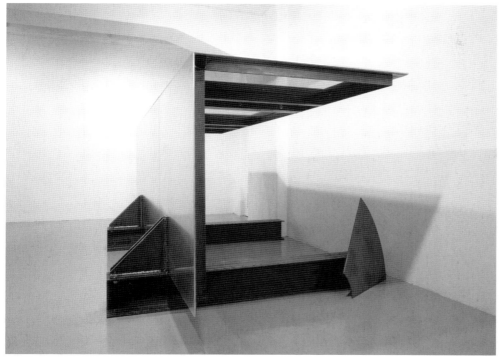

203

203
Kashinoki IV
1988
Partially reproduced in 1990 I
1990 teilweise wiederhergestellt
Steel I-beams, angle steel, steel plates,
and aluminium I I-Träger aus Stahl,
Winkelstahl, Stahlplatten und Aluminium
121 x 300 x 170 cm
Akira Ikeda Gallery, Japan

Exhibitions I Ausstellungen
1988 Akira Ikeda Gallery, Tokyo
1990 Akira Ikeda Gallery, Taura, Yokosuka
1992 *Group Show*, Akira Ikeda Gallery,
Taura, Yokosuka

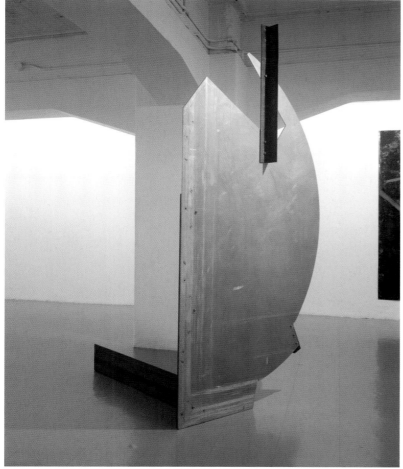

206

204

204
Untitled
1988
Steel I-beams and die-pressed sheet steel l
I-Träger aus Stahl und gepresstes Stahlblech
135 x 112 x 16 cm
Private Collection l Privatsammlung, Japan

Exhibitions l Ausstellungen
1988 *Painting & Sculpture: Noriyuki Haraguchi,
Isamu Wakabayashi, Jonathan Borofsky, Imi Knoebel*,
Akira Ikeda Gallery, Tokyo
1989 *Color and/or Monochrome: A Perspective on
Contemporary Art*, The National Museum of Modern
Art, Tokyo; The National Museum of Modern Art,
Kyoto

Bibliography
Haraguchi, 1970–1993 (see No. 29): Cat. 19

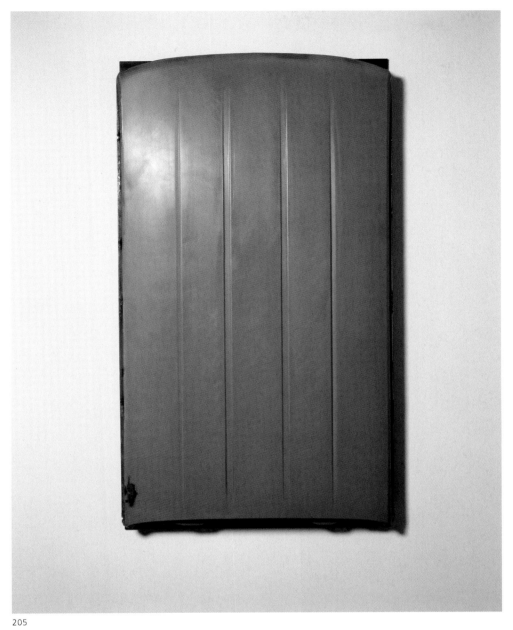

205
Untitled
1988
Steel I-beams and die-pressed sheet steel l
I-Träger aus Stahl und gepresstes Stahlblech
205 x 113 x 18 cm
Akira Ikeda Gallery, Japan

Bibliography
Haraguchi, 1970–1993 (see No. 29): Cat. 20

205

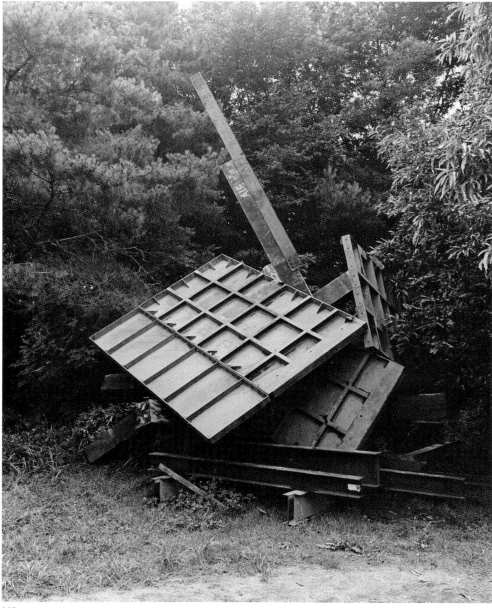

207

206
Construction 11
1989
Angle steel and aluminium I Winkelstahl
und Aluminium
239 x 115 x 131 cm
Akira Ikeda Gallery, Japan

Exhibition I Ausstellung
1990 Group Show, Akira Ikeda Gallery, Tokyo

(illustration page 147)

207
Matsubayashi I
1989
Destroyed I Zerstört
Wood and steel I-beams I Holz und I-Träger aus Stahl
500 x 500 x 480 cm

Installed on the occasion of the Summer Art Festival
in Hakushu '89, Kitakoma-gun, remaining until 1991 I
Aufgestellt anlässlich des Summer Art Festival in
Hakushu '89, Kitakoma-gun, zum Verbleib bis 1991

Further exhibitions I Weitere Ausstellungen
1990–91 Summer Art Festival in Hakushu '90, '91,
Kitakoma-gun

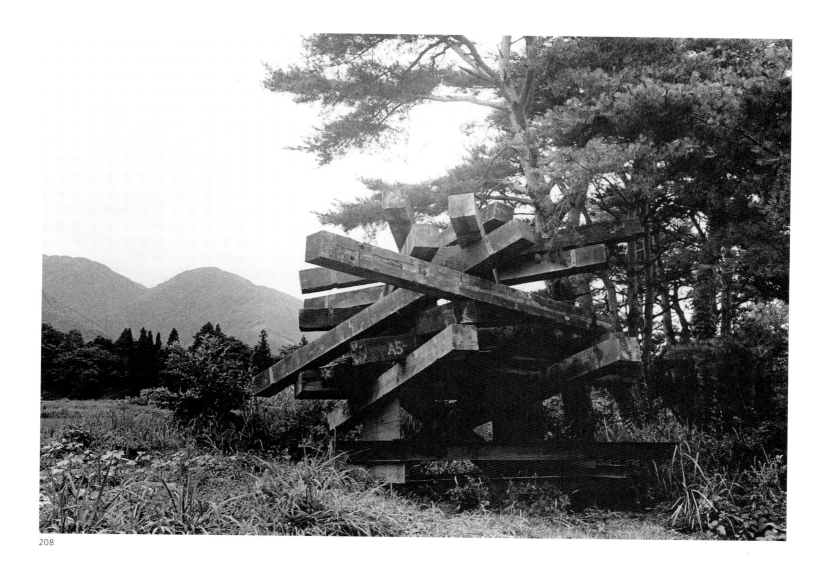

208

208
Matsubayashi II
1989
Destroyed I Zerstört
Steel I-beams and wood I I-Träger aus Stahl und Holz
450 x 450 x 400 cm

Installed on the occasion of the *Summer Art Festival in Hakushu '89*, Hakushu-cho, remaining until 1991 I Aufgestellt anlässlich des *Summer Art Festival in Hakushu '89*, Kitakoma-gun, zum Verbleib bis 1991

Further exhibitions I Weitere Ausstellungen
1990–91 *Summer Art Festival in Hakushu '90*, *'91*, Kitakoma-gun

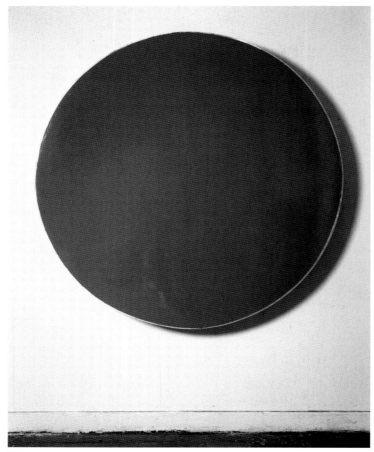

209

209
Untitled
1989
Green polyurethane on aluminium
honeycomb panel I Grünes Polyurethan
auf Verbundplatte aus Aluminium
mit Wabenkern
Ø 181 x 15 cm
Private collection I Privatsammlung, Japan

Exhibition I Ausstellung
1989 *Color and/or Monochrome: A Perspective
on Contemporary Art*, The National Museum of
Modern Art, Tokyo; The National Museum
of Modern Art, Kyoto

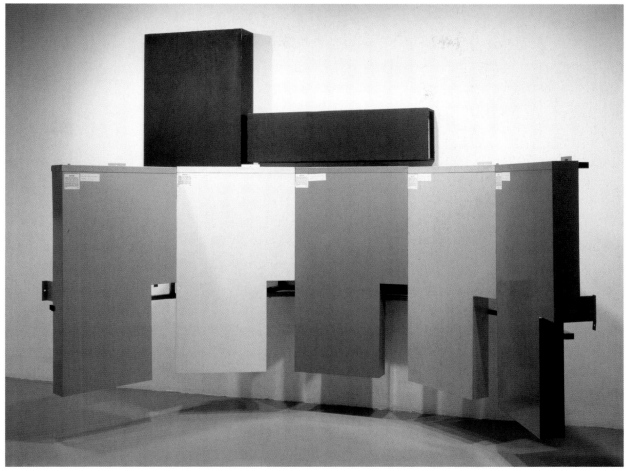

210

210
Untitled
1989
Aluminium, steel covers, and black polyurethane I
Aluminium, Stahlverkleidungen und schwarzes
Polyurethan
195 x 265 x 116 cm
Private Collection I Privatsammlung, Japan

Exhibitions I Ausstellungen
1989 *Painting & Relief*, Akira Ikeda Gallery, Tokyo
1989 *Color and/or Monochrome: A Perspective
on Contemporary Art*, The National Museum of
Modern Art, Tokyo; The National Museum
of Modern Art, Kyoto

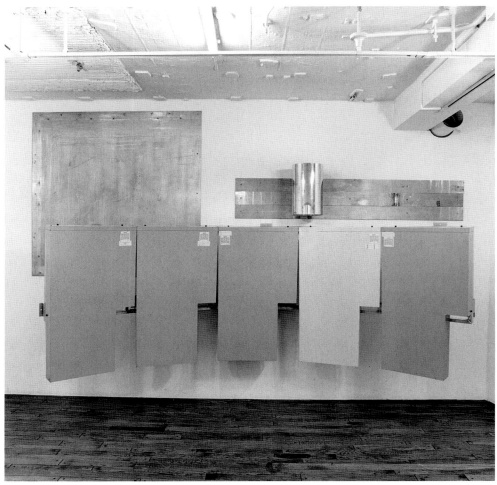

211

211
Untitled
1989
Temporary work I Temporäre Arbeit
Aluminium and steel covers I
Aluminium und Stahlverkleidungen
250 x 400 x 80 cm

Exhibition I Ausstellung
1989 Gallery Gen, Tokyo

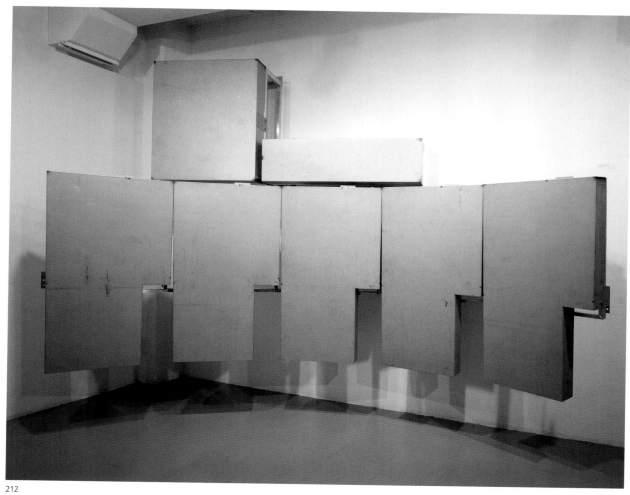

212

212
Corner Relief
1990
Aluminium and steel covers I
Aluminium und Stahlverkleidungen
216 x 150 cm
Akira Ikeda Gallery, Japan

Exhibition I Ausstellung
1990 Akira Ikeda Gallery, Tokyo

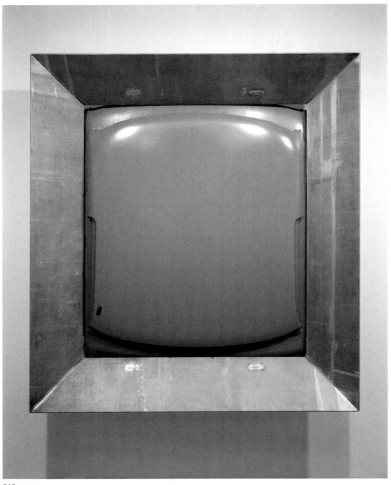

213

213
Frame
1990
Aluminium and die-pressed sheet steel l
Aluminium und gepresstes Stahlblech
171 x 151 x 35 cm
Akira Ikeda Gallery, Japan

Exhibition l Ausstellung
1990 Akira Ikeda Gallery, Tokyo

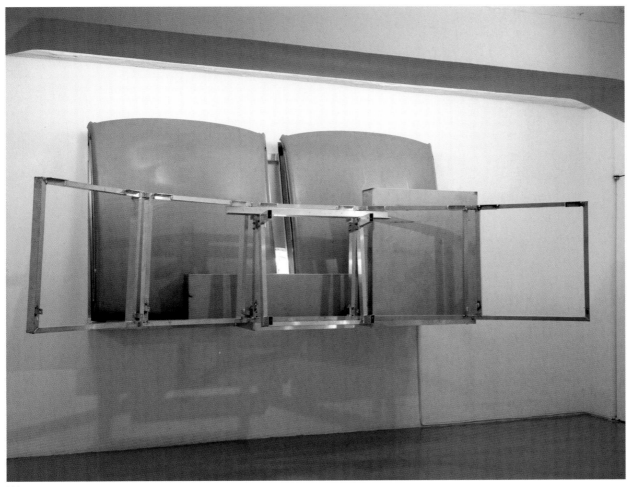

214

214
Untitled
1990
Aluminium, die-pressed sheet steel,
and fluorescent light I Aluminium,
gepresstes Stahlblech und Leuchtstoffröhre
131 x 306.5 x 145.5 cm
Private collection I Privatsammlung, Japan

Exhibition I Ausstellung
1990 Akira Ikeda Gallery, Tokyo

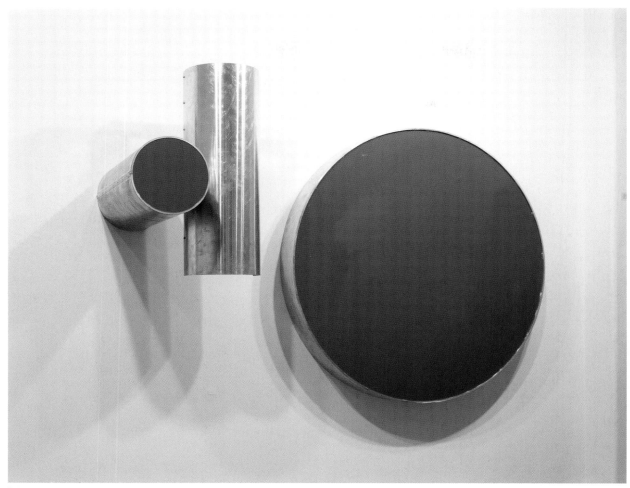

215

215
Three Cylinders
1990
Aluminium and green polyurethane I Aluminium
und grünes Polyurethan
Two pieces I Zwei Teile: 78 x 54 x 65 cm,
⌀ 121.5 x 15 cm
Together I Zusammen: 125 x 196 x 65 cm
Akira Ikeda Gallery, Japan

Exhibition I Ausstellung
1990 Akira Ikeda Gallery, Tokyo

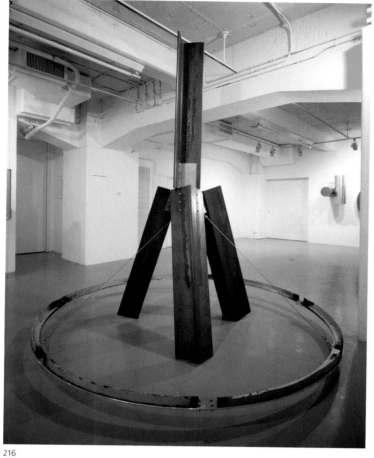

216

216
Four Pieces of L-shaped Steel and Yellow Circle
1990
Angle steel, steel cable, and steel I Winkelstahl,
Drahtseil und Stahl
255 x Ø 240 cm
Galerie Thaddaeus Ropac, Salzburg

Exhibition I Ausstellung
1990 Akira Ikeda Gallery, Tokyo

217
Suspended Steel Relief
1990
Steel beams, steel, and blocks and tackles I
Stahlträger, Stahl und Flaschenzüge
Two steel pieces I Zwei Stahlteile: 158 x 190 x 90 cm,
96 x 74.5 x 75.5 cm
Overall installation I Gesamte Aufhängung:
275 x 326 x 116 cm
Akira Ikeda Gallery, Japan

Exhibition I Ausstellung
1990 Akira Ikeda Gallery, Tokyo

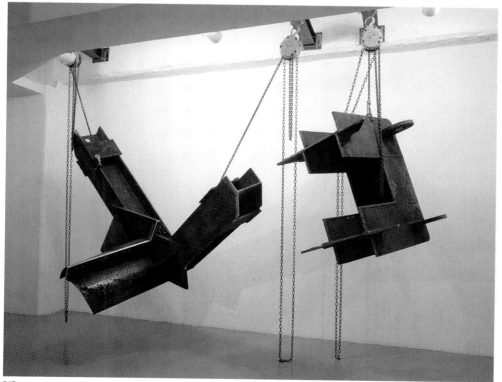

217

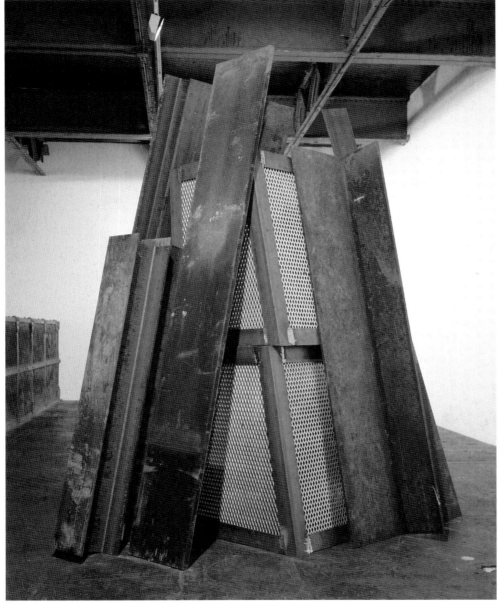

218

218
Floating in the Night Sea
1990
Temporary reproducible work l
Temporäre, wiederherstellbare Arbeit
Concrete, steel gratings, steel plates, steel I-beam,
and angle steel l Beton, Stahlgitter, Stahlplatten,
I-Träger aus Stahl und Winkelstahl
229.5 x 102 x 105 cm
Certificate with instructions and signature held by l
Zertifikat mit Konstruktionsanleitung und Signatur
im Besitz der Akira Ikeda Gallery, Japan

Exhibition l Ausstellung
1990 Akira Ikeda Gallery, Taura, Yokosuka

Bibliography
Works 1981–1986 (see No. 66)

219
Untitled
1990
Steel and oil l Stahl und Öl
Pool of oil l Ölwanne: 15 x ⌀ 800 cm
With substructure l Mit Unterbau: 24 x ⌀ 800 cm
Akira Ikeda Gallery, Japan

Exhibition l Ausstellung
1990 *Minimal Art*, The National Museum of Art,
Osaka (Cat., texts by Akira Tatehata, "Mono-ha
and Minimalism": 14–16; Noriyuki Haraguchi: 92)

Bibliography
Haraguchi, 1970–1993 (see No. 29): Cat. 21

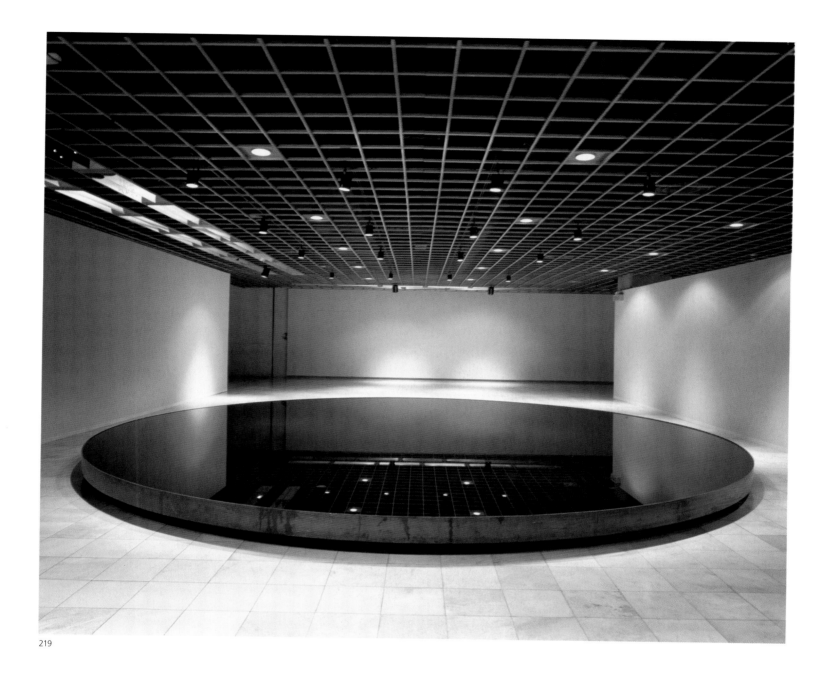

219

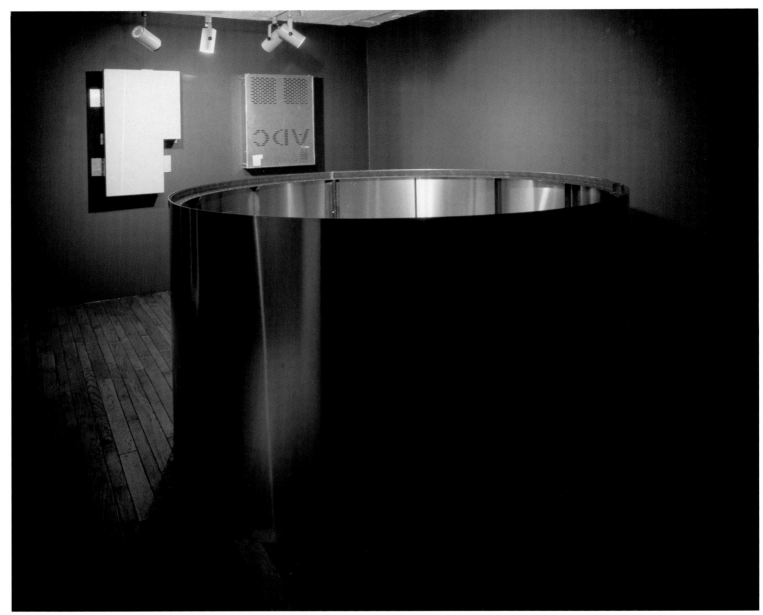

220, 221, 222

220
Untitled
1990
Aluminium and steel cover I
Aluminium und Stahlverkleidung
114.5 x 64 x 18 cm
Private collection I Privatsammlung, Japan

Exhibition I Ausstellung
1990 Gallery Gen, Tokyo

221
Untitled
1990
Steel cover I Stahlverkleidung
96.5 x 73 x 13 cm
Private collection I Privatsammlung, Japan

Exhibition I Ausstellung
1990 Gallery Gen, Tokyo

222
Untitled
1990
Temporary reproducible work I
Temporäre, wiederherstellbare Arbeit
Steel and aluminium I Stahl und Aluminium
125 x Ø 234 cm
Certificate with instructions and signature
held by I Zertifikat mit Konstruktionsanleitung
und Signatur im Besitz der Akira Ikeda Gallery,
Japan

Exhibition I Ausstellung
1990 Gallery Gen, Tokyo

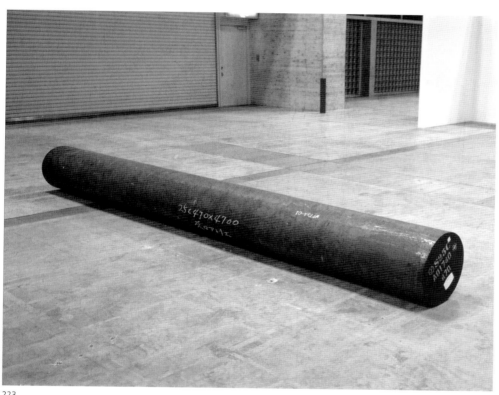

223

223
Untitled, FAS
1990
Cast steel I Stahlguss
240 cm x ∅ 48
Private collection I Privatsammlung, Japan

Exhibition I Ausstellung
1990 *Pharmakon '90: Makuhari Messe*
Contemporary Art Exhibition, Nippon Convention
Center, Makuhari Messe, Chiba (Cat.)

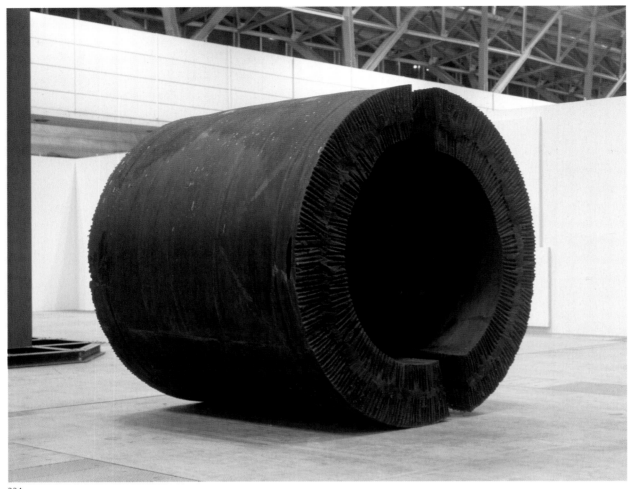

224

224
Untitled, FBS
1990
Rubber | Gummi
⌀ 280 x 240 cm
Akira Ikeda Gallery, Japan

Exhibition | Ausstellung
1990 *Pharmakon '90: Makuhari Messe*
Contemporary Art Exhibition, Nippon Convention
Center, Makuhari Messe, Chiba (Cat.)

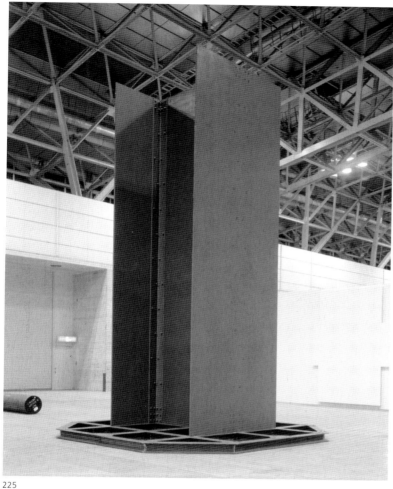

225

225
Untitled, FCS
1990
Steel I-beams, steel plates, and angle steel I
I-Träger aus Stahl, Stahlplatten und Winkelstahl
650 x 220 x 210 cm
Private collection I Privatsammlung, Japan

Exhibition I Ausstellung
1990 *Pharmakon '90: Makuhari Messe
Contemporary Art Exhibition*, Nippon Convention
Center, Makuhari Messe, Chiba (Cat.)

226
Untitled, FDS
1990
Aluminium and steel covers I
Aluminium und Stahlverkleidungen
130 cm x ∅ 820 cm
Akira Ikeda Gallery, Japan

Exhibition I Ausstellung
1990 *Pharmakon '90: Makuhari Messe
Contemporary Art Exhibition*, Nippon Convention
Center, Makuhari Messe, Chiba (Cat.)

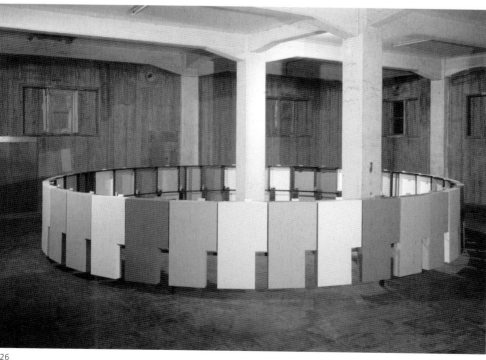

226

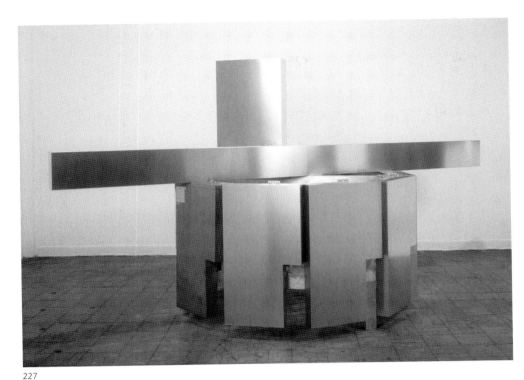

227

227
HG
1991
Aluminium and steel covers I
Aluminium und Stahlverkleidungen
240 x 450 x 226 cm
Akira Ikeda Gallery, Japan

Exhibition I Ausstellung
1991 Gotoh Museum of Art, Chiba

228
CA-1
1991
Aluminium and die-pressed sheet steel I
Aluminium und gepresstes Stahlblech
244 x 145 x 145 cm
Akira Ikeda Gallery, Japan

Exhibition I Ausstellung
1991 Gotoh Museum of Art, Chiba

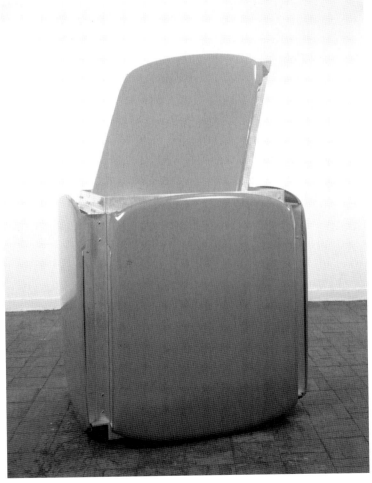

228

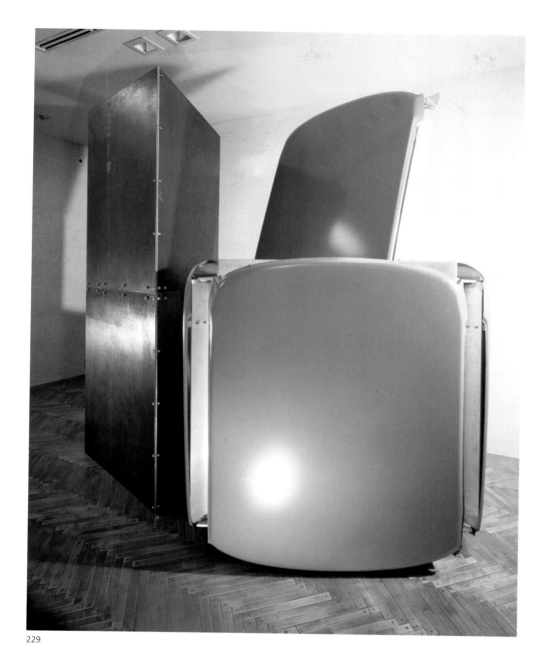

229

229
CA-2 · EVR-1 (Yutai)
1991
Destroyed I Zerstört
Steel plates, aluminium, and die-pressed sheet steel I
Stahlplatten, Aluminium und gepresstes Stahlblech
Two pieces I Zwei Teile: 250 x 110 x 90 cm,
245 x 145 x 145 cm
Formerly I Ehemals: Dentsu Inc., Tokyo

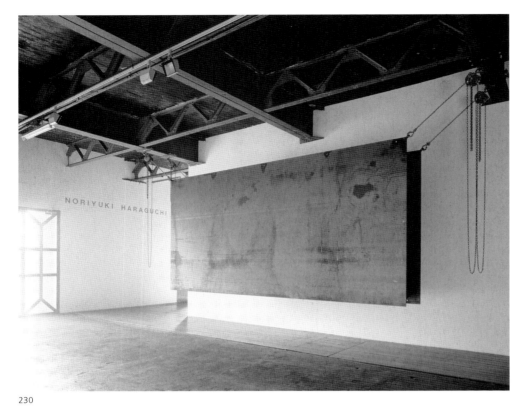

230

230
Untitled
1991
Steel plates and blocks and tackles l
Stahlplatten und Flaschenzüge
Two steel plates, together l Zwei Stahlplatten
zusammen: 240 x 500 x 65 cm
Akira Ikeda Gallery, Japan

Exhibition l Ausstellung
1991 Akira Ikeda Gallery, Taura, Yokosuka

231
Untitled
1991
Steel plate and blocks and tackles l
Stahlplatte und Flaschenzüge
Two segments of a steel plate l Zwei Segmente
einer Stahlplatte: 240 x 500 x 1.6 cm, Ø180 x 1.6 cm
Akira Ikeda Gallery, Japan

Exhibition l Ausstellung
1991 Akira Ikeda Gallery, Taura, Yokosuka

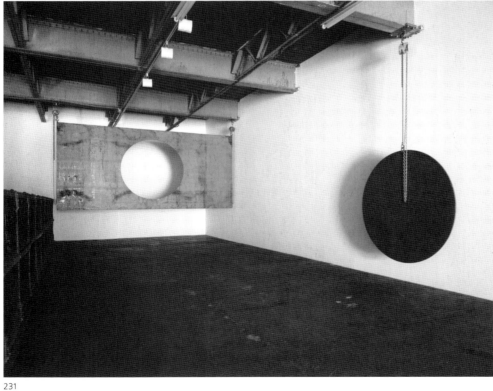

231

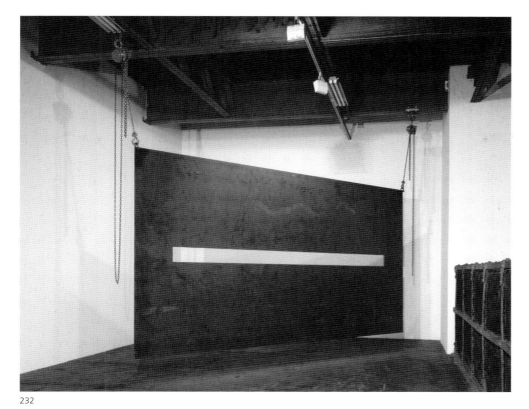

232

Untitled
1991
Steel plate and blocks and tackles |
Stahlplatte und Flaschenzüge
Steel plate | Stahlplatte: 240 x 500 x 1.6 cm
Akira Ikeda Gallery, Japan

Exhibition | Ausstellung
1991 Akira Ikeda Gallery, Taura, Yokosuka

233

Untitled
1991
Steel pipe and blocks and tackles |
Stahlrohr und Flaschenzüge
Steel pipe | Stahlrohr: 260 x ⌀ 250 cm
Akira Ikeda Gallery, Japan

Exhibition | Ausstellung
1991 Akira Ikeda Gallery, Taura, Yokosuka

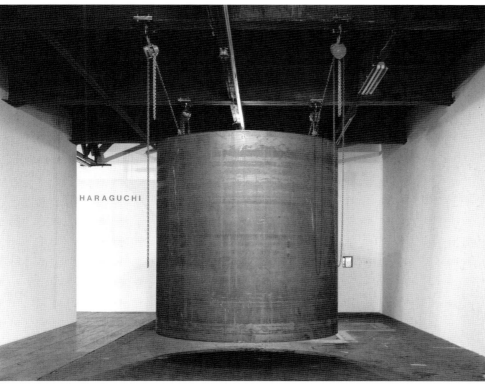

233

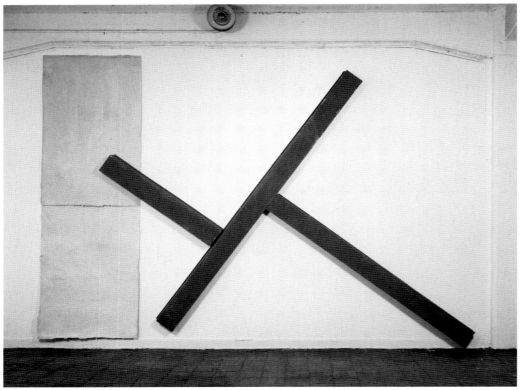

234

234
3M-3
1991
Temporary reproducible work I
Temporäre, wiederherstellbare Arbeit
Kaolin-coated Nepali paper and steel I
Mit Porzellanerde gestrichenes Papier aus Nepal
und Stahl
Papers I Papiere: 394 x 130 cm
Steel I Stahl: 370 x 488 x 11.5 cm
Together I Zusammen: 397 x 565 x 11.5 cm
Certificate with instructions and signature held by I
Zertifikat mit Konstruktionsanleitung und Signatur
im Besitz der Akira Ikeda Gallery, Japan

Exhibition I Ausstellung
1991 Gotoh Museum of Art, Chiba

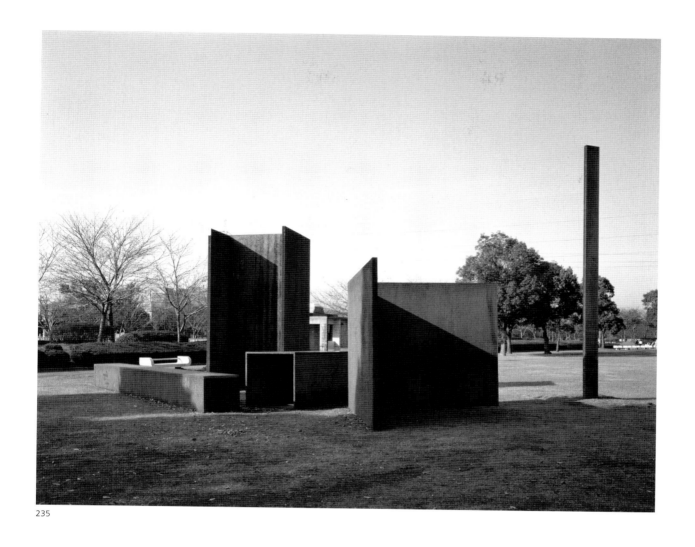

235

235
1. 2. 3. 4. 5.
1993
Steel plates I Stahlplatten
20 x 20 x 5 m
Municipality of I Gemeinde von Oita

Exhibition I Ausstellung
1993 *Oita Contemporary Art Exhibition '93:*
Propose to the Urban Environment – Impractical,
Oita (Cat.: 27–28)

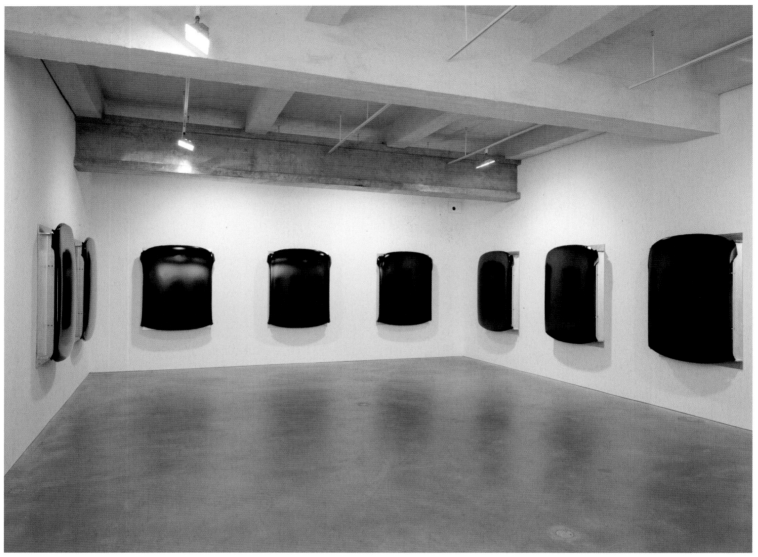

Eight pieces from 238–250

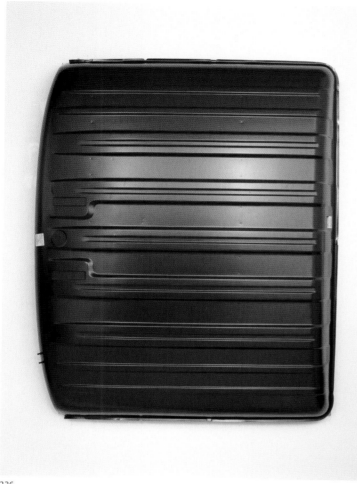

236

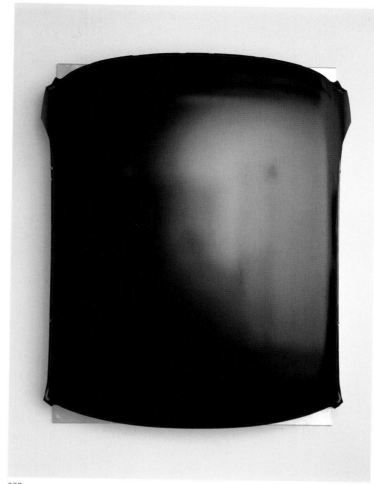

238

236
63100-2460-1
1993
Aluminium and die-pressed sheet steel I
Aluminium und gepresstes Stahlblech
187 x 150 x 28.5 cm
Private collection I Privatsammlung, Japan

Exhibition I Ausstellung
1993 *Noriyuki Haraguchi: New Works*,
Akira Ikeda Gallery, New York (Cat. 23 in
Noriyuki Haraguchi, 1970–1993)

237
63100-2460-2
1993
Aluminium and die-pressed sheet steel I
Aluminium und gepresstes Stahlblech
187 x 150 x 28.5 cm
Private collection I Privatsammlung, Japan

Exhibition I Ausstellung
1993 *Noriyuki Haraguchi: New Works*,
Akira Ikeda Gallery, New York

238
63111-91616-1
1993
Aluminium and die-pressed sheet steel I
Aluminium und gepresstes Stahlblech
146 x 118.5 x 23.5 cm
Private collection I Privatsammlung, Japan

Exhibition I Ausstellung
1993 *Noriyuki Haraguchi: New Works*,
Akira Ikeda Gallery, New York

239
63111-91616-2
1993
Aluminium and die-pressed sheet steel I
Aluminium und gepresstes Stahlblech
146 x 118.5 x 23.5 cm
Private collection I Privatsammlung, Japan

Exhibition I Ausstellung
1993 *Noriyuki Haraguchi: New Works*,
Akira Ikeda Gallery, New York

240
63111-91616-3
1993
Aluminium and die-pressed sheet steel I
Aluminium und gepresstes Stahlblech
146 x 118.5 x 23.5 cm
Private collection I Privatsammlung, Japan

Exhibition I Ausstellung
1993 *Noriyuki Haraguchi: New Works*,
Akira Ikeda Gallery, New York

241
63111-91616-4
1993
Aluminium and die-pressed sheet steel I
Aluminium und gepresstes Stahlblech
146 x 118.5 x 23.5 cm
Akira Ikeda Gallery, Japan

Exhibition I Ausstellung
1993 *Noriyuki Haraguchi: New Works*,
Akira Ikeda Gallery, New York (Cat. 24 in
Noriyuki Haraguchi, 1970–1993)

242
63111-91616-5
1993
Aluminium and die-pressed sheet steel I
Aluminium und gepresstes Stahlblech
146 x 118.5 x 23.5 cm
Private collection I Privatsammlung, Japan

Exhibition I Ausstellung
1993 *Noriyuki Haraguchi: New Works*,
Akira Ikeda Gallery, New York

243
63111-91616-6
1993
Aluminium and die-pressed sheet steel I
Aluminium und gepresstes Stahlblech
146 x 118.5 x 23.5 cm
Private collection I Privatsammlung, Japan

Exhibition I Ausstellung
1993 *Noriyuki Haraguchi: New Works*,
Akira Ikeda Gallery, New York

244
63111-91616-7
1993
Aluminium and die-pressed sheet steel I
Aluminium und gepresstes Stahlblech
146 x 118.5 x 23.5 cm
Private collection I Privatsammlung, Japan

Exhibition I Ausstellung
1993 *Noriyuki Haraguchi: New Works*,
Akira Ikeda Gallery, New York

245
63111-91616-8
1993
Aluminium and die-pressed sheet steel I
Aluminium und gepresstes Stahlblech
146 x 118.5 x 23.5 cm
Private collection I Privatsammlung, Japan

Exhibition I Ausstellung
1993 *Noriyuki Haraguchi: New Works*,
Akira Ikeda Gallery, New York

246
63111-91616-9
1993
Aluminium and die-pressed sheet steel I
Aluminium und gepresstes Stahlblech
146 x 118.5 x 23.5 cm
Akira Ikeda Gallery, Japan

Exhibition I Ausstellung
1993 *Noriyuki Haraguchi: New Works*,
Akira Ikeda Gallery, New York

247
63111-91616-10
1993
Aluminium and die-pressed sheet steel I
Aluminium und gepresstes Stahlblech
146 x 118.5 x 23.5 cm
Private collection I Privatsammlung, Japan

Exhibition I Ausstellung
1993 *Noriyuki Haraguchi: New Works*,
Akira Ikeda Gallery, New York

248
63111-91616-11
1993
Aluminium and die-pressed sheet steel I
Aluminium und gepresstes Stahlblech
146 x 118.5 x 23.5 cm
Private collection I Privatsammlung, Japan

Exhibition I Ausstellung
1993 *Noriyuki Haraguchi: New Works*,
Akira Ikeda Gallery, New York

249
63111-91616-12
1993
Aluminium and die-pressed sheet steel I
Aluminium und gepresstes Stahlblech
146 x 118.5 x 23.5 cm
Private collection I Privatsammlung, Japan

Exhibition I Ausstellung
1993 *Noriyuki Haraguchi: New Works*,
Akira Ikeda Gallery, New York

250
63111-91616-13
1993
Aluminium and die-pressed sheet steel I
Aluminium und gepresstes Stahlblech
146 x 118.5 x 23.5 cm
Private collection I Privatsammlung, Japan

Exhibition I Ausstellung
1993 *Noriyuki Haraguchi: New Works*,
Akira Ikeda Gallery, New York

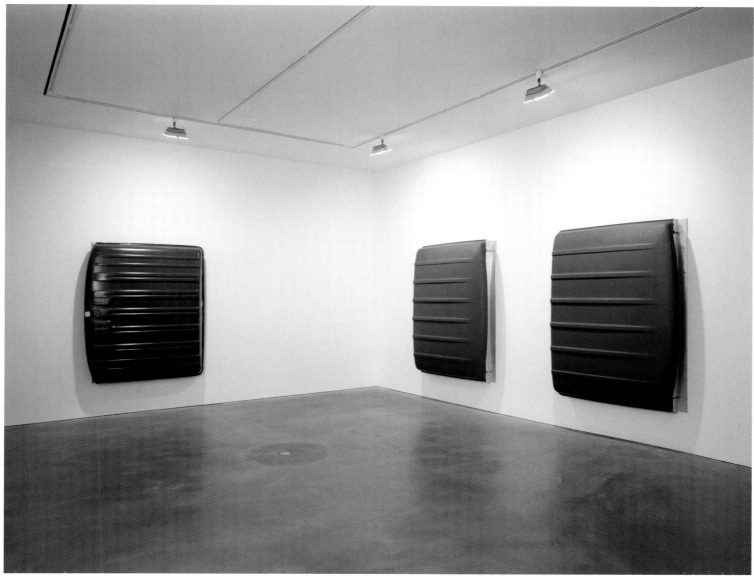

252, 253, 254

251
MC-908496-1
1993
Aluminium and die-pressed sheet steel I
Aluminium und gepresstes Stahlblech
196.5 x 150 x 34 cm
Akira Ikeda Gallery, Japan

Exhibition I Ausstellung
1993 *Noriyuki Haraguchi: New Works*,
Akira Ikeda Gallery, New York

252
MC-908496-2
1993
Aluminium and die-pressed sheet steel I
Aluminium und gepresstes Stahlblech
196.5 x 150 x 34 cm
Akira Ikeda Gallery, Japan

Exhibition I Ausstellung
1993 *Noriyuki Haraguchi: New Works*,
Akira Ikeda Gallery, New York

253
MC-908496-3
1993
Aluminium and die-pressed sheet steel I
Aluminium und gepresstes Stahlblech
196.5 x 150 x 34 cm
Akira Ikeda Gallery, Japan

Exhibition I Ausstellung
1993 *Noriyuki Haraguchi: New Works*,
Akira Ikeda Gallery, New York

254
MC-908496-4
1993
Aluminium and die-pressed sheet steel I
Aluminium und gepresstes Stahlblech
196.5 x 150 x 34 cm
Akira Ikeda Gallery, Japan

Exhibition I Ausstellung
1993 *Noriyuki Haraguchi: New Works*,
Akira Ikeda Gallery, New York

255
TG-1 (from a Car Roof)
1993
Aluminium and plaster I Aluminium und Gips
145 x 115 x 21.5 cm
Akira Ikeda Gallery, Japan

256
TG-2 (from a Car Roof)
1993
Aluminium and plaster I Aluminium und Gips
145 x 115 x 21.5 cm
Akira Ikeda Gallery, Japan

257
TG-3 (from a Car Roof)
1993
Aluminium and plaster I Aluminium und Gips
145 x 115 x 21.5 cm
Akira Ikeda Gallery, Japan

258
TG-4 (from a Car Roof)
1993
Aluminium and plaster I Aluminium und Gips
145 x 115 x 21.5 cm
Akira Ikeda Gallery, Japan

Exhibition I Ausstellung
1993 Akira Ikeda Gallery, Tokyo (Cat.)

259
TG-5 (from a Car Roof)
1993
Aluminium and plaster I Aluminium und Gips
145 x 115 x 21.5 cm
Private collection I Privatsammlung, Japan

Exhibition I Ausstellung
1993 Akira Ikeda Gallery, Tokyo (Cat.)

260
TG-6 (from a Car Roof)
1993
Aluminium and plaster I Aluminium und Gips
120 x 110 x 20 cm
Akira Ikeda Gallery, Japan

Exhibition I Ausstellung
1993 Akira Ikeda Gallery, Tokyo (Cat.)

261
TG-7 (from a Car Roof)
1993
Aluminium and plaster I Aluminium und Gips
120 x 110 x 20 cm
Private collection I Privatsammlung, Japan

Exhibition I Ausstellung
1993 Akira Ikeda Gallery, Tokyo (Cat.)

262
TG-8 (from a Car Roof)
1993
Aluminium and plaster I Aluminium und Gips
119.5 x 108.5 x 21.5 cm
Akira Ikeda Gallery, Japan

263
TG-9 (from a Car Roof)
1993
Aluminium and plaster I Aluminium und Gips
119.5 x 108.5 x 21.5 cm
Akira Ikeda Gallery, Japan

Exhibition I Ausstellung
1993 Akira Ikeda Gallery, Tokyo (Cat.)

258

261

263

264
Untitled, 1
1993
Aluminium and die-pressed sheet steel I
Aluminium und gepresstes Stahlblech
120.5 x 107 x 21 cm
Akira Ikeda Gallery, Japan

Exhibitions I Ausstellungen
1993 *Noriyuki Haraguchi: New Works*,
Akira Ikeda Gallery, New York (Cat. 22 in
Noriyuki Haraguchi, 1970–1993)
1995 *Summer Show*, Akira Ikeda Gallery, Nagoya

265
Untitled, 2
1993
Aluminium and die-pressed sheet steel I
Aluminium und gepresstes Stahlblech
120.5 x 107 x 21 cm
Private collection I Privatsammlung, Japan

Exhibitions I Ausstellungen
1993 *Noriyuki Haraguchi: New Works*,
Akira Ikeda Gallery, New York
1995 *Summer Show*, Akira Ikeda Gallery, Nagoya

266
Untitled, 3
1993
Aluminium and die-pressed sheet steel I
Aluminium und gepresstes Stahlblech
120.5 x 107 x 21 cm
Collection of the artist I Besitz des Künstlers

267
Panel Relief
1993
Putty on plywood, paper, and die-pressed sheet steel I
Kitt auf Sperrholz, Papier und gepresstes Stahlblech
181 x 122 x 26 cm
Private collection I Privatsammlung, Japan

Exhibition I Ausstellung
1993 Akira Ikeda Gallery, Tokyo (Cat.)

266

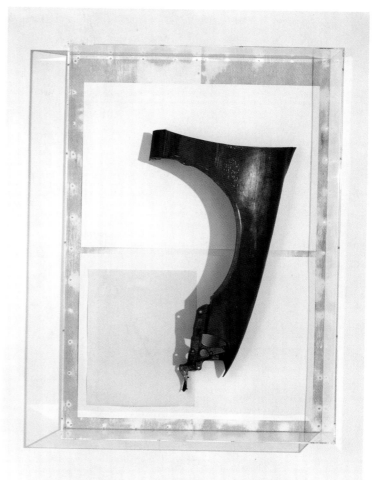

267

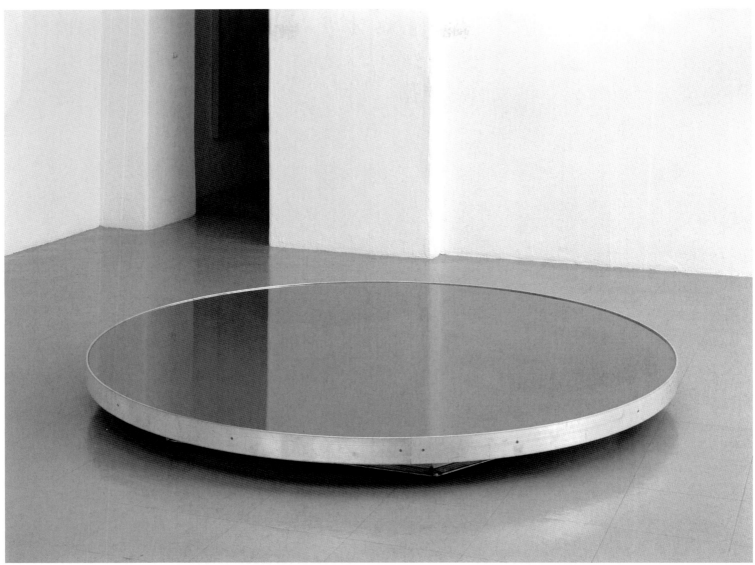

268

268
Water Disk
1993
Aluminium and green polyurethane I Aluminium
und grünes Polyurethan
18 x ∅ 202 cm
Private collection I Privatsammlung, Japan

Exhibition I Ausstellung
1993 Akira Ikeda Gallery, Tokyo (Cat.)

269

269
Untitled
1994
Pastel and pencil on canvas | Pastell und Bleistift
auf Leinwand
23 x 16 cm
Private collection | Privatsammlung, Japan

Exhibition | Ausstellung
1995 *Nagoya Contemporary Art Fair VIII*,
Nagoya City Gallery

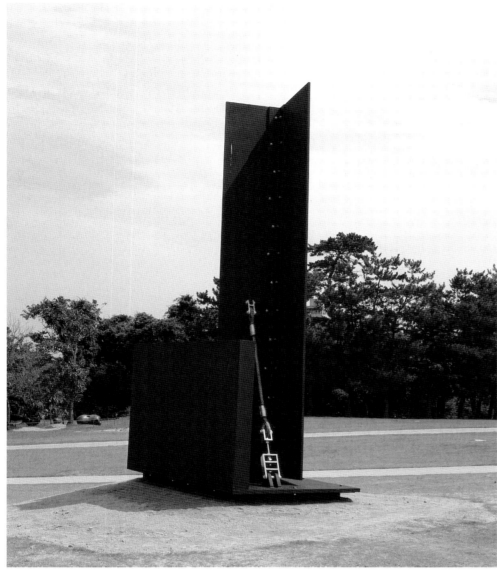

270

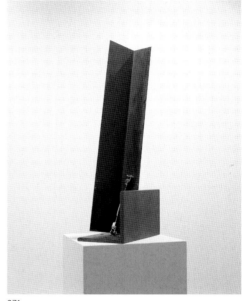

271

270
Ube
1995
Steel plates, angle steel, steel cable, and steel
fastening pieces I Stahlplatten, Winkelstahl, Drahtseil
und Befestigungsteile aus Stahl
630 x 200 x 400 cm
Ube City

Exhibition I Ausstellung
1995 *16th Modern Sculpture of Japan Exhibition*,
Tokiwa Park, Ube

271
Untitled
1995
Maquette for I für *Ube*, 1995
Angle steel, copper, steel cable, and steel
fastening pieces I Winkelstahl, Kupfer, Drahtseil
und Befestigungsteile aus Stahl
84.5 x 20 x 35 cm
Private collection I Privatsammlung, Japan

Exhibition I Ausstellung
1995 *Small Sculptures*, Akira Ikeda Gallery, Tokyo

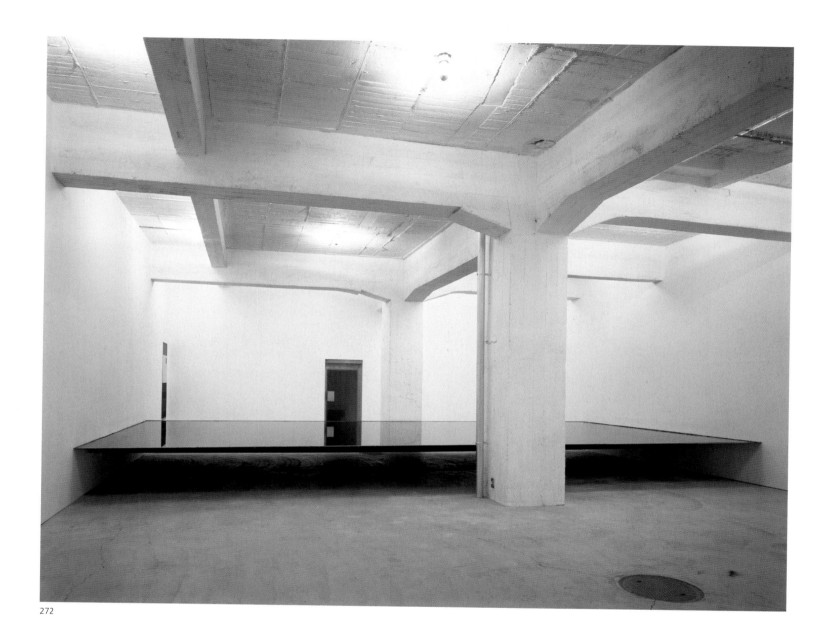

272

272
Yumen
1995
Aluminium, iron, and oil I Aluminium, Eisen und Öl
21 x 888 x 445 cm (installed 39 cm above the floor I
installiert 39 cm über dem Boden)
Akira Ikeda Gallery, Japan

Exhibition I Ausstellung
1995 Akira Ikeda Gallery, Nagoya (Cat.)

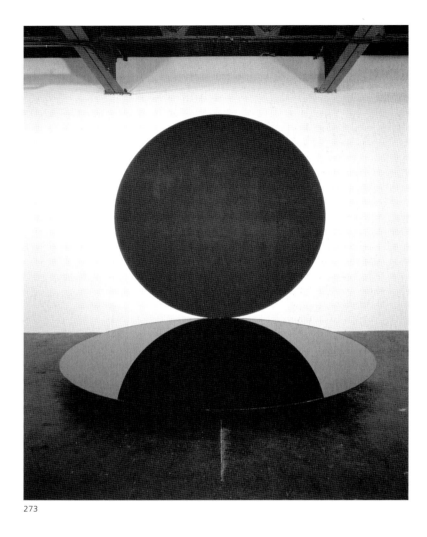

273

273
Circle
1996
Aluminium, oil, and acrylic on wood I
Aluminium, Öl und Acryl auf Holz
Pool of oil I Ölwanne: 24.5 x Ø 350 cm
Acrylic painting I Acrylgemälde: Ø 350 cm
Collection of the artist I Besitz des Künstlers

Exhibition I Ausstellung
1996 Akira Ikeda Gallery, Taura, Yokosuka

274
Four
1996
Steel, oil, and acrylic on wood I Stahl, Öl und
Acryl auf Holz
Four pools of oil, each I Vier Ölwannen jeweils:
35 x 274 x 454 cm
Akira Ikeda Gallery, Japan

Exhibition I Ausstellung
1996 Akira Ikeda Gallery, Taura, Yokosuka

275
Untitled (Taura)
1996
Temporary work I Temporäre Arbeit
Acrylic on wood and oil I Acryl auf Holz und Öl
66 x 539 x 633 cm

Exhibition I Ausstellung
1996 Akira Ikeda Gallery, Taura, Yokosuka

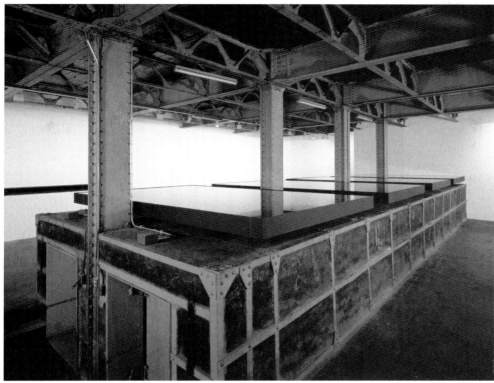

274

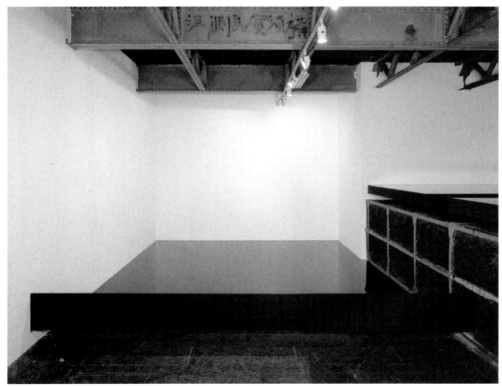

275

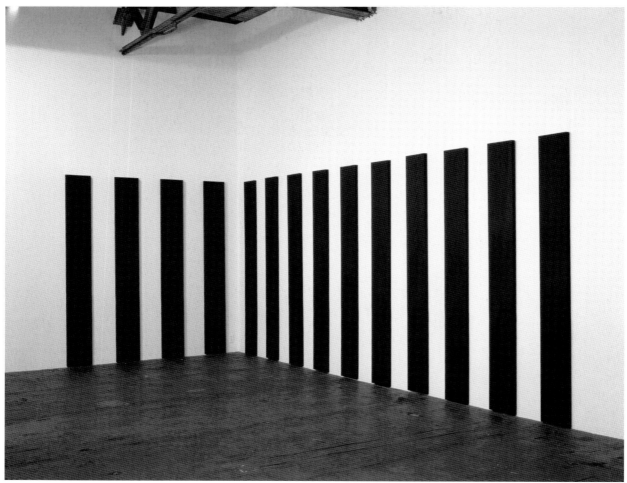

276

276
14 Boards
1996
Acrylic on cardboard I Acryl auf Pappe
Fourteen pieces, each I Vierzehn Teile jeweils:
243 x 29 x 4 cm
Collection of the artist I Besitz des Künstlers

Exhibition I Ausstellung
1996 Akira Ikeda Gallery, Taura, Yokosuka

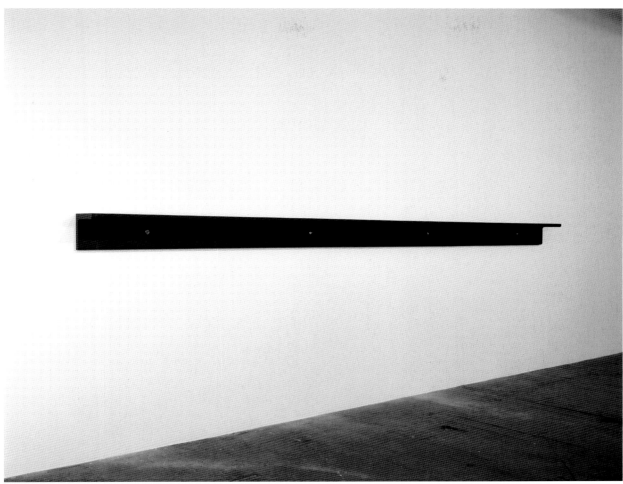

277

277
L
1996
Acrylic on wood I Acryl auf Holz
23.5 x 549 x 23.5 cm
Collection of the artist I Besitz des Künstlers

Exhibition I Ausstellung
1996 Akira Ikeda Gallery, Taura, Yokosuka

278
a-3
1996
Naturally corroded iron plate I
Natürlich korrodierte Eisenplatte
24 x 18 cm
Akira Ikeda Gallery, Japan

Exhibition I Ausstellung
1996 *Nagoya Contemporary Art Fair IX*,
Nagoya City Gallery

280, 281, 279, 282

279	280	281
Grey	Grey 1	Grey 2
1997	1997	1997
Oil on canvas I Öl auf Leinwand	Acrylic on canvas I Acryl auf Leinwand	Oil on canvas I Öl auf Leinwand
148 x 99 cm	47 x 79 cm	47 x 79 cm
Collection of the artist I Besitz des Künstlers	Collection of the artist I Besitz des Künstlers	Collection of the artist I Besitz des Künstlers
Exhibition I Ausstellung	Exhibition I Ausstellung	Exhibition I Ausstellung
1997 Akira Ikeda Gallery, Tokyo	1997 Akira Ikeda Gallery, Tokyo	1997 Akira Ikeda Gallery, Tokyo

284

282
Untitled
1997
Acrylic on canvas I Acryl auf Leinwand
148 x 89 cm
Collection of the artist I Besitz des Künstlers

Exhibition I Ausstellung
1997 Akira Ikeda Gallery, Tokyo

283
Untitled
1997
Oil on canvas I Öl auf Leinwand
148 x 99 cm
Collection of the artist I Besitz des Künstlers

Exhibition I Ausstellung
1997 Akira Ikeda Gallery, Tokyo

284
Untitled
1998
Green polyurethane and charcoal on canvas
mounted on canvas with acrylic I Grünes Polyurethan
und Kohle auf Leinwand über Acryl auf Leinwand
73 x 61 x 11 cm
Private collection I Privatsammlung, Japan

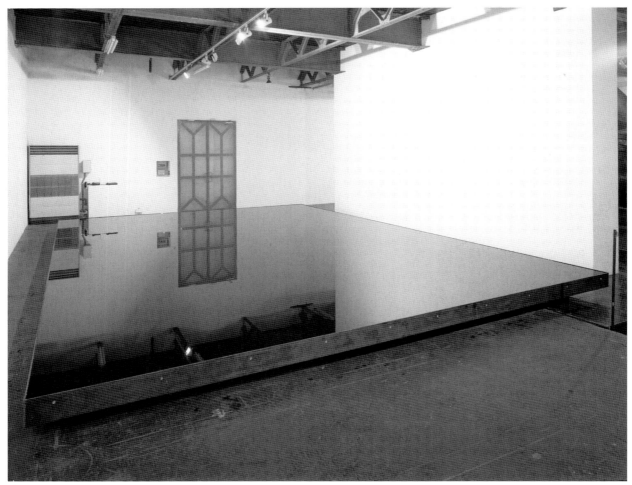

285

285
Untitled
1998
Aluminium, steel, and oil I Aluminium, Stahl und Öl
Pool of oil I Ölwanne: 18 x 600 x 800 cm
With substructure I Mit Unterbau: 25 x 800 x 600 cm
Akira Ikeda Gallery, Japan

Exhibitions I Ausstellungen
1998 Akira Ikeda Gallery, Taura, Yokosuka
2001 *Noriyuki Haraguchi. Elemente der
Wahrnehmung. Arbeiten 1963–2001*, Städtische
Galerie im Lenbachhaus, Munich I München

286
Untitled
1999
Temporary work I Temporäre Arbeit
Oil paint on plywood and oil and Indian ink
on wooden floor I Ölfarbe auf Sperrholz sowie
Öl und Tusche auf Holzboden
270 x 950 cm

Exhibition I Ausstellung
1999 *Atami Biennale*, Atami

Bibliography
"Atami Biennale", in *Acrylart* (1 April 2000):
XXXVIII, 5–11

286

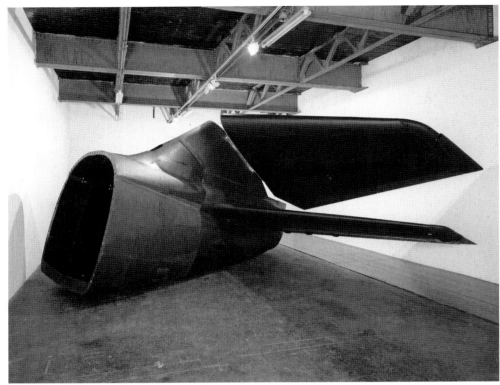

287

287
Black Viking S-3
2000
Black polyurethane and carbon paper on plywood
and aluminium I Schwarzes Polyurethan und
Kohlepapier auf Sperrholz und Aluminium
317 x 816 x 595 cm
Collection of the artist I Besitz des Künstlers

Exhibition I Ausstellung
2001 *Noriyuki Haraguchi. Elemente der
Wahrnehmung. Arbeiten 1963–2001*, Städtische
Galerie im Lenbachhaus, Munich I München

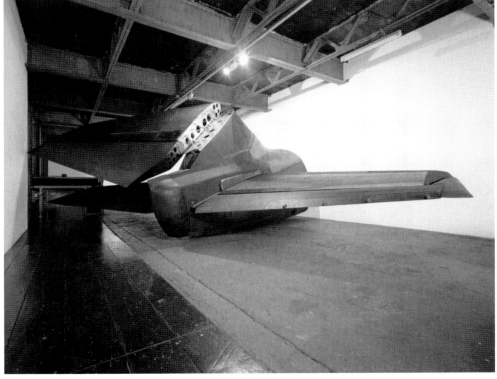

287

288
Untitled, ML-1
2000
Aluminium and black polyurethane on plywood |
Aluminium und schwarzes Polyurethan auf Sperrholz
150 x 150 x 15 cm
Akira Ikeda Gallery, Japan

Exhibition | Ausstellung
2001 *Noriyuki Haraguchi. Elemente der
Wahrnehmung. Arbeiten 1963–2001*, Städtische
Galerie im Lenbachhaus, Munich | München

289
Untitled, ML-2
2000
Aluminium and black polyurethane on plywood |
Aluminium und schwarzes Polyurethan auf Sperrholz
150 x 150 x 15 cm
Akira Ikeda Gallery, Japan

Exhibition | Ausstellung
2001 *Noriyuki Haraguchi. Elemente der
Wahrnehmung. Arbeiten 1963–2001*, Städtische
Galerie im Lenbachhaus, Munich | München

290
Untitled, ML-3
2000
Aluminium and black polyurethane on plywood |
Aluminium und schwarzes Polyurethan auf Sperrholz
150 x 150 x 15 cm
Akira Ikeda Gallery, Japan

Exhibition | Ausstellung
2001 *Noriyuki Haraguchi. Elemente der
Wahrnehmung. Arbeiten 1963–2001*, Städtische
Galerie im Lenbachhaus, Munich | München

291
Untitled, ML-4
2000
Aluminium and black polyurethane on plywood |
Aluminium und schwarzes Polyurethan auf Sperrholz
150 x 150 x 15 cm
Akira Ikeda Gallery, Japan

Exhibition | Ausstellung
2001 *Noriyuki Haraguchi. Elemente der
Wahrnehmung. Arbeiten 1963–2001*, Städtische
Galerie im Lenbachhaus, Munich | München

292
Untitled, ML-5
2000
Aluminium and black polyurethane on plywood |
Aluminium und schwarzes Polyurethan auf Sperrholz
150 x 150 x 15 cm
Akira Ikeda Gallery, Japan

Exhibition | Ausstellung
2001 *Noriyuki Haraguchi. Elemente der
Wahrnehmung. Arbeiten 1963–2001*, Städtische
Galerie im Lenbachhaus, Munich | München

293
Untitled, ML-6
2000
Aluminium and black polyurethane on plywood |
Aluminium und schwarzes Polyurethan auf Sperrholz
150 x 150 x 15 cm
Akira Ikeda Gallery, Japan

Exhibition | Ausstellung
2001 *Noriyuki Haraguchi. Elemente der
Wahrnehmung. Arbeiten 1963–2001*, Städtische
Galerie im Lenbachhaus, Munich | München

288

294
Untitled, ML-7
2000
Aluminium and black polyurethane on plywood l
Aluminium und schwarzes Polyurethan auf Sperrholz
150 x 150 x 15 cm
Akira Ikeda Gallery, Japan

Exhibition l Ausstellung
2001 *Noriyuki Haraguchi. Elemente der*
Wahrnehmung. Arbeiten 1963–2001, Städtische
Galerie im Lenbachhaus, Munich l München

295

295
Oil Works 1
2000
Plan for I Plan für *Oil Works 1* (18 x 602 x 482 cm)
Bronze, cardboard, cloth, glass bottle, oil, and ink jet
printing and gouache on paper I Bronze, Pappe,
Stoff, Glasfläschchen, Öl sowie Tintenstrahldruck
und Gouache auf Papier
Bronze case I Bronzekasten: 4.1 x 73.7 x 55 cm
Cloth-covered cardboard box I Stoffbespannte
Pappschachtel: 3.7 x 73.7 x 54.6 cm
Bottle of oil I Ölfläschchen: 14 x ∅ 3 cm
Title sheet, gouache of the planned work, and six
additional sheets of paper with instructions, each I
Titelblatt, Gouache mit einer Zeichnung des pro-
jektierten Werkes und sechs weitere Blatt Papier mit
Konstruktionsanleitungen jeweils: 50 x 65 cm
Akira Ikeda Gallery, Japan

Exhibition I Ausstellung
2001 *Noriyuki Haraguchi. Elemente der
Wahrnehmung. Arbeiten 1963–2001*, Städtische
Galerie im Lenbachhaus, Munich I München

296
Oil Works 2
2000
Plan for I Plan für *Oil Works 2* (18 x 752 x 552 cm)
Bronze, cardboard, cloth, glass bottle, oil, and ink jet
printing and gouache on paper I Bronze, Pappe,
Stoff, Glasfläschchen, Öl sowie Tintenstrahldruck
und Gouache auf Papier
Bronze case I Bronzekasten: 4.1 x 73.7 x 55 cm
Cloth-covered cardboard box I Stoffbespannte
Pappschachtel: 3.7 x 73.7 x 54.6 cm
Bottle of oil I Ölfläschchen: 14 x ∅ 3 cm
Title sheet, gouache of the planned work, and six
additional sheets of paper with instructions, each I
Titelblatt, Gouache mit einer Zeichnung des pro-
jektierten Werkes und sechs weitere Blatt Papier mit
Konstruktionsanleitungen jeweils: 50 x 65 cm
Akira Ikeda Gallery, Japan

Exhibition I Ausstellung
2001 *Noriyuki Haraguchi. Elemente der
Wahrnehmung. Arbeiten 1963–2001*, Städtische
Galerie im Lenbachhaus, Munich I München

300

297
Oil Works 3
2000
Plan for I Plan für *Oil Works 3* (18 x 602 x 362 cm)
Bronze, cardboard, cloth, glass bottle, oil, and ink jet
printing and gouache on paper I Bronze, Pappe,
Stoff, Glasfläschchen, Öl sowie Tintenstrahldruck
und Gouache auf Papier
Bronze case I Bronzekasten: 4.1 x 73.7 x 55 cm
Cloth-covered cardboard box I Stoffbespannte
Pappschachtel: 3.7 x 73.7 x 54.6 cm
Bottle of oil I Ölfläschchen: 14 x ⌀ 3 cm
Title sheet, gouache of the planned work, and six
additional sheets of paper with instructions, each I
Titelblatt, Gouache mit einer Zeichnung des pro-
jektierten Werkes und sechs weitere Blatt Papier mit
Konstruktionsanleitungen jeweils: 50 x 65 cm
Akira Ikeda Gallery, Japan

Exhibition I Ausstellung
2001 *Noriyuki Haraguchi. Elemente der
Wahrnehmung. Arbeiten 1963–2001*, Städtische
Galerie im Lenbachhaus, Munich I München

298
Oil Works 4
2000
Plan for I Plan für *Oil Works 4* (18 x 482 x 482 cm)
Bronze, cardboard, cloth, glass bottle, oil, and ink jet
printing and gouache on paper I Bronze, Pappe,
Stoff, Glasfläschchen, Öl sowie Tintenstrahldruck
und Gouache auf Papier
Bronze case I Bronzekasten: 4.1 x 73.7 x 55 cm
Cloth-covered cardboard box I Stoffbespannte
Pappschachtel: 3.7 x 73.7 x 54.6 cm
Bottle of oil I Ölfläschchen: 14 x ⌀ 3 cm
Title sheet, gouache of the planned work, and six
additional sheets of paper with instructions, each I
Titelblatt, Gouache mit einer Zeichnung des pro-
jektierten Werkes und sechs weitere Blatt Papier mit
Konstruktionsanleitungen jeweils: 50 x 65 cm
Akira Ikeda Gallery, Japan

Exhibition I Ausstellung
2001 *Noriyuki Haraguchi. Elemente der
Wahrnehmung. Arbeiten 1963–2001*, Städtische
Galerie im Lenbachhaus, Munich I München

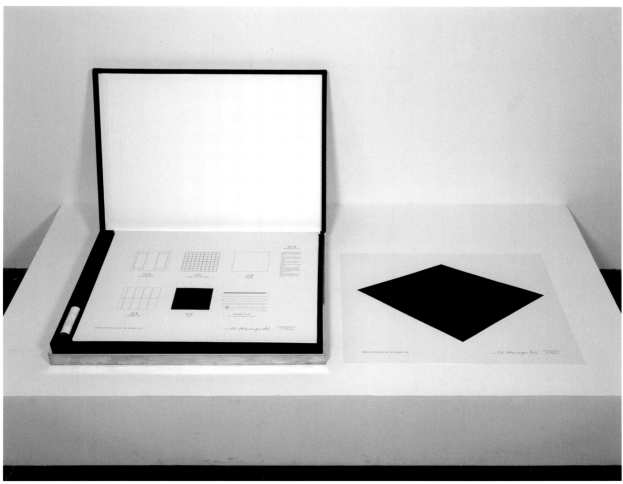

306

299
Oil Works 5
2000
Plan for I Plan für *Oil Works 5* (18 x 722 x 602 cm)
Bronze, cardboard, cloth, glass bottle, oil, and ink jet
printing and gouache on paper I Bronze, Pappe,
Stoff, Glasfläschchen, Öl sowie Tintenstrahldruck
und Gouache auf Papier
Bronze case I Bronzekasten: 4.1 x 73.7 x 55 cm
Cloth-covered cardboard box I Stoffbespannte
Pappschachtel: 3.7 x 73.7 x 54.6 cm
Bottle of oil I Ölfläschchen: 14 x ∅ 3 cm
Title sheet, gouache of the planned work, and six
additional sheets of paper with instructions, each I
Titelblatt, Gouache mit einer Zeichnung des pro-
jektierten Werkes und sechs weitere Blatt Papier mit
Konstruktionsanleitungen jeweils: 50 x 65 cm
Akira Ikeda Gallery, Japan

Exhibition I Ausstellung
2001 *Noriyuki Haraguchi. Elemente der
Wahrnehmung. Arbeiten 1963–2001*, Städtische
Galerie im Lenbachhaus, Munich I München

300
Oil Works 6
2000
Plan for I Plan für *Oil Works 6* (18 x 722 x 242 cm)
Bronze, cardboard, cloth, glass bottle, oil, and ink jet
printing and gouache on paper I Bronze, Pappe,
Stoff, Glasfläschchen, Öl sowie Tintenstrahldruck
und Gouache auf Papier
Bronze case I Bronzekasten: 4.1 x 73.7 x 55 cm
Cloth-covered cardboard box I Stoffbespannte
Pappschachtel: 3.7 x 73.7 x 54.6 cm
Bottle of oil I Ölfläschchen: 14 x ∅ 3 cm
Title sheet, gouache of the planned work, and six
additional sheets of paper with instructions, each I
Titelblatt, Gouache mit einer Zeichnung des pro-
jektierten Werkes und sechs weitere Blatt Papier mit
Konstruktionsanleitungen jeweils: 50 x 65 cm
Akira Ikeda Gallery, Japan

Exhibition I Ausstellung
2001 *Noriyuki Haraguchi. Elemente der
Wahrnehmung. Arbeiten 1963–2001*, Städtische
Galerie im Lenbachhaus, Munich I München

301
Oil Works 7
2000
Plan for l Plan für *Oil Works 7* (18 x 662 x 482 cm)
Bronze, cardboard, cloth, glass bottle, oil, and ink jet
printing and gouache on paper l Bronze, Pappe,
Stoff, Glasfläschchen, Öl sowie Tintenstrahldruck
und Gouache auf Papier
Bronze case l Bronzekasten: 4.1 x 73.7 x 55 cm
Cloth-covered cardboard box l Stoffbespannte
Pappschachtel: 3.7 x 73.7 x 54.6 cm
Bottle of oil l Ölfläschchen: 14 x Ø 3 cm
Title sheet, gouache of the planned work, and six
additional sheets of paper with instructions, each l
Titelblatt, Gouache mit einer Zeichnung des pro-
jektierten Werkes und sechs weitere Blatt Papier mit
Konstruktionsanleitungen jeweils: 50 x 65 cm
Akira Ikeda Gallery, Japan

Exhibition l Ausstellung
2001 *Noriyuki Haraguchi. Elemente der
Wahrnehmung. Arbeiten 1963–2001*, Städtische
Galerie im Lenbachhaus, Munich l München

302
Oil Works 8
2000
Plan for l Plan für *Oil Works 8* (18 x 722 x 482 cm)
Bronze, cardboard, cloth, glass bottle, oil, and ink jet
printing and gouache on paper l Bronze, Pappe,
Stoff, Glasfläschchen, Öl sowie Tintenstrahldruck
und Gouache auf Papier
Bronze case l Bronzekasten: 4.1 x 73.7 x 55 cm
Cloth-covered cardboard box l Stoffbespannte
Pappschachtel: 3.7 x 73.7 x 54.6 cm
Bottle of oil l Ölfläschchen: 14 x Ø 3 cm
Title sheet, gouache of the planned work, and six
additional sheets of paper with instructions, each l
Titelblatt, Gouache mit einer Zeichnung des pro-
jektierten Werkes und sechs weitere Blatt Papier mit
Konstruktionsanleitungen jeweils: 50 x 65 cm
Akira Ikeda Gallery, Japan

Exhibition l Ausstellung
2001 *Noriyuki Haraguchi. Elemente der
Wahrnehmung. Arbeiten 1963–2001*, Städtische
Galerie im Lenbachhaus, Munich l München

303
Oil Works 9
2000
Plan for l Plan für *Oil Works 9* (18 x 702 x 602 cm)
Bronze, cardboard, cloth, glass bottle, oil, and ink jet
printing and gouache on paper l Bronze, Pappe,
Stoff, Glasfläschchen, Öl sowie Tintenstrahldruck
und Gouache auf Papier
Bronze case l Bronzekasten: 4.1 x 73.7 x 55 cm
Cloth-covered cardboard box l Stoffbespannte
Pappschachtel: 3.7 x 73.7 x 54.6 cm
Bottle of oil l Ölfläschchen: 14 x Ø 3 cm
Title sheet, gouache of the planned work, and six
additional sheets of paper with instructions, each l
Titelblatt, Gouache mit einer Zeichnung des pro-
jektierten Werkes und sechs weitere Blatt Papier mit
Konstruktionsanleitungen jeweils: 50 x 65 cm
Akira Ikeda Gallery, Japan

Exhibition l Ausstellung
2001 *Noriyuki Haraguchi. Elemente der
Wahrnehmung. Arbeiten 1963–2001*, Städtische
Galerie im Lenbachhaus, Munich l München

304
Oil Works 10
2000
Plan for l Plan für *Oil Works 10* (18 x 602 x 602 cm)
Bronze, cardboard, cloth, glass bottle, oil, and ink jet
printing and gouache on paper l Bronze, Pappe,
Stoff, Glasfläschchen, Öl sowie Tintenstrahldruck
und Gouache auf Papier
Bronze case l Bronzekasten: 4.1 x 73.7 x 55 cm
Cloth-covered cardboard box l Stoffbespannte
Pappschachtel: 3.7 x 73.7 x 54.6 cm
Bottle of oil l Ölfläschchen: 14 x Ø 3 cm
Title sheet, gouache of the planned work, and six
additional sheets of paper with instructions, each l
Titelblatt, Gouache mit einer Zeichnung des pro-
jektierten Werkes und sechs weitere Blatt Papier mit
Konstruktionsanleitungen jeweils: 50 x 65 cm
Akira Ikeda Gallery, Japan

Exhibition l Ausstellung
2001 *Noriyuki Haraguchi. Elemente der
Wahrnehmung. Arbeiten 1963–2001*, Städtische
Galerie im Lenbachhaus, Munich l München

305
Oil Works 11
2000
Plan for l Plan für *Oil Works 11* (18 x 802 x 602 cm)
Bronze, cardboard, cloth, glass bottle, oil, and ink jet
printing and gouache on paper l Bronze, Pappe,
Stoff, Glasfläschchen, Öl sowie Tintenstrahldruck
und Gouache auf Papier
Bronze case l Bronzekasten: 4.1 x 73.7 x 55 cm
Cloth-covered cardboard box l Stoffbespannte
Pappschachtel: 3.7 x 73.7 x 54.6 cm
Bottle of oil l Ölfläschchen: 14 x Ø 3 cm
Title sheet, gouache of the planned work, and six
additional sheets of paper with instructions, each l
Titelblatt, Gouache mit einer Zeichnung des pro-
jektierten Werkes und sechs weitere Blatt Papier mit
Konstruktionsanleitungen jeweils: 50 x 65 cm
Akira Ikeda Gallery, Japan

Exhibition l Ausstellung
2001 *Noriyuki Haraguchi. Elemente der
Wahrnehmung. Arbeiten 1963–2001*, Städtische
Galerie im Lenbachhaus, Munich l München

306
Oil Works 12
2000
Plan for l Plan für *Oil Works 12* (18 x 542 x 482 cm)
Bronze, cardboard, cloth, glass bottle, oil, and ink jet
printing and gouache on paper l Bronze, Pappe,
Stoff, Glasfläschchen, Öl sowie Tintenstrahldruck
und Gouache auf Papier
Bronze case l Bronzekasten: 4.1 x 73.7 x 55 cm
Cloth-covered cardboard box l Stoffbespannte
Pappschachtel: 3.7 x 73.7 x 54.6 cm
Bottle of oil l Ölfläschchen: 14 x Ø 3 cm
Title sheet, gouache of the planned work, and six
additional sheets of paper with instructions, each l
Titelblatt, Gouache mit einer Zeichnung des pro-
jektierten Werkes und sechs weitere Blatt Papier mit
Konstruktionsanleitungen jeweils: 50 x 65 cm
Collection of the artist l Besitz des Künstlers

Exhibition l Ausstellung
2001 *Noriyuki Haraguchi. Elemente der
Wahrnehmung. Arbeiten 1963–2001*, Städtische
Galerie im Lenbachhaus, Munich l München

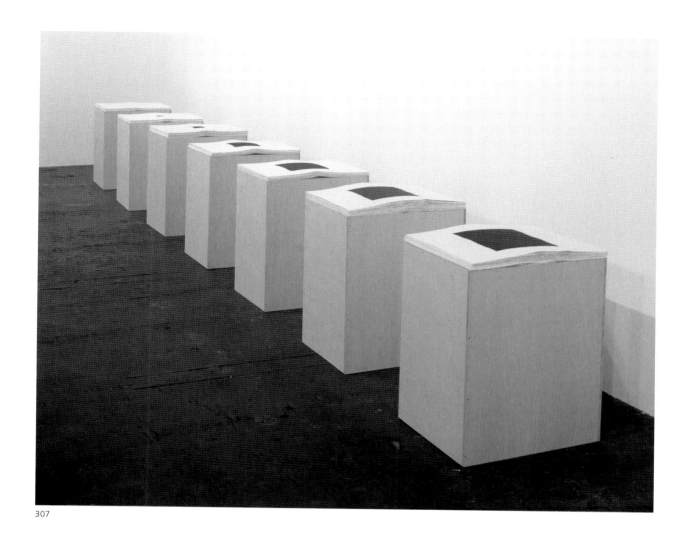

307

307
Untitled, 2001–2500
2000
Gouache on paper I Gouache auf Papier
Five hundred sheets, each I Fünfhundert Blatt jeweils:
56 x 76 cm
Akira Ikeda Gallery, Japan

Exhibition I Ausstellung
2001 *Noriyuki Haraguchi. Elemente der Wahrnehmung. Arbeiten 1963–2001*, Städtische Galerie im Lenbachhaus, Munich I München

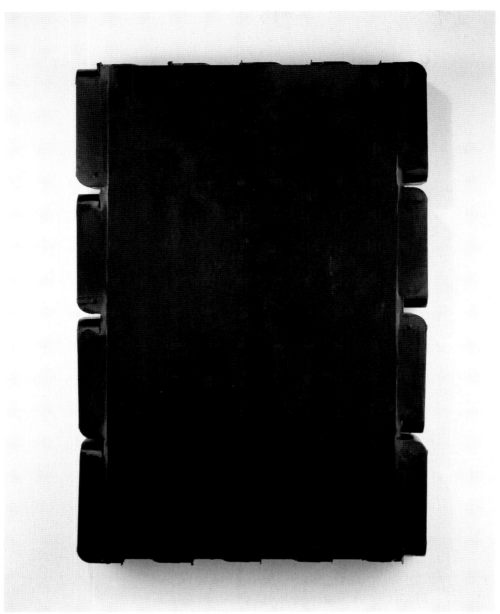

308

308
Plastic
2001
Black polyurethane on plastic l
Schwarzes Polyurethan auf Kunststoff
160 x 105 x 15 cm
Akira Ikeda Gallery, Japan

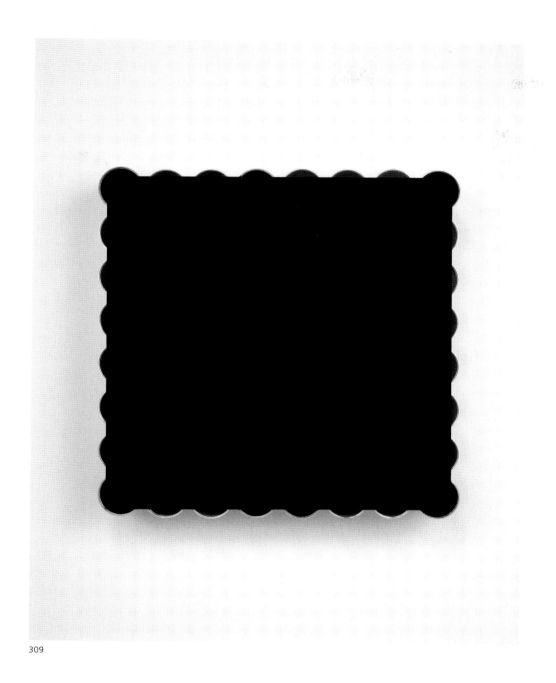

309

309
Aluminium
2001
Black polyurethane on aluminium I
Schwarzes Polyurethan auf Aluminium
120 x 120 x 20 cm
Akira Ikeda Gallery, Japan

Exhibition Biography I
Ausstellungsbiographie

1946
Noriyuki Haraguchi was born I wurde geboren
in Yokosuka
1970
Graduated from I Abschluss an der Nihon
University, Faculty of Arts (major in oil painting I
Hauptfach Ölmalerei)
2001
Lives and works I Lebt und arbeitet in Yokosuka

Solo Exhibitions I Einzelausstellungen

1968
Muramatsu Gallery, Tokyo

1969
Tamura Gallery, Tokyo

1970
Tamura Gallery, Tokyo

1971
Tamura Gallery, Tokyo

1972
Sato Gallery, Tokyo
Gin Gallery, Tokyo

1973
Gallery Iteza, Kyoto
Tamura Gallery, Tokyo

1974
Tamura Gallery, Tokyo
Gallery Iteza, Kyoto

1975
Tamura Gallery, Tokyo
Gin Gallery, Tokyo
Nirenoko Gallery, Tokyo

1976
Sato Gallery, Tokyo
Gallery U, Nagoya
Maki Gallery, Tokyo

1977
Kaneko Art Gallery, Tokyo

1978
Galerie Alfred Schmela, Düsseldorf

1979
Sakura Gallery, Nagoya
Koh Gallery, Tokyo

1980
Annely Juda Fine Art, London
Art in Progress, Düsseldorf

1981
Sakura Gallery, Nagoya
Akira Ikeda Gallery, Nagoya

1982
Akira Ikeda Gallery, Tokyo

1983
Juda Rowan Gallery, London

1984
Akira Ikeda Gallery, Nagoya

1985
Karin Bolz Galerie, Mülheim an der Ruhr
Akira Ikeda Gallery, Tokyo

1986
Noriyuki Haraguchi: Works 1981–1986,
Akira Ikeda Gallery, Nagoya

1987
Hoffman Borman Gallery, Santa Monica
Judson Art Warehouse Viewing Gallery, New York
Maki Gallery, Tokyo
Gallery Gen, Tokyo

1988
Judson Art Warehouse Viewing Gallery, New York
Akira Ikeda Gallery, Tokyo
AC & T Corporation, Tokyo
San Diego State University Art Gallery

1989
Gallery Gen, Tokyo

1990
Akira Ikeda Gallery, Tokyo
Yoshimitsu Hijikata Gallery, Nagoya
AC & T Corporation, Tokyo
Akira Ikeda Gallery, Taura, Yokosuka
Gallery Gen, Tokyo

1991
Akira Ikeda Gallery, Taura, Yokosuka
Gotoh Museum of Art, Chiba

1993
Akira Ikeda Gallery, Tokyo
Noriyuki Haraguchi: New Works,
Akira Ikeda Gallery, New York

Noriyuki Haraguchi: Matter and Mind,
Akira Ikeda Gallery, New York

1994
Akira Ikeda Gallery, Tokyo

1995
Hotel & Art AMBIK Contemporary Art, Atami
Akira Ikeda Gallery, Nagoya

1996
Akira Ikeda Gallery, Taura, Yokosuka

1997
Akira Ikeda Gallery, Tokyo

1998
Akira Ikeda Gallery, Taura, Yokosuka

2001
Galerie Hans Mayer, Berlin
Noriyuki Haraguchi. Elemente der Wahrnehmung.
Arbeiten 1963–2001, Städtische Galerie
im Lenbachhaus, Munich I München

Group Exhibitions I Gruppenausstellungen

1966
7th Contemporary Art Exhibition of Japan,
Tokyo Metropolitan Art Museum

1967
9 Artists, Muramatsu Gallery, Tokyo

1968
1st Apple in Space, Hibiya Gallery, Tokyo
Nippon Kama-Itachi, Yokohama Citizens' Gallery

1969
5th International Young Artists Exhibition,
Seibu Department Store, Tokyo
3 Artists, Akiyama Gallery, Tokyo
4th Japan Art Festival, The National Museum
of Modern Art, Tokyo (Award of Excellence)
2nd Apple in Space, Muramatsu Gallery, Tokyo
Trends in Contemporary Art, The National Museum
of Modern Art, Kyoto

1970
Opening, Tokiwa Gallery, Tokyo
3rd Apple in Space, American Center Tokyo

1971
Word and Image, Pinar Gallery, Tokyo
10th Contemporary Art Exhibition of Japan,
Tokyo Metropolitan Art Museum
3 Artists, Gallery Iteza, Kyoto

1972
Sinkers and Springs, American Center Tokyo
Contemporary Artists '72,
Yokohama Citizens' Gallery

1973
Ten-Ten (Exhibition of Points), Taura Sea Port,
Yokosuka
8th Japan Art Festival, Central Art Museum, Tokyo
(Award of Excellence)
Dimensions and Situations, Kinokuniya Gallery, Tokyo
1st Hakone Open-Air Museum Exhibition,
Hakone Open-Air Museum
5th Modern Sculpture of Japan Exhibition,
Tokiwa Park, Ube
'74 Dessin, Gin Gallery, Tokyo

1974
Japan. Tradition und Gegenwart,
Städtische Kunsthalle Düsseldorf

1975
From Method to Method, Yokohama Prefectural
Hall Gallery
Dimensions and Situations, Kinokuniya Gallery, Tokyo
6th Modern Sculpture of Japan Exhibition,
Tokiwa Park, Ube
Still Life of Today '75, Yokohama Citizens' Gallery

1976
Kyoto Biennale '76, Kyoto Municipal Art Museum
Dimensions and Situations, Kinokuniya Gallery,
Tokyo
The Biennale of Sydney, Art Gallery of New
South Wales, Sydney

1977
documenta 6, Kassel
Biennale de Paris, Musée national d'art moderne,
Paris
Galerie Alfred Schmela, Düsseldorf (with other artists
of the gallery I mit anderen Künstlern der Galerie)

1978
6th Contemporary Sculpture Exhibition,
Suma Detached Palace Garden, Kobe

1980
Vision for the 80s, Hara Museum
of Contemporary Art, Tokyo

1981
Schwarz, Städtische Kunsthalle Düsseldorf
*Construction in Process: Art of the 70s I Konstrukcja
w procesie. Sztuka lat 70 tych*, factory I Fabrik
in Łódź
Contemporary Japanese Art Exhibition,
The Korean Cultural and Art Foundation,
Misul Gallery, Seoul

1982
A Panorama of Contemporary Art in Japan,
The Museum of Modern Art, Toyama
8th Contemporary Sculpture Exhibition,
Suma Detached Palace Garden, Kobe

1984
The 1970s, Kamakura Gallery, Tokyo
*Trends of Contemporary Japanese Art, 1970–1984:
Universality/Individuality*, Tokyo Metropolitan
Art Museum

1985
Works by Watercolors, Part III, Kamakura Gallery,
Tokyo
Maquette Models and Drawings for Sculptures,
Galerie Jullien-Cornic, Paris
*Summer Show: Frank Stella, Richard Serra, Jean
Michel Basquiat, Anselm Kiefer, Noriyuki Haraguchi*,
Akira Ikeda Gallery, Tokyo

1986
Contemporary Japanese Art Exhibition,
Taipei Municipal Museum of Art
Mono-ha (with I mit Noboru Takayama, Koji Enokura),
Kamakura Gallery, Tokyo
Dispersed Core, Akira Ikeda Gallery, Tokyo
Black and White in Art Today, The Museum
of Modern Art, Saitama
Drawings, Akira Ikeda Gallery, Nagoya

1987
Drawing for Sculpture, Thomas Segal Gallery, Boston
Toyama Now '87, The Museum of Modern Art,
Toyama
Relief & Sculpture, Akira Ikeda Gallery, Nagoya
Gallery Te, Tokyo (with I mit Naoyoshi Hikosaka)

1988
(C)Overt: A Series of Exhibitions, P.S.1, New York
*Painting & Sculpture: Noriyuki Haraguchi, Isamu
Wakabayashi, Jonathan Borofsky, Imi Knoebel*,
Akira Ikeda Gallery, Tokyo
Print Works by 12 Artists, Gallery of Council
for Cultural Planning and Development, Taiwan
Summer Art Festival in Hakushu '88, Kitakoma-gun

1989
Nagoya Contemporary Art Fair II, Nagoya Electricity
Museum Building
Painting & Relief, Akira Ikeda Gallery, Tokyo
Summer Art Festival in Hakushu '89, Kitakoma-gun
*Color and/or Monochrome: A Perspective on
Contemporary Art*, The National Museum of Modern
Art, Tokyo; The National Museum of Modern Art,
Kyoto

1990
Group Show, Akira Ikeda Gallery, Tokyo
Nagoya Contemporary Art Fair III, Nagoya Electricity
Museum Building
*Pharmakon '90: Makuhari Messe Contemporary
Art Exhibition*, Nippon Convention Center,
Makuhari Messe, Chiba
Pharmakon '90: Bags and Posters, Akira Ikeda
Gallery, Tokyo
Summer Art Festival in Hakushu '90, Kitakoma-gun
Minimal Art, The National Museum of Art, Osaka

1991
Summer Art Festival in Hakushu '91, Kitakoma-gun
70s–80s Contemporary Art, Kamakura Gallery, Tokyo

1992
Group Show, Akira Ikeda Gallery, Tokyo
Group Show, Akira Ikeda Gallery, Taura, Yokosuka
Nagoya Contemporary Art Fair V, Nagoya City Gallery
New Drawings, Akira Ikeda Gallery, Nagoya
Summer Art Festival in Hakushu '92, Kitakoma-gun
Joseph Beuys, Piero Manzoni, Noriyuki Haraguchi,
Akira Ikeda Gallery, Tokyo

1993
Nagoya Contemporary Art Fair VI, Nagoya City
Gallery
Summer Art Festival in Hakushu '93, Kitakoma-gun
*Oita Contemporary Art Exhibition '93: Propose to
the Urban Environment – Impractical*, Oita

1994
Nagoya Contemporary Art Fair VII,
Nagoya City Gallery
Summer Art Festival in Hakushu '94, Kitakoma-gun
Mono-ha (with I mit Noboru Takayama),
Kamakura Gallery, Tokyo

1995
*Matter and Perception, 1970: Mono-ha and the
Search for Fundamentals*, The Museum of Fine Arts,
Gifu; Hiroshima City Museum of Contemporary Art;
Kitakyushu Municipal Museum of Art, Fukuoka;
The Museum of Modern Art, Urawa
Japanese Culture: The Fifty Postwar Years, Meguro
Museum of Art, Tokyo; Hiroshima City Museum
of Contemporary Art; Hyogo Prefectural Museum
of Modern Art; Fukuoka Prefectural Museum of Art
Nagoya Contemporary Art Fair VIII, Nagoya
City Gallery
Asiana: Contemporary Art from the Far East,
Fondazione Mudima, Palazzo Vendramin Calergi,
Venice I Venedig
Summer Show, Akira Ikeda Gallery, Nagoya
Small Sculptures, Akira Ikeda Gallery, Tokyo
16th Modern Sculpture of Japan Exhibition,
Tokiwa Park, Ube

1996
Nagoya Contemporary Art Fair IX, Nagoya City
Gallery
*Japon 1970. Matière et perception. Le Mono-ha
et la recherche des fondements de l'art*, Musée d'Art
moderne de Saint-Etienne
Pino Pascali, Jiro Takamatsu, Noriyuki Haraguchi,
Akira Ikeda Gallery, Tokyo
Summer Art Festival in Hakushu '96, Kitakoma-gun

1997
Nagoya Contemporary Art Fair X, Nagoya City Gallery
Kwangju Biennale, Kwangju
Cravity: Axis of Contemporary Art,
The National Museum of Art, Osaka

1998
Nagoya Contemporary Art Fair XI, Nagoya City Gallery

1999
Atami Biennale, Atami
Nagoya Contemporary Art Fair XII, Nagoya City
Gallery

2000
Kwangju Biennale, Kwangju
Nagoya Contemporary Art Fair XIII, Nagoya City
Gallery

2001
In Time, Akira Ikeda Gallery, Taura, Yokosuka
Nagoya Contemporary Art Fair XIV, Nagoya City
Gallery

This catalogue raisonné is published on the occasion of the exhibition *Noriyuki Haraguchi. Elemente der Wahrnehmung. Arbeiten 1963–2001* from 28 April to 22 July 2001 in the Städtische Galerie im Lenbachhaus, Munich. The catalogue and the exhibition were realised in co-operation with the Akira Ikeda Gallery, Japan.

Dieser Catalogue raisonné erscheint anlässlich der Ausstellung *Noriyuki Haraguchi. Elemente der Wahrnehmung. Arbeiten 1963–2001*, vom 28. April bis zum 22. Juli 2001 in der Städtischen Galerie im Lenbachhaus, München. Katalog und Ausstellung wurden in Zusammenarbeit mit der Akira Ikeda Gallery, Japan, realisiert.

Catalogue and Exhibition I Katalog und Ausstellung
Helmut Friedel

Text Editing I Redaktion
Jürgen Geiger, Stuttgart

Translations I Übersetzungen
Fiona Elliott, Edinburgh
Sabine Mangold, Berlin
Rise Wada, Yokohama

English Copy Editing I Englisches Lektorat
Tas Skorupa, Berlin

Design I Gestaltung
Gabriele Sabolewski

Typesetting I Satz
Jürgen Geiger, Stuttgart

Reprographics I Reproduktionen
Repromayer, Reutlingen

Printed by I Gesamtherstellung
Dr. Cantz'sche Druckerei, Ostfildern-Ruit

Published by I Erschienen im
Hatje Cantz Verlag
Senefelderstraße 12
73760 Ostfildern-Ruit
Germany
Tel: ++49 711 4405 0
Fax: ++49 711 4405 220
www.hatjecantz.de

Distribution in the US
D.A.P., Distributed Art Publishers, Inc.
155 Avenue of the Americas, Second Floor
New York, NY 10013-1507
USA
Tel: ++1 212 627 1999
Fax: ++1 212 627 9484

ISBN 3-7757-1055-8

Printed in Germany

Die Deutsche Bibliothek - CIP-Einheitsaufnahme
Noriyuki Haraguchi : catalogue raisonné 1963 - 2001; [on the occasion of the Exhibition Noriyuki Haraguchi. Elemente der Wahrnehmung. Arbeiten 1963 - 2001, from 28 April to 22 July 2001 in der Städtische Galerie im Lenbachhaus, Munich] / Helmut Friedel. [Transl. Fiona Elliott ...]. - Ostfildern-Ruit : Hatje Cantz, 2001
ISBN 3-7757-1055-8

Cover illustration I Umschlagabbildung
Noriyuki Haraguchi, *Untitled* (CAT. No. 286)